146711

758.2
Ste

Stein, Roger B.

Seascape and the
American imagina-
tion

DATE DUE

Seascape and the
American Imagination

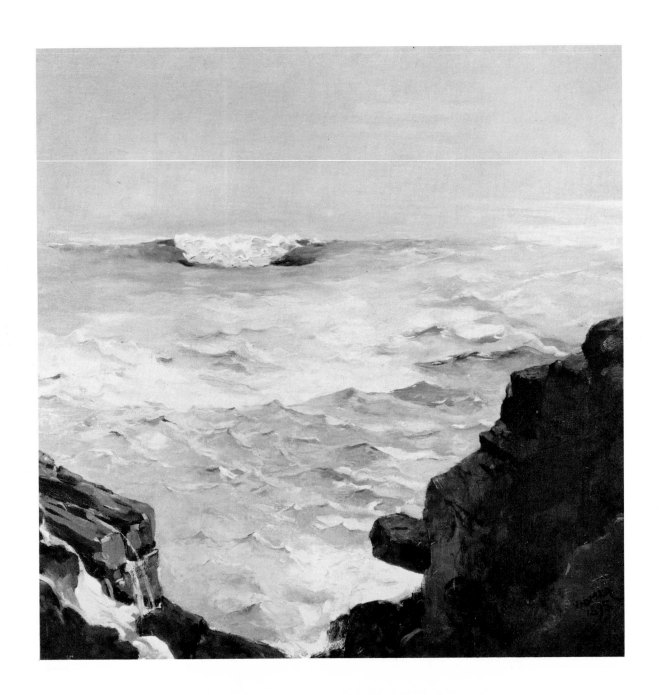

Seascape

and the

American Imagination

Roger B. Stein

Clarkson N. Potter, Inc./Publisher New York

In association with the Whitney Museum of American Art

Distributed by Crown Publishers, Inc.

COVER: Detail of Plate V. Fitz Hugh Lane. *Harbor Scene (Gloucester Harbor, the Fort and Ten Pound Island)* (1848). Oil on canvas, 20 × 30 inches. The Newark Museum, Newark, New Jersey.

FRONTISPIECE: Winslow Homer. *Cannon Rock,* 1895. Oil on canvas, 39 × 29 inches. The Metropolitan Museum of Art, New York; Gift of George A. Hearn.

Published simultaneously in Canada by General Publishing Company Limited.

First edition.

Printed in the United States of America.

146711

Library of Congress Cataloging in Publication Data

Stein, Roger B.
 Seascape and the American imagination.

 Bibliography: p.
 Includes index.
 1. Marine painting, American. I. Title.
ND1372.S8 758′.2′0973 75–8979
ISBN 0–517–52171–7

Photograph Credits

Armen Photography, Gilbert Ask, E. Irving Blomstrann, Geoffrey Clements, Richard Di Liberto, Bill Finney, Christopher Focht, Helga Photo Studio, Herrington-Olson Photography, Peter A. Juley and Son, Jean Lange, LeBel's Studio, Linda Lorenz, Taylor and Dull, Inc., James K. Ufford, Herbert P. Vose.

For Grey

Contents

Acknowledgments

Acknowledging the debts I have incurred in the course of this study is a pleasure, because it reminds me that scholarship, like all meaningful work, is at best a cooperative enterprise. I have been especially fortunate in the assistance, the encouragement, and the shared enthusiasm of many individuals. At the outset, I wish to express my thanks to Gervais Reed and LaMar Harrington of the Henry Gallery, University of Washington, several years ago for setting me on the route to American seascape by encouraging an intellectual historian to work with visual materials for an exhibition. Second, to John Wilmerding, a pioneer in these waters, my debt, like that of all who venture into the field of American marine painting, is very great. He has mapped the territory in art historical terms in his *History of American Marine Painting*, has explored in scholarly depth on a number of individual painters, and has been encouraging and generous personally. If, in the following study, I take a somewhat different route, it is with the recognition that my task is easier because of the soundings he

has taken along the way. Third, I am grateful to the Whitney Museum of American Art for the invitation to do the exhibition, which has forced me to give a visual shape to my thinking about the problem of seascape and the American imagination. That act of faith has been supported by concrete assistance by everybody from John I. H. Baur, Director Emeritus, who himself did the first major American seascape exhibition many years ago at the Brooklyn Museum, and Tom Armstrong, Director, to secretaries, assistants, and security staff, all of whom have been extraordinarily helpful to an outsider in their midst. At the risk of invidious distinctions, I must single out Patricia Hills, Adjunct Curator of 18th- and 19th-Century Art, who has been my advocate, my counsel, and a sharp and helpful critic of the vagaries of my pen, and Margaret Aspinwall, who has edited further with kindness and precision. Finally, none of my various thrusts of the harpoon would have captured the great leviathan without the consistent, perceptive, and sensitive skill of Jennifer Russell, who translated all my efforts into accomplished deeds at the Museum.

For scholarly aid, help in locating and securing individual works of art, and a variety of other kinds of assistance over the years, I should like to thank the following: Robin Boulton-Smith, David Brooke, Russell Burke, William P. Campbell, J. Revell Carr, Louisa Dresser, Edward H. Dwight, Katherine and Eugene Emigh, Stuart P. Feld, Linda Ferber, Charles Ferguson, William H. Gerdts, Lucretia Giese, David C. Huntington, Barbara Johnson, Michael Jorrín, Valerie Jorrín, Gerald Kadish, Katherine Kadish, Harry L. Koenigsberg, Richard Koke, Kenneth C. Lindsay, Jean Lipman, Laura C. Luckey, Edgar DeN. Mayhew, David McKibben, Mariann Nowack, Nancy Osterud, Dorothy W. Phillips, Jane L. Richards, Benjamin Rifkin, Melanie Schwarzer, Lewis A. Shepard, Theodore E. Stebbins, Jr., Michael D. Sturges, Joshua L. Taylor, Nicki Thiras, William H. Truettner, Fearn Thurlow, S. Morton Vose II, Joan Washburn, Peter C. Welsh, George D. Wintress, John Zukowsky, and a special thanks to Lloyd Goodrich whose fund of knowledge in crucial areas of my work I have profited from both in its published form and personally.

To the many students on whom, over the years, I have tried out my ideas, I hope that the shape those ideas have taken here will indicate to them that my assertion that I was learning too was not rhetorical but an expression of the reciprocal nature of the interchange. Last, a special nod to David and Jonathan, whose particular generosity was in putting up with a father's many absences, in body or mind, during the months when this other, but not rival, child was aborning.

For material assistance I wish to thank the Research Foundation of the State University of New York for a summer free to work on this

project; Harpur College and the English Department at the State University of New York at Binghamton for facilities and secretarial support; and the National Collection of Fine Arts for a Visiting Scholar appointment in that ideal atmosphere in which to work.

ROGER B. STEIN
Guest Curator

Seascape and the
American Imagination

Seascape and the American Imagination

1.
The Origins of American Seascape

From the discoveries of Columbus in 1492 to the first settlements at Jamestown and Plymouth at the outset of the seventeenth century and for three hundred years thereafter, American experience has been inextricably linked to the sea. The sea has been the barrier to be crossed on the way to the New World, which dislocated the immigrant from all that was familiar in the old. It has been the source of cod and whale oil to feed and light the lamps of Europe and America, a nautical highway for burgeoning commerce and industry, and a testing ground for American skill and prowess. In a multitude of ways American culture has been defined and shaped profoundly by its experience with the sea. Our powerful thrust into the western frontier has been counterbalanced by a thrust eastward into the equally vast and untamed Atlantic Ocean, and our art has recognized and recorded that fact. We have heard much about the artistic recorders of our landscape from the Hudson River, the Cat-

skills, and Niagara Falls to the Rocky Mountains and beyond, but the imaginative record of American experience with the sea is less well known. And yet, historically speaking, seascape art has a prior claim upon our attention, for the sea engaged the American imagination long before Americans fell in love with their land. The history of American seascape should thus document the range and variety of our encounters with the maritime world.

It can do more than that, however. Seascape is an artistic mode, an organization of expressive gestures that can give permanence to our visual awareness of the sea, the coast, and the voyage. As such it is as much a record of our thoughts and feelings about that outer fluid space and our attempts to map it and to impose upon it a conceptual grid as it is a documentary record of that space itself. The works of art that comprise the tradition of American seascape art demand to be read, thus, not only as elements in the history of a particular genre called "marine painting"[1] but also as ways in which Americans have understood themselves as a people in the New World. Because the expressive

language is artistic, we must inevitably confront how an individual artist constructs his pictorial world, for each artist's gesture is his own and unique, though it may later be transformed and multiplied by a Currier & Ives print, rearranged and stamped in red on a muslin souvenir kerchief, incised as scrimshaw on a whale's tooth, or reproduced in some other way, in whole or in part, by another artist. Yet because seascape taps such an important shared cultural experience, these individual works become particular configurations of that experience, forms of cultural self-definition. By exploring the range and variety of our seascape tradition, we can achieve a richer sense of our artistic heritage and perhaps come to understand better the nature of American experience: our aspirations and our fears, our achievements and our failures, our triumphs and our tragedies.

At the outset of our study, there is a paradox, or at least a tension, inherent in the very notion of seascape; it implies the imposition of form and order, of a perspective and a point of view, upon that which is by definition formless and shapeless. The sea has embodied through the centuries ideas of the vast and the untamed, the All, the Universal Oneness, or even Chaos. In the Judeo-Christian tradition the first seascape artist is Deity himself, in the opening chapter of Genesis, when He separates the heavens from the earth and delineates a horizon between sea and sky. As if to emphasize the tenuous nature of the act, the later chapters on Noah and the flood reinforce the point: because of human beings' moral failure, that stay against chaos, that line of separation which differentiates and makes space measurable, may be withdrawn and the land world of the human community swallowed up by the Deluge. Often with a rich sense of this threat implicit in our creation myth, the seascape artist over the centuries has attempted to further differentiate the original space, to make humanly understandable, if not ultimately humanly habitable, the endless and intrinsically terrifying openness of the undifferentiated space of the sea.

Later Biblical responses to the sea ranged from the terror and awe of those who went down to the sea in ships and beheld "the wonders of the deep" (in Psalm 107 and the Book of Jonah) to New Testament attempts to find a spiritual reconciliation and a mediator for the unobliged power of Deity through Christ stilling the tempest on the Sea of Galilee or shipwrecked Paul proselytizing on the isle of Melita.[2] Within the classical tradition, the Greeks were a seafaring people, with Poseidon, brother of Zeus, to personify the sea. Homer's frequent epithets about the "wine-dark sea" in the descriptive passages of Odysseus's quest into seascape space are well known. In Western art before the Renaissance, however, the space of the sea was generally limited and confined. It appeared in illuminated manuscripts and mosaics, on delicate golden nefs and on the Bayeux tapestries, in bestiaries and books of hours, and on the sculpted programs of cathedral façades. But almost always seascape space was restricted to a few wavy lines, a ship, a fish, a tiny vista: hieratic conceptual recognitions of the role of the sea in relation to some religious or secular event, not mimetic representations of the ultimate openness of that seascape space itself.[3]

The importance of this pattern for the history of seascape and the American imagination is not general and prefatory but immediate and direct. The full, open seascape space has been linked to an imaginative conception of America since ancient times. "America" was for centuries the unknown place beyond the vast sea. American seascape began as a noble dream of the Western imagination, encompassing the utopian Atlantis of Plato's *Timaeus,* medieval legends of the Fortunate Isles, of the terrestrial paradise and Ultima Thule, some ideal kingdom that existed beyond or under the sea, which could be reached only by a perilous voyage. These mythical versions of America were at once places hinted at through vague reports of early voyagers and ways of filling up the vast and frightening void beyond the Pillars of Hercules.[4]

During the Renaissance, America was transformed from a visionary ideal into an actual land mass across the Atlantic Ocean. The commercial and imperial impulses that sent Columbus and a

host of others out exploring into the hitherto inhibiting space were counterbalanced, however, by the aesthetic impulse of the Renaissance toward order and control. After the soaring immensities of the Amiens and Beauvais cathedrals or the complexities of the vaults of San Marco in Venice, we have Brunelleschi's rationally comprehensible Church of San Lorenzo or the reduction of cosmic mysteries to the order of Raphael's *Disputa* and *The School of Athens*. The Renaissance instinct to map space and thus make it comprehensible was a powerful one—not to submit to the vast unknown but to shape it for human use.

Within this context one can trace, in the cartographic record before and after Columbus, the gradual transformation of that space beyond the shores of Europe and Africa as it was progressively subdued. The fanciful beasts and equally fanciful coastlines were replaced by a clearer sense of direction in space: the void had its boundaries. The land was imaginatively brought under control by naming it, by giving it verbal and visual reality, long before it was much inhabited. Sifting through the maps one is struck by the wealth of the evidence and by the complex interrelation between conceptual and perceptual patterns, between older European ideas giving traditional shape to the new American sea spaces and new empirical evidence modifying older conceptions. The borrowings, the adaptations, the cannibalizing of earlier maps by later map makers—these problems fall within the province of the professional student of cartography and engravings. For us it is the interaction that is most striking; not "fact" driving out imagination but the interplay between the two. As the centers of the maps define with growing precision the western littoral of the Atlantic, the heavily loaded borders and cartouches of the maps still insist upon our understanding the new facts within the classical, mythological, heraldic, and folkloric patterns of European culture.[5]

There is thus something stark and awkward about the 1677 John Foster *Map of New England* (Fig. 1), the first to be published in New England itself, a harshly simple Puritan statement which limits the sea space to a calm decorative element. The land is divided by rivers that push into the interior, studded with trees and the names of coastal towns. This map is an apt emblem of the Puritan desire to subordinate the sea to what William Bradford, speaking of the Pilgrims' landing at Plymouth, called "the firme and stable earth, their proper elemente."[6]

Maps are apprehended as two-dimensional abstractions of space, though frequently, as the Foster map makes clear, the impulse toward the three-dimensional peopled them with ships and beasts and suggestions of towns and Indian villages. The harbor view extended this perceptual process fully into the third dimension. As a visual tradition it was crystallizing in Holland in the very years that saw the colonization of the eastern seaboard of America. The seventeenth century was to become the great age of Dutch seascape painting. The Dutch were a great maritime people, an important naval power, and a prospering commercial culture with a strong visual tradition that included battle painting, ship portraiture, and the finest engravers in Europe. In this era the Dutch artists' celebration of all facets of middle-class life included palpable atmospheric renditions of harbors and beaches, of local fishermen and bold seagoing vessels. Through the popularity of these works among English and continental connoisseurs and their reproduction in engraved versions, the Dutch artists and their followers made available to Americans a bold new language, a set of visual conventions for bringing together ships, coast, sea, and sky into a harmonious relationship: a conquest of pictorial space as important aesthetically as the explorers' conquest of the seas themselves.[7]

Laurens Block brought the Dutch tradition from Holland to America in the mid-seventeenth century. His delicate watercolor view of New Amsterdam (Fig. 2) is one of the first, but it suggests the pattern carried into the eighteenth century: a strong horizontal orientation, emphasizing the panoramic. The eye restlessly moves along the picture plane searching for recognizable buildings; the sea becomes a foreground introduction, our space

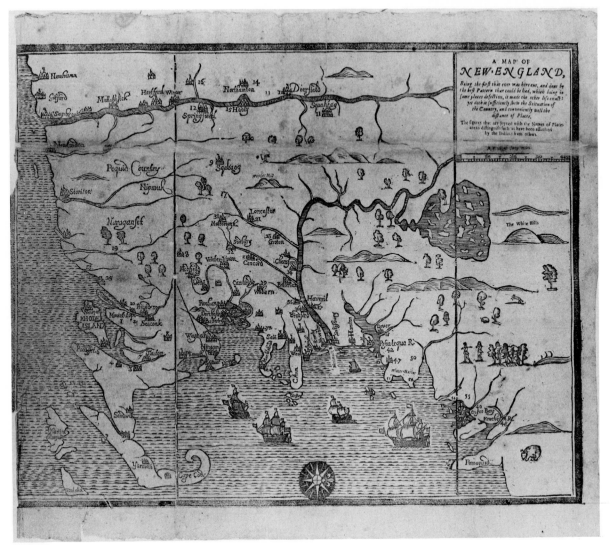

1. John Foster. *A Map of New England*, 1677. Published in William Hubbard, *A Narrative of the Trouble with Indians in New England*. Woodcut, 11 11/16 x 15⅝ inches. American Antiquarian Society, Worcester, Massachusetts.

perhaps but pointing us shoreward toward the recognizable signs of the human community. This little watercolor was carried back to Holland as a visual record and richly framed, probably in the eighteenth century, the simplicities of the New World view enclosed by the heraldic patterns of the Old World. It thus becomes an apt emblem of Old World ways of enclosing and framing—here literally—the New World.[8]

The framed vision became in fact the characteristic shape of American seascape during the colonial period. Within the harbor view tradition it is re-

4

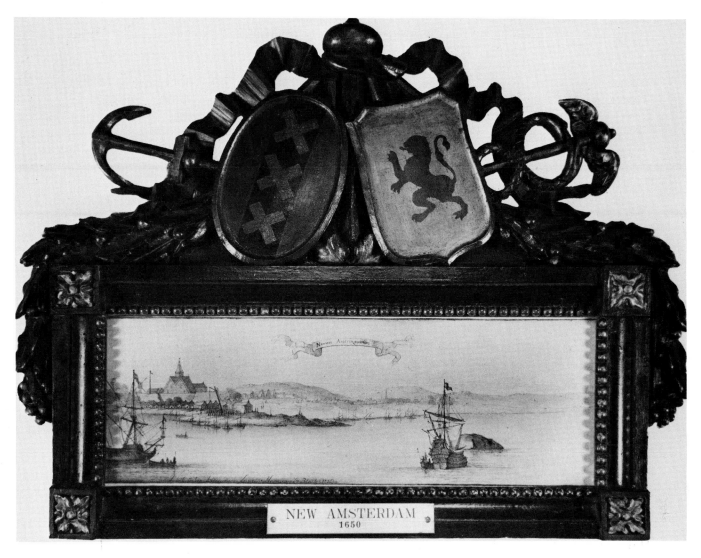

2. Laurens Block. *Novum Amsterodamum*, (1650). Wash and ink on paper, 5⅞ x 19⅜ inches. The New-York Historical Society, New York.

peated in the 1719–21 William Burgis *South Prospect of New York* (Fig. 3), reprinted with changes by Bakewell in 1748.[9] The multitude of ships posed at varying angles testify to the maritime destiny of New York, but they are squeezed into a narrow channel in the middle ground. Beyond them stretch the neat regularities of the human community across the bay, with recognizable profiles of particular buildings. The foreground space is designed to contain and control the view through its carefully balanced pattern of rural meadow, comfortably peopled dockside, and the superimposed

5

formalities of the cartouche, with its heraldic emblems of state and presiding deities. The stable horizontal patterning of the whole also serves to reinforce the dominant impression that this is an abstract and symbolic map of the harbor space, not a direct perception.

These early American harbor views seem intent upon limiting the sea space. The contemporary of Charleston, South Carolina, of about 1773 (Fig. 5), is also strongly atmospheric, but it returns to the simple horizontal format with a narrow rim of land in the foreground from which little figures look out across the bay toward the town. When Leitch advertised for subscribers to the engraved version of the painting (the original, like the Cooper and Block views, went back to Europe), he promised his

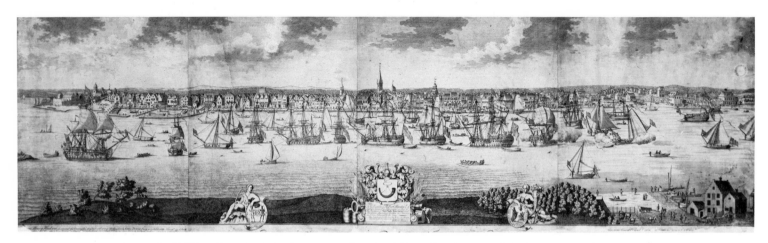

3. William Burgis. *A South Prospect of ye Flourishing City of New York in the Province of New York in America,* 1719–21. Line engraving, 20½ x 77 inches. The New-York Historical Society, New York.

view of Philadelphia (c. 1720) by Peter Cooper is organized in the same manner as the Burgis view. Later in the century we have two views in oils by the obscure Thomas Leitch. The first, of New York of about 1750 (Fig. 4), opens up the sea and sky space and allows the ships to organize pyramidally the recession toward the dwarfed buildings on the low horizon in the best Dutch manner. The second, customers that the view "will be so exact a portrait of the town as it appears from the water, that houses in view will be distinctly known." Mapping and framing the harbor space for his viewer, the colonial artist turned his back on the openness of the sea.[10]

The ultimate statement of this attempt to control harbor space came in the great series of charts and

4. Thomas Leitch. *View of New York,* c. 1750. Oil on canvas, 25⅜ x 30 inches. Henry Francis du Pont Winterthur Museum, Winterthur, Delaware.

5. Thomas Leitch. *View of Charles Town, S.C.,* c. 1773. Oil on canvas, 20 x 60 inches.
Museum of Early Southern Decorative Arts, Winston-Salem, North Carolina.

views executed under the direction of J. F. W. Des Barres, entitled *The Atlantic Neptune* (1777–84). The title page bows to the classical tradition but the charts themselves, the first comprehensive series of maps of the North American coast from the treacherous Isle of Sable off Newfoundland to the Southern colonies, are ample testimony to the subduing of the external world to human will. Harbors are plotted, soundings carefully noted, as are towns, roads into the interior, and elevations. The views reappear, at the head of the charts or as separate aquatinted engravings, predominantly in the radically horizontal format, to counteract the abstraction of the map and offer to captains and pilots recognizable coastal profiles of the shores they were approaching. A remarkable marriage of art and maritime science, of visual delicacy and nautical precision, *The Atlantic Neptune* is the climax of a cartographic tradition, a prized possession of sailors for several generations, and a signal aesthetic achievement.[11]

What is remarkable in the hundred years between the Foster map and *The Atlantic Neptune* is the fragmentary nature of the visual evidence of American seascape. Given the importance of the sea to Americans experientially, one might expect a richer visual record. The verbal record is somewhat fuller. There are of course hundreds of travel narratives, and allusions to nautical experience in sermons and poems and fiction, but the specifically imaginative exploration of sea experience is still limited. Given also the great achievements in seventeenth-century Dutch seascape painting and its translation to England in the 1670s, when the Van de Veldes arrived from Holland to spawn a British school of seascape artists in the next century—Charles Brooking, Samuel Scott, the Cleveleys, Nicholas Pocock, Peter Monamy, Francis Swaine—the question becomes more compelling.[12]

Historians of American art and culture have traditionally accounted for the fragmentary evidence by speaking of the limited facilities and op-

8

portunities in the British American colonies for artistic growth; but that is not in itself sufficient. Another part of the answer lies undoubtedly in the disappearance of the evidence. The engraved maps and views have survived because of their duplication, and some views, as we have noted, found their way to public buildings or to Europe where they were preserved as records of that exotic place beyond the seas. But most of the marine views that colonial painters and printshops sold as decorative works, however crude, to colonial customers seem to have disappeared along with the buildings in which such works hung. A third answer suggests itself from the most important body of pictorial evidence that has survived: portraiture. A careful reading of these works offers some clues as to the character of Americans' imaginative response to the sea in the colonial period, responses that parallel those of our poets and early novelists.[13]

The pair of portraits attributed to "Thomas Smith, Mariner" should indicate the pattern. In the handling of paint in both, they are less sophisticated versions of the Flemish and English manner. Both incorporate sea views but restrict the sea space to a relatively small window opening at the upper left. The sea is known to us as it is defined by a dominating human figure. The first, of *Major Thomas Savage* (1679), is a secular statement. Savage was a merchant and colonial official and had been commander of the Boston forces in King Philip's War in 1675. He is depicted as a man of high station in the splendor of his position, with his family coat of arms. The view of Boston in the window, with marching troops and the small glimpse of the harbor beyond (one of the first) serves to locate him conceptually in terms of his role in the town.[14]

Captain Thomas Smith's *Self-Portrait* of about 1690 (Fig. 6) is a more complex, religious statement that is organized by the little poem in the lower left:

Why why should I the world be minding
therin a World of Evils Finding.
 Then Far[e]well World: Farwell thy Jarres

thy Joies thy Toies thy Wiles thy Warrs
Truth Sounds Retreat: I am not sorye,
 The Eternall Drawes to him my heart
 By Faith (which can thy Force Subvert)
To Crowne me (after Grace) with Glory.

The meaning of the canvas is defined by a series of emblems: static pictorial signs that are arbitrarily organized to correlate with the conceptual verbal statement.[15] The seaman lives in a world of conflict, emblematized here by the naval battle in the window view (the seascape here, that is, standing for experience in the outside world more generally speaking). He will move toward inevitable death, indicated by the stylized skull (it looks like a gravestone carving). The final movement is spiritual, but the artist depends upon the poem to say this. He has not found pictorial means to define that ultimate stage of the spiritual journey.

As cultural statements these earliest emblematic seascape portraits clarify colonial attitudes. The spatial organization of the conventional baroque window portrait becomes a useful pictorial language for controlling and limiting the meaning of the sea, reducing it to a function of social role in the case of the *Savage* portrait or making it an abstract sign of worldly conflict which must be transcended by the spiritual voyager in the Smith *Self-Portrait*. The colonial artist and his sitter did not seek a direct engagement of the self with the sea, but rather to establish a barrier—pictorial and conceptual—against the direct experience with that wild and unruly openness. Taken together these two portraits are a reminder that seascape could be used to point both outward into the world of affairs and inward toward the soul and the psyche.

As the colonies prospered in the eighteenth century, Americans seemed less preoccupied with spiritual concerns. Our artists explored the window or background seascape in a variety of portraits that used ships and harbors to define the commercial calling of their sitters. In some cases they borrowed from European mezzotint sources. John Smibert sought the latest ship engravings from London to use in his backgrounds, if his

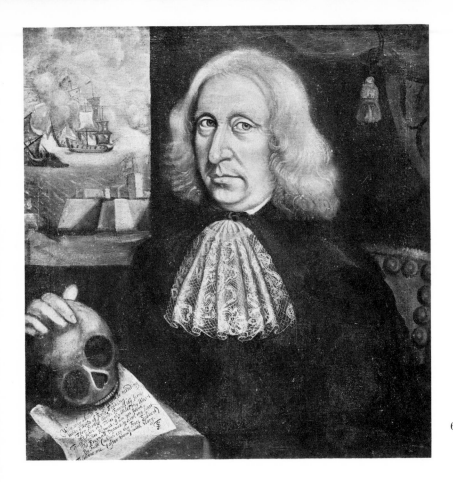

6. Thomas Smith. *Self-Portrait*, c. 1690. Oil on canvas, 24½ x 23¾ inches. Worcester Art Museum, Worcester, Massachusetts.

merchant-sitters requested them, even though Smibert could see the ships of Boston harbor out of his studio window on the Long Wharf: a notable case of the triumph of an existing conventional image over direct visual perception. The maker of the *Joseph Hallett* portrait, about 1728 (Fig. 7), in New York drew upon a 1696 mezzotint by John Smith (Fig. 8) after Godfrey Kneller's *Earl of Exeter* to assist him in pose and drapery, but the elegant classical garden in the *Exeter* portrait, which defines the leisure world of those who remained at home in the mother country, fixed in status and position, was clearly inappropriate to the socially mobile rising mercantile class of New York. The ideal

garden represented Old World stability and permanence; by contrast, the ship which the *Hallett* painter substituted, with care and precision, defined the status and role of the new American man.[16]

This same conceptual use of the sea is particularly clear in the case of the portrait, attributed to Joseph Blackburn, of the young Portsmouth, New Hampshire, merchant *Samuel Moffatt*, 1760–61 (Fig. 9), who is seen not on his ship but holding a model in his hand. Shipping was a risky business, with chances of great fortunes but also constant risk of losing ship and cargo in the treacherous waters of the Atlantic. The artist here has carefully

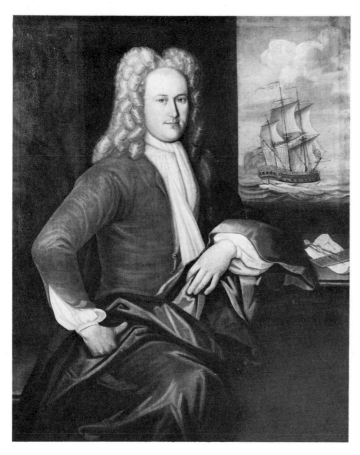

7. Gerardus Duyckinck I (attributed). *Joseph Hallett*, c. 1728. Oil on canvas, 49½ x 40¼ inches. The New-York Historical Society, New York.

8. John Smith (after Godfrey Kneller). *Earl of Exeter*, 1696. Mezzotint, 13¾ x 10⅛ inches. Anonymous collection.

organized his material, within the limits of his abilities, to locate his patron within his maritime world. The solidity of the figure and the elegance of the dress is backed by the suggestion of the conventional classical column, which reinforces our sense of order. The dark interior to the left is balanced by Moffatt's world of trade to the right, with its suggestive images of barren coasts or islands and a shipwreck. But the merchant's guiding hand holds the ship model, safe and sound, controlling the horizon space between the sea below and the sky above. The Moffatt ship is ultimately a comfortable plaything. The visual world of the portrait reassures where life does not.[17] Moses Marcy lived in inland Southbridge, Massachusetts, but his mercantile interests led the artist who painted the wall panel for his house (Fig. 10) to depict him not only with his cup and bowl and pipe

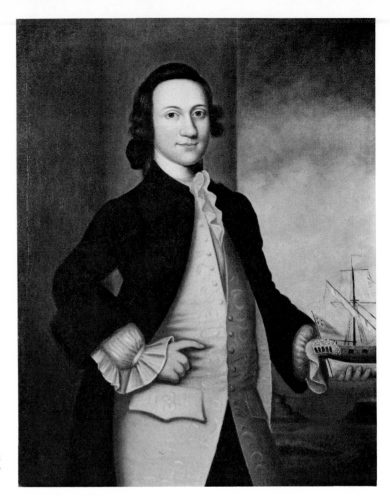

9. Joseph Blackburn (attributed). *Samuel Moffatt*, 1760–61. Oil on canvas, 36 x 28½ inches. Moffatt-Ladd House, National Society of the Colonial Dames in New Hampshire, Portsmouth.

and house, images of rural conviviality, but also with a charming ship and sea at his back to define his economic role. The notion of sea space and ships here again is mental, conceptual, rather than a record of a world perceived.

The seascape portrait also spatially defined sex roles, as is evident in a pair of portraits done by William Williams in 1766 of young *William Hall* (Fig. 11) and his sister *Deborah Hall* (Fig. 12). The young man is in a library, with an elegant carved table and a ledger book beside him. His future destiny as a man of affairs is suggested by the open space of the sea which we glimpse through the arched window. His sister Deborah lives in enclosed space, the classical garden. She is linked to traditional Old World values, not to the wild and open (which requires a lighthouse beacon to guide one) but to the refined and contained (and even her squirrel has been tamed). Neither figure, of course, seriously interacts with the surrounding space, but Williams here suggests a major imaginative pattern of American seascape and American art and culture more generally considered: the differentiation of male and female space. The American woman

10. Unknown artist. *Moses Marcy in a Landscape,* c. 1760. Oil on panel, 39¾ x 25⅞ inches (sight). Old Sturbridge Village, Massachusetts.

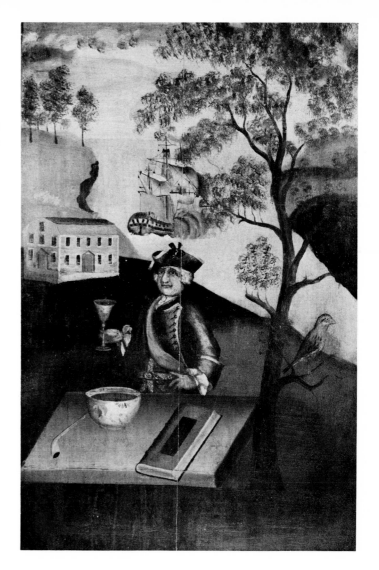

was to be mostly cut off from the possibilities of venturing outward, except as a passenger or in male disguise (in the novels) or when shaped as a figurehead to the bowsprits of sailing vessels. The woman was to be the guardian of the land while the man ventured into dark and stormy seas. The little miniature that Edward Savage painted of his fiancée *Sarah Seaver* (Fig. 13) at the end of the eighteenth century is the exception which proves the rule: she sits writing a letter, but the tiny ship glimpsed through the window is not hers; it stands for her absent lover, just embarked for Europe.[18]

But of course Savage's sea journey is a mental fact, not a directly perceived experience. American seascape painting in the colonial period had mapped harbors and defined men's lives in relation to maritime experience, but it had not put the sea and the American self into dynamic relation with one another. The static framing of seascape imaged colonial ideas of aesthetic and social order. Even the finest of colonial portraits, Robert Feke's *Brigadier General Samuel Waldo,* about 1748 (Fig. 14), is an image of a gentleman of high station. He does not interact meaningfully with the harbor of Louisbourg behind him, even though he had been second in command in the Pepperrell expedition which took the town. John Smibert had written in great excitement at the time of the expedition to take Louisbourg of the vessels sailing off to blockade the harbor, and the effect of the expedition if it succeeded ("a terrible blow to France as it wil effectually destroy their fishery & make ye navigation to Canada very dangerous"). None of this kind

of excitement about the event gets into Feke's splendid portrait. Only a tiny puff of smoke from the fort below disturbs the tranquil harbor view. In the *Waldo* as in its vernacular counterpart, the *Moses Marcy* wall panel, sea venturing is an act of the mind.[19]

As the colonial period came to a close in the 1770s in an escalating series of commercial and

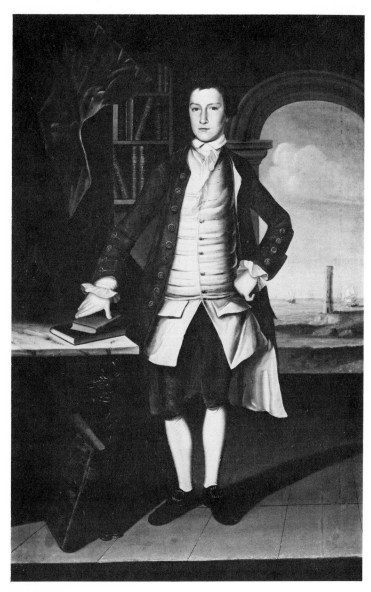

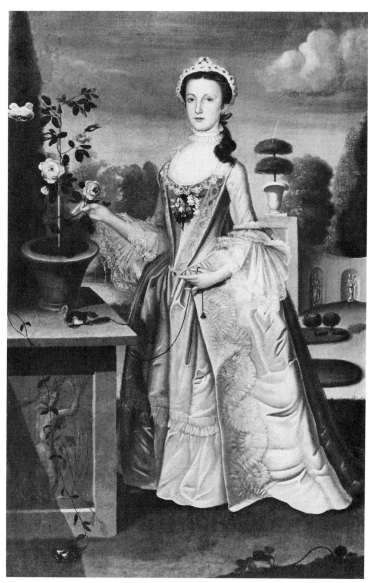

12. William Williams. *Deborah Hall*, 1766. Oil on canvas, 71¼ x 46½ inches. The Brooklyn Museum, New York; Dick S. Ramsay Fund.

11. William Williams. *William Hall*, 1766. Oil on canvas, 71 x 46 inches. Henry Francis du Pont Winterthur Museum, Winterthur, Delaware.

14

13. Edward Savage. *Sarah Seaver Savage*, c. 1791. Watercolor, 2¾ x 2¼ inches (sight). Worcester Art Museum, Worcester, Massachusetts.

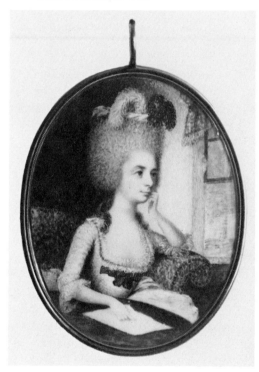

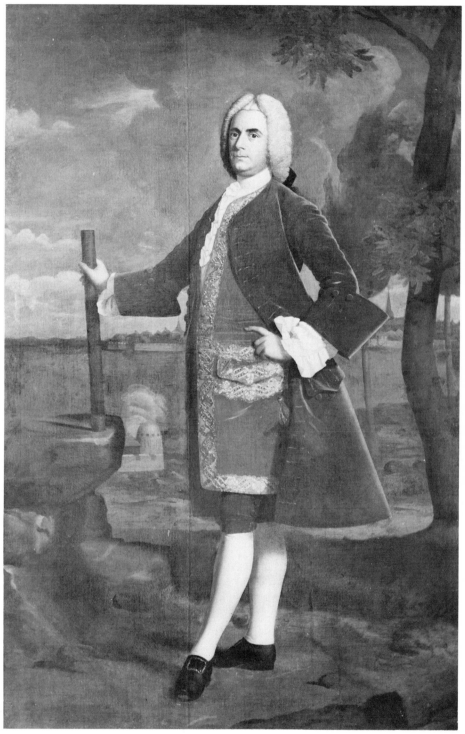

14. Robert Feke. *Brigadier General Samuel Waldo*, c. 1748. Oil on canvas, 96¾ x 60¼ inches. Bowdoin College Museum of Art, Brunswick, Maine; Bequest of Mrs. Lucy Flucker Knox Thatcher.

political clashes with Britain that belie the artist's attempts to image the stability of the new American man and his harbor world, William Williams painted an enigmatic little work, recently reattributed and currently titled *Imaginary Landscape, 1772* (Fig. 15). The painting has thus far eluded attempts to pin down its direct sources, if they exist, but it is an important work from several points of view. In the first place it is one of the rare extant examples of those marine views which colonial artists and shops advertised among their wares—not adjunct to some portrait or, as Leitch had put it, "so exact a portrait of the town as it appears from the water that houses in view will be distinctly known." The "town" as such is hidden from view by the bluff, and only the towers of some Gothic churches are visible signs of its existence beyond our sight. The medieval crenellated tower in the foreground with its half-timbered house on top is not so "imaginary" as might seem. Examples of the general type, used as lighthouses, could be found not only in the paintings and engravings of the seventeenth-century Dutch marine painters and Claude Lorrain but also in the harbors of Europe or even Spanish America. The ships too are by no means imaginary; they are British men-of-war. An intriguing possibility suggests itself from the almost exact likeness of the ships in the painting to those in the engraving of Havana harbor by Peter Canot, published in 1764. Williams is known to have been in the West Indies in 1760–61, just before the British took Havana from the Spanish during the Seven Years War. This view may, then, be a remembered image of that harbor. What is unclear is the meaning of the little foreground figures, the elegantly dressed pair at the tower pointing to the ships, the little peasantlike group at the water's edge seeming to be firing off a shot at or toward the ships. The painting seems to be in some sense a political image of British naval power, defined by the precisely rendered ships moving in an offshore breeze, whether at the battle of Havana in 1762 or not. Given the painting's date of 1772, one may speculate further whether in New York this work was an appeal to the commercial and political interests of the Court party against the claims of the protesting American Whigs.[20]

Finally, what strikes one about the work is its reorientation of seascape space. The space is indeed framed by the tower, the tree, and the foreground rim, but it opens on the left-hand side to the sea. The crisp rhythm of the waves, the repetitive shapes of the men-of-war, the brilliant color and atmosphere all contribute to a dynamic sense of flow from the stabilities of land outward toward the open sea and sky. The Williams painting is not yet a "romantic" work, but it is a premonition.

Britannia rules the waves in the little Williams seascape, but the artist himself was to return to England in 1776 as hostilities between the colonies and the mother country broke out into open warfare. Des Barres pushed his charting of the harbors of the northern coasts toward completion because his work was supported by the British admiralty, for whom the charts were to be an aid in subduing the rebellious colonies. And with the war a new era in the history of American seascape had arrived.

2. From Classic to Romantic

The shaping of American culture has always been a complex interaction between the resources of the New World and the pressures from Europe. The colonial artist attempted to work out his sense of the new American man and his maritime environment by adapting the shapes which the Old World offered—engravings and mezzotints, formal conventions of the window portrait or the harbor view—to his own needs with as much skill as he could muster, given the limited opportunities for artistic training. The lodestone of Europe to the American artist was strong, however, and from the aesthetic standpoint the story of American seascape must now return to Europe.

Graphic artists on both sides of the Atlantic used seascape material to propagandize the Revolutionary conflict. James Peale, who was a soldier during the war, would memorialize the *Attack Against Fort*

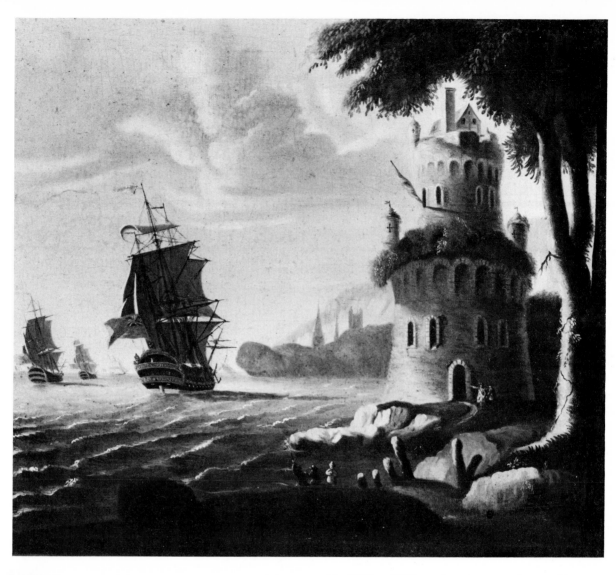

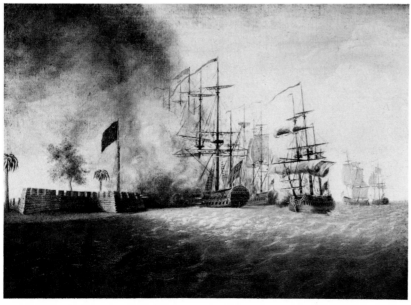

15. William Williams. *Imaginary Landscape*, 1772. Oil on canvas, 16 x 18½ inches. The Newark Museum, Newark, New Jersey.

16. James Peale. *Sir Peter Parker's Attack Against Fort Moultrie, June 28, 1776*, (1782). Oil on canvas, 20¼ x 29½ inches. Colonial Williamsburg Foundation, Virginia.

Moultrie (Fig. 16) on canvas. James's brother Charles Willson Peale, who had copied Swaine prints and sketched ships in the 1760s in London, had, like so many others, come home to engage actively in the war, painting portraits and sketching battle scenes all the while.[21] The naval war created flambuoyant heroes like John Paul Jones. Meanwhile our two most important artists, John Singleton Copley and Benjamin West, had settled in London. West, though by now history painter to King George III, made no bones about his American allegiances. Copley's political ties were more ambiguous, but the work of both reminds us that though political partisanship may have sharply divided Americans from Englishmen, artistically Americans considered themselves and were considered by their contemporaries to be part of an international community that transcended the "merely political."

Copley's experience as a seascape painter during his American years was limited to some youthful copying of mythological prints of *Galatea* triumphing on the waves and *The Return of Neptune* (Fig. 17), both of about 1754, and a few portraits with seascapes in the windows.[22] Yet his first important commission in England was a bold new statement in the seascape tradition and a major landmark in the history of Western art: *Watson and the Shark,* 1778 (Pl. I). In this single work, executed only four years after he had left Boston but incorporating his artistic experience in England and on the continent (and most especially in Rome), Copley gathered up the artistic tradition as it had been passed on to him and pushed it forward toward the future.[23]

After years as a "mere portraitist," he had been exposed in Europe to the classical tradition of art, and he eagerly grasped at the commission from Brook Watson to do something more ambitious in the vein of history painting: to memorialize the occasion when Watson, now a prosperous Tory merchant in London, had lost his leg and nearly his life as a young man in Havana harbor. Given the nautical subject, the boldness of Copley in the *Watson* lay in his reconciliation of the tradition of history painting with the demands of his seascape

material through the structural organization of images on the canvas. In the Havana harbor background of the painting, with its strong horizontal organization and its meticulously drawn ships at rest, we recognize the view tradition, with its emphasis on the habitable human world. Indeed Copley, who had never been to Havana, cribbed from prints by Canot and others to depict the local landmarks, images of the community: church, monastery, and Morro Castle guarding the harbor entrance. The near-contemporary incident Copley was depicting smacked of lurid reportage, inimical to neoclassical notions of history painting as the celebration of some grand and noble event in past history or in mythology, appropriately costumed to distance and elevate us, as Sir Joshua Reynolds had been arguing in his *Discourses* at the Royal Academy in these years. Yet in the central range of the *Watson,* Copley had responded to these injunctions in principle, though he had reinterpreted them. He gave his material the classical organization of the static Raphaelesque grand style of history painting, with its massive pyramidal structure of the boat and its occupants engaged in a heroic act. The postures of the boat figures are classically posed like frozen sculpture: one like St. George about to slay the dragon, another (the black) with hand raised in what seems almost a benediction. Thus the quiet background rhythms of horizontals and verticals are played off against the organizing element of the boat and its occupants.

But the great boldness of the painting and its generating source lay in the raw and powerful dramatic confrontation between Watson and the shark, an almost surreal symbolic—rather than emblematic—statement of the conflict between man and nature. Perilously close to the viewer, because Copley has boldly eliminated that comfortable *repoussoir* of land and figures looking out to sea, the foreground offers us an outstanding statement of what the eighteenth century called "the Sublime": an aesthetic category that defined the unmediated power of Deity in the universe, emphasizing obscurity, indefiniteness, the immeasurable, the uncontained and uncontrolled—in

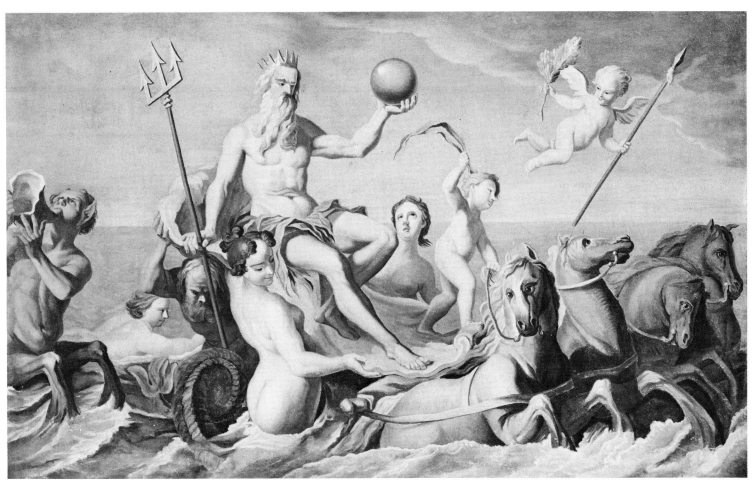

17. John Singleton Copley. *The Return of Neptune*, c. 1754. Oil on canvas, 27½ x 44½ inches. The Metropolitan Museum of Art, New York; Gift of Mrs. Orme Wilson, in memory of her parents, Mr. and Mrs. J. Nelson Borland, 1959.

sum, the very reverse of all those qualities that the eighteenth century associated with the clockmaker god in an orderly Newtonian universe.[24] In tapping the aesthetic of the sublime for seascape purposes, Copley seems to be releasing all of those potentialities of his material that the colonial artist had sought to confine and contain. He announces thereby the direction in which romantic seascape would turn both in Europe and America at the turn of the century—in Europe one thinks immediately of Turner, the great English master of the mode; in America, of Washington Allston initially, and after him a range of artists from Thomas Birch and Thomas Doughty to Thomas Cole and beyond.

Yet one must insist that *Watson and the Shark* is not a romantic painting. The sublime conflict between man and the sea in the foreground is juxtaposed to the quiet harbor view and then ordered and brought under classical control by the spokesmen for the human community in the great action of the middle ground. The formal configuration of the painting has important political overtones: his political contemporaries had supported the Lockean order announced in the Declaration of Independence and the Constitution, but they deplored the sublime excesses of Sam Adams, Tom Paine, and above all the French Revolution; Copley shared with his artistic contemporaries the belief that art—including seascape art—aspired toward the depiction of human order and control. The foreground figures of Watson and the shark remind us of the possibility, as Herman Melville was later to put it, that "the invisible spheres were formed in fright,"[25] that the sea is and always has been a potential harbinger of chaos. Nevertheless, in this work Copley was able ultimately to forge an uneasy balance, to will order upon the disparate nature of his seascape world.

That the painting shows the strains involved in such an achievement makes it a work of its moment of 1778. Copley was attempting to blend the different modes—the harbor view, the sublime, and the classical—and reinterpreting the nature of the grand style by applying it to the near-contemporary. Though near in time, however, the event was exotically distanced in space for its English audience. Havana was for them a commercial goldmine, as the background suggests, but it was also part of the New World of strange wonders beyond the sea. Copley's insistence upon translating the grand style into contemporary terms and contemporary dress was an important part of his achievement and of his "Americanness."

In this respect he had drawn sustenance and support from his colleague and mentor Benjamin West in *The Death of Wolfe* (1770), which Copley had seen in 1774, immediately upon his arrival from America. The consequences of Copley and West's contemporary and American allegiances would be felt in Britain within a few years, when they were the only artists asked to submit proposals for a large canvas signaling the relief of the British squadron at Gibraltar.[26] No Reynoldsian classicizer was asked to submit to the Corporation of London's competition. The merchants of Guildhall apparently found the no-nonsense contemporaneity of their American colleagues more compatible to their vision. In 1778, the same year as the *Watson*, West had completed the first version of his *Battle of La Hogue,* a memorial of a seventeenth-century victory of the British and Dutch naval forces (see Fig. 18). Copley now won the Gibraltar commission, but his achievement in the final painting of *The Siege of Gibraltar* (completed in 1791) was a retreat from the bold new composite format of *Watson and the Shark* and closer to the more fully articulated baroque organization of space in West's *La Hogue.* Never again was Copley to handle seascape themes with the power of the *Watson.* Several stunning preparatory studies (1788–89) for *The Siege of Gibraltar* offer us isolated moments of the sublime power of the sea over helpless humans and the contrasting strength of men in boats. In the finished canvas these notes had to be subordinated to the desired effect of celebrating the victorious control of man (the British) over his universe, but the sketches are further testimony to Copley's awareness of the sublime mode in seascape painting.

In some ways Copley's compatriot West was, in the broader perspective of art history, a bolder explorer of the sublime in art. His earliest work,

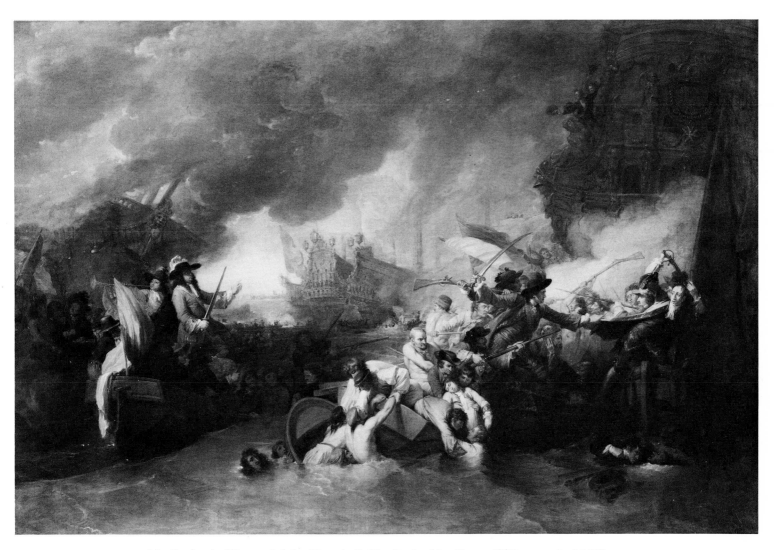

18. Benjamin West and John Trumbull. *The Battle of La Hogue*, 1778, retouched 1806.
Oil on canvas, 64½ x 96 inches. The Metropolitan Museum of Art, New York;
Purchase, Harris Brisbane Dick Fund, 1964.

like that of so many other American colonial painters, was based upon print sources. In the *Fanciful Landscape* he naively combined a variety of motifs: pastoral and urban, landscape and harbor scene. In another panel on wood of his youth, originally an overmantel, he turned more directly to Dutch prints to dramatize a *Storm at Sea* (Fig. 19), with its ships at the mercy of sublime nature and the viewer almost deluged by the waves, so low is our point of view. West rarely returned to seascape in later years; for him the idea of the sublime was linked more directly to its religious sources in Biblical paintings of *Saul and the Witch of Endor* or the several canvases based upon the Book of Revelations.[27]

Much of West's work was in the mythological vein, an acceptable neoclassical mode for the man who had inherited the presidency of the Royal Academy from Sir Joshua Reynolds. At one point he read Fénelon's moralistic novel, *Les Aventures de Télémaque, fils d'Ulysse* (published in 1699) and did a sketch (Fig. 20) of Calypso pleading with shipwrecked Telemachus, who is accompanied by Minerva in the guise of Mentor, to remain with her. (She tempts the young man with promises of immortality.) The sketch suggests a human drama

framed by the gentle rhythms of Calypso's land world, with the sea and shipwrecked boat glimpsed behind the two male figures. By the time the large oil canvas (Pl. II) was complete, West's ideas had crystallized in rather different ways. Not only are the positions of the figures reversed, they are scaled way down and the human drama subordinated to the drama of natural forces. The canvas splits in half, polarizing human alternatives: the world of woman—soft, sensuous, rhythmically flowing, enclosed, and at one with the umbrageous foliage of Beautiful landscape; the world of man —dark, threatening, resistant, opening into a stormy Sublime seascape. In this painting, as so often in his career, West captured his age's aesthetic ideas, gave them visual shape (the male-female split was already, as we have seen, a convention of portraiture), and offered a formulation for the age to come. This conventional division, which is at once social, moral, and aesthetic, of male venturing out into harsh sublime seascape space, female enclosed in sensuously beautiful landscape, appears in everything from portraiture to dime novels or the romances of Fenimore Cooper, from battle paintings to genre seascape. It would take a Winslow Homer to break the convention, and even in his

19. Benjamin West. *Storm at Sea*, 1750–52. Oil on board, 12 x 42½ inches. Pennsylvania Hospital, Philadelphia.

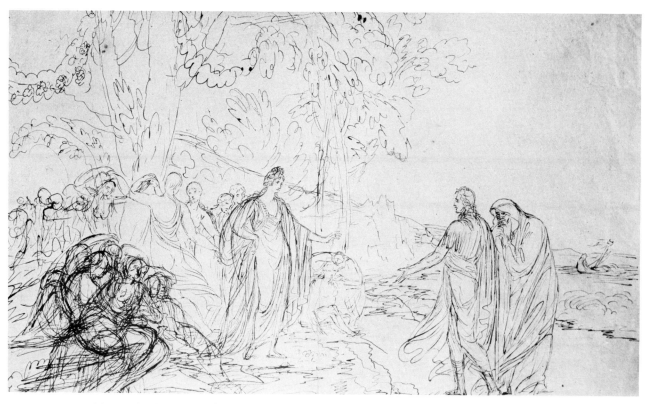

20. Benjamin West. *Telemachus and Calypso*, (1772). Ink on paper, 12⅛ x 19⅜ inches. University of Kansas Museum of Art, Lawrence; Gift of John Maxon in memory of James Wortham.

case it came only after years of identifying women either with pastoral or with the seaside vacationers at summer spas.

More immediately, however, it is the sense that the sea offers the challenge of bold adventuring, of the questing spirit in search of identity in the vastness of natural space, which is historically the important note of the opening decade of the nineteenth century. The ordered certainties of the neoclassical world had been shattered by the French Revolution. Disillusioned political liberals like Wordsworth and Coleridge retreated to nature to shape that more direct and personal voice which

we have come to call romanticism. Thus when the young American painters John Vanderlyn and Washington Allston left London in 1803, they had at their backs as they traveled through the Low Countries to Paris not only the example of Benjamin West but also the imaginative explosion of the *Lyrical Ballads*, Wordsworth and Coleridge's early expression of the new aesthetic, and its visual counterpart in the early paintings of Turner.

As a youth in Kingston, New York, Vanderlyn had first tried his hand at seascape by working from print sources, and his little watercolor *Harbor Scene* of 1789 (Fig. 21) shows him adopting the

21. John Vanderlyn. *Harbor Scene*, 1789. Wash, bistre and touche on paper, 6¾ x 8½ inches. Collection of Miss Mildred Burchard.

Claudian conventions of the Beautiful (see Figs. 22, 23): a quiet and peaceful foreground with lounging figures and evidence of ruins, a landscape frame of tower to the left and townscape to the right, symbols of past and present. The precisely articulated ship in the middle ground center stands at rest and blocks up the harbor space, enclosing us in a habitable world rather than releasing us into the vastness beyond.[28] As a young professional in America, Vanderlyn had then turned inevitably to portraiture. For Vanderlyn in 1800 as for Copley before him, Europe now offered the possibility of extending his artistic horizons, but rather than responding to the new impulses of romanticism, Vanderlyn tried to maintain the classical posture, and his *Ariadne Asleep on the Isle of Naxos* of 1812 locates the questing Theseus in a tiny, carefully enclosed Claudian seascape view in the background. The beauty of the dreamlike floating figure of Ariadne dominates the canvas. From Vanderlyn's point of view the myth may have been little more than a strategy for legitimizing his desire to paint the nude. From ours, however, it repeats in a visually muted way the human alternatives in relation to the sea through the haunting story of the abandoned Ariadne, bereft of family and husband, sensuously enclosed in delicate foliage while Theseus's world is merely hinted at in the hole in space. Vanderlyn's classicism did not win him an audience in America when he returned, despite his minor prize for the *Ariadne* in Paris and the later engraving of the work by Asher Durand. He would ultimately find public recognition only at the end of his career, with the commission for the large *Landing of Columbus* in the Capitol rotunda.

In 1803 the future lay with Vanderlyn's traveling companion Allston. He had brought from America in 1800 an understanding of the Burkean theory of the sublime and the beautiful. Not classically beautiful Claude but sublime Salvator Rosa had been his pictorial model, in the 1800 *Rocky Coast with Banditti*. Although his close personal friendship

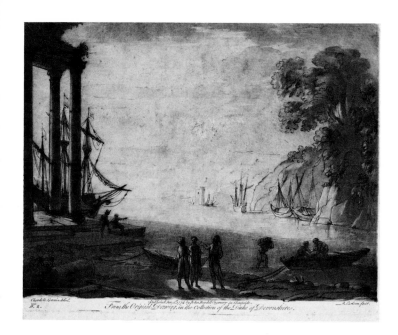

22. Richard Earlom, engraver, after p. 2 of Claude Lorrain, *Liber Veritatis*. Published by John Boydell, January 1, 1774. Mezzotint, 7½ x 10⅛ inches. Collection of Dr. and Mrs. Raul Grinberg.

23. Richard Earlom, engraver, after p. 96 of Claude Lorrain, *Liber Veritatis*. Published by John Boydell, May 1, 1775. Mezzotint, 7½ x 10⅛ inches. Collection of Dr. and Mrs. Raul Grinberg.

with Coleridge began only after he left London and Paris for Rome in 1805, "The Rime of the Ancient Mariner," that epitome of sublime romantic seascape, must have been already in his head. Coleridge's visionary model was combined with the visual examples of early Turner in London and now with firsthand exposure to the canvases of the seventeenth-century Dutch artists and Joseph Vernet who had been Turner's models in sublime seascapes. The result was Allston's 1804 *Rising of a Thunderstorm at Sea* (Fig. 24) a bold statement of the new romantic attitudes toward the sea. In one economical pictorial gesture, Allston made available to his audience the new world of the romantic sublime. We are set adrift in the vastness of seascape space.[29]

The major redistribution of space and the radical alteration in point of view is immediately apparent. The transformation effected by this painting is both of seascape space as outer fact and of the nature of our perceptions. Not only are the human elements—the struggling pilot boat in the foreground and the distant ship—reduced in size by the sea and sky which surround and envelop them, but by placing us at the level of the horizon, we too are engulfed by the surging waves, a trough separating us from the struggling boat and the humans with whom we might identify. This heavily sculptured three-dimensional experience of sea space is in turn juxtaposed to the two-dimensional ship—truly, in Coleridge's words, "a painted ship upon a painted ocean"—sitting flatly and mockingly

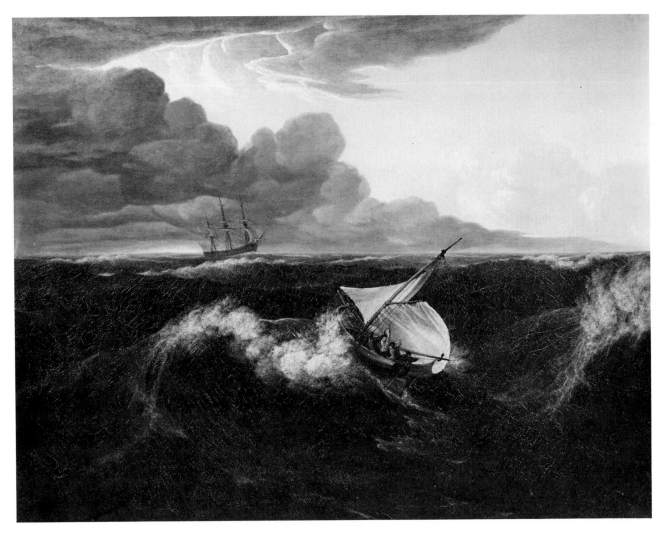

24. Washington Allston. *Rising of a Thunderstorm at Sea,* (1804). Oil on canvas, 38½ x 51 inches. Museum of Fine Arts, Boston; Everett Fund.

small on the horizon beyond our reach. *Rising of a Thunderstorm at Sea* not only emphasizes seascape as a record of men's outer risk-taking but also our inner psychological response to the vastness of the sea and sky which overwhelms us, as it dwarfs our

friends in the pilot boat. And here there is no reassuring harbor view or umbrageous foliage, no saving power in either rescuing boat or dancing nymphs, no distancing in time or space. We face the power of the dark sublime sea alone. If there is

any hope, it can come only from the brilliant light of the sun above, but that too is beyond our power to manipulate.

The importance of Allston's pictorial formulation of the terms of romantic seascape for American art of the coming century is central, though Allston himself would rarely repeat the achievement, turning instead mainly to other subject matter and other, quieter moods. His 1811 *Coast Scene on the Mediterranean* is a lovely exercise in Claudian nostalgia; his unfinished *Belshazzar* locates the sublime in an Old Testament context. Only occasionally would Allston turn back to the sublime sea of his earliest vision, as the late sketch for the *Ship at Sea in a Squall* testifies.[30] The relevance of the *Rising of a Thunderstorm* to the American seascape artist and his audience would only emerge after the impulses which Allston had gathered into the work had been focused precisely and particularly upon our national experience. In that redirection of seascape and the American imagination, the War of 1812 played a crucial role.

3.
The Crystallization of a National Identity

The Revolutionary War had created a new political identity but its impact on our art was, as we have seen, minimal. It was the War of 1812 that crystallized aesthetically our sense of national identity. It focused our artists' attention on the potentialities of native materials with an added sense of urgency, opened up for them a symbolic language of a compelling kind, and created a prospering audience in the years that followed who were willing to support and encourage, individually and collectively, the work of our native artists. The war itself was a precipitating factor: one has only to compare John Wesley Jarvis's huge portrait of *Oliver Hazard Perry*, 1816 (Fig. 25), to one of Gilbert Stuart's *Washingtons*, 1797 (Fig. 26), to see the difference.

The *Washington* is a gravely dignified portrait of a hero who is separated from us by his impersonal dignity, surrounded by generalized emblems of his position: the elegant chair, the sword of battle now ceremoniously at rest, the state paper in hand. The drapery and architectural frame emphasize his classic stature, and the distanced seascape beyond is but one more reminder of his national role, rather than something which directly engages either Washington or the viewer. Within two years Washington would be dead and the canonizing of him would rapidly increase. A characteristic mourning picture of about 1800 (Fig. 27) finds "the genius of America trampling on the British colours and placing a laurel wreath on the head of Washington," but the presentation is equally static and emblematic. The ships at sea in the carefully enclosed middle space symbolize American power, but our task is to read and understand these emblems, not to experience them directly.[31]

By contrast, Jarvis captures Oliver Hazard Perry at the height of his heroic action of 10 September 1813, when as commodore of the American fleet on Lake Erie his ships captured the entire British fleet. Perry passes from the disabled brig *Lawrence* to the *Niagara*, the cry "Don't Give Up the Ship" emblazoned on the banner behind him. The sheer size of the image, the active thrust of the figure, and the dynamically dependent three surrounding figures, even to details like the upward sweep of the sword crossing with the downward thrust of the prominently placed pistol: all proclaim the new romantic hero, individual avatar of a nation defining itself in the present moment through naval glory. The work took its place as a public image among a group of naval heroes commissioned by the city of New York to hang in City Hall. Thomas Sully's elegant companion portrait of *Stephen Decatur* (Fig. 28) may be a finer work technically, but it is abstracted, looking backward to the classic age rather than forward into the dynamic American future.

The battle of Lake Erie was itself the subject of numerous paintings, the finest of which was painted by Thomas Birch. Like the Jarvis *Perry*, it is

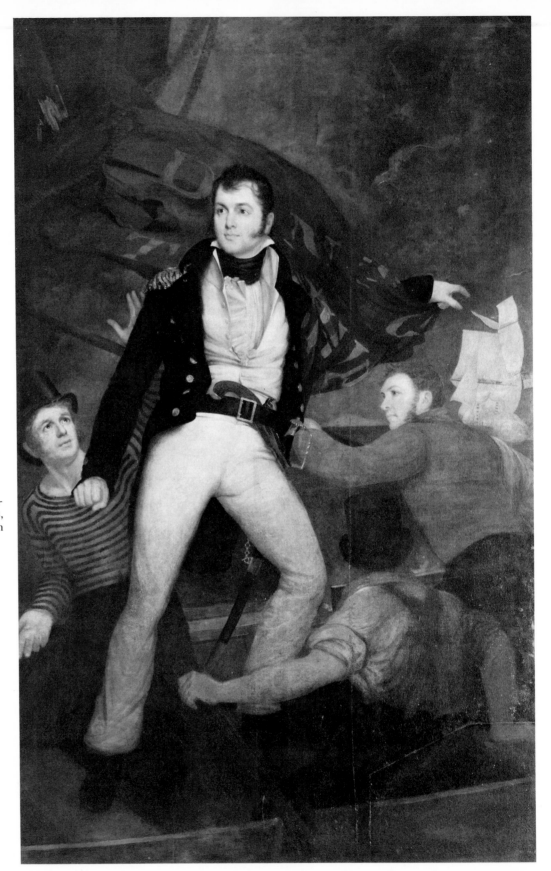

25. John Wesley Jarvis. *Oliver Hazard Perry*, (1816). Oil on canvas, 96 x 60 inches. Art Commission of the City of New York.

28

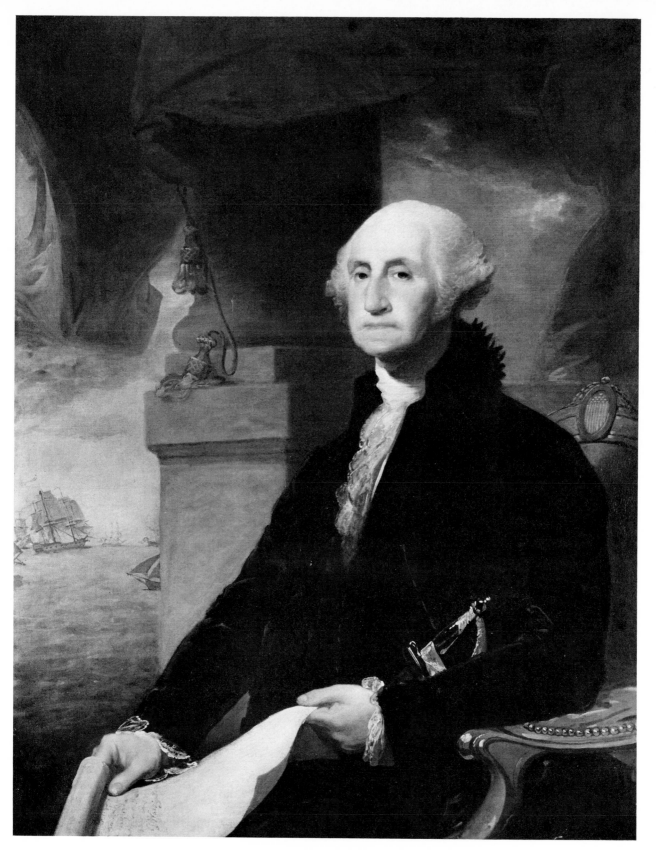

26. Gilbert Stuart. *George Washington*, 1797. Oil on canvas, 51¼ x 40 3/16 inches. The New York Public Library, New York; Astor, Lenox and Tilden Foundations.

27. Catherine Townsend Warner. *Mourning Picture—George Washington*, c. 1800. Needlework and watercolor on silk, 20⅜ x 17⅛ inches. Abby Aldrich Rockefeller Folk Art Collection, Williamsburg, Virginia.

28. Thomas Sully. *Stephen Decatur*, 1814. Oil on canvas, 94 x 66 inches. Art Commission of the City of New York.

on a grand scale commensurate with the artist's sense of the event. Birch was the son of the English emigré engraver William Birch, whose little 1800 line engraving of the *Preparation for War to Defend Commerce* announced the idea of American national prowess but in shapes that clearly locate that idea within the orderly pictorial structures of the land world. Birch's *Battle of Lake Erie*, about 1814 (Fig. 29), treats Lake Erie as an inland sea. Following the example of the Dutch seventeenth-century battle painters, from Vroom, Willaerts, and Beerstraten to Ludeking, Abraham Storck, and the Van de Veldes, and their eighteenth-century English and continental followers from Cleveley and Pocock to Whitcombe and Loutherbourg, Birch drops the horizon low to open up the space above and puts the viewer at the waterline closely related to the American ship moving into battle. This ship in turn becomes the organizing element compositionally, all pyramiding out from its peak into space in two and three dimensions. American power thus organizes sea space on a grand scale (compare Fig. 4).

The same is true in the smaller paintings of individual engagements which Birch and others produced and reproduced during the war years and after. What a work like the *"United States" and "Macedonian"* (Fig. 30) makes clear is Birch's effectiveness in creating visual symbols of the new nationalism. Accurate portrayal of the event becomes an important issue, for his audience had plentiful verbal accounts of these battles in the journals of the day. Birch has organized his images simply but effectively not only to make clear the dominance of the American ship but also to dramatize the notion of "the engagement" by placing at the lower center the puff of smoke that separates, yet links, the two frigates. Placed at the waterline ourselves, we cannot be fully disengaged. The American flag is prominently displayed and the condition of the two ships clearly predicts victory for Stephen Decatur and American naval skill. Yet however central the human action is, it is comparatively small. Birch, like Allston in the *Rising of a Thunderstorm*, conceives of the drama of

ships against a massive background of open space. Without insisting on it, Birch's sense of scale and proportion, like Michele Felice Corne's in the *USS "Hornet" Sinking HMBS "Peacock," 1813* (Fig. 31), with its tiny boats and birds midway between the two ships, suggests that the natural world itself is a primary actor in the human drama, that human and national skill must be understood and in a way subordinated to the great romantic conflict between men and nature.[32]

These paintings betoken a confidence at once conceptual and pictorial: that men—especially the American seaman—can live in a harmonious relation with the vastness of the sea. Unlike Birch's colonial predecessors, the romantic artist can exult in the sea itself and does not need to domesticate and compress a fearful sea into a window view. Birch's audience supported his romantic energies because they found in the paintings confirmation of their national aspirations. They commissioned and bought his original oils and numerous replicas. His works were engraved by Tiebout and others for mass distribution, and these engravings in turn were copied by later artists like Thomas Chambers, whose version of *The "Constitution" and the "Guerriere,"* about 1845 (Fig. 32), achieves a certain freshness through its strong colors and the intrinsic interest of its visual patterning of clouds and flags and waves. For its nineteenth-century audience this symphonic arrangement all focuses our attention on the national achievement so vividly emblematized in the prominent flags. In another of the many popular images proliferated by the war and American nationalism, a muslin kerchief (Fig. 33) gathers together in one grouping the large-scale Battles of Lake Erie and Champlain and six individual engagements and organizes these along with portraits, eagles, liberty ("the genius of America"), a mourning picture for Lawrence (complete with the motto "Don't Give Up the Ship"), and the signing of the peace treaty. They are combined into one harmonious composition which fully domesticates (with ample flowers), for the consumption of landlubbers, seascape to the American imagination. The souvenir kerchief is an

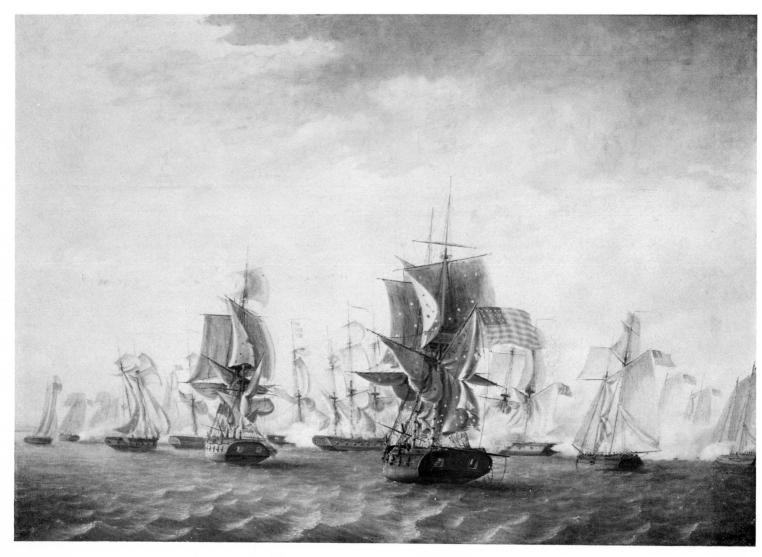

29. Thomas Birch. *Battle of Lake Erie*, c. 1814. Oil on canvas, 66 x 96½ inches.
Pennsylvania Academy of the Fine Arts, Philadelphia.

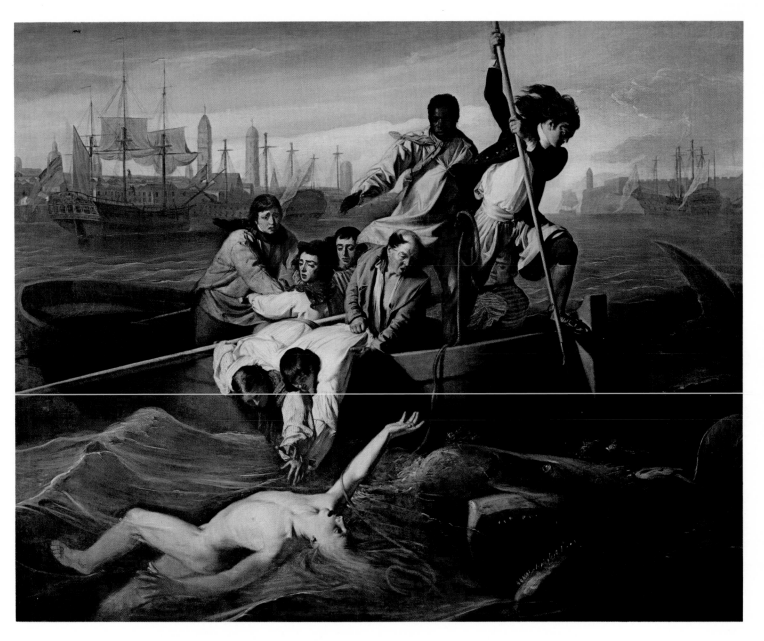

Plate I. John Singleton Copley. *Watson and the Shark,* 1778. Oil on canvas, 71¾ x 90½ inches. National Gallery of Art, Washington, D.C.; Ferdinand Lammot Belin Fund.

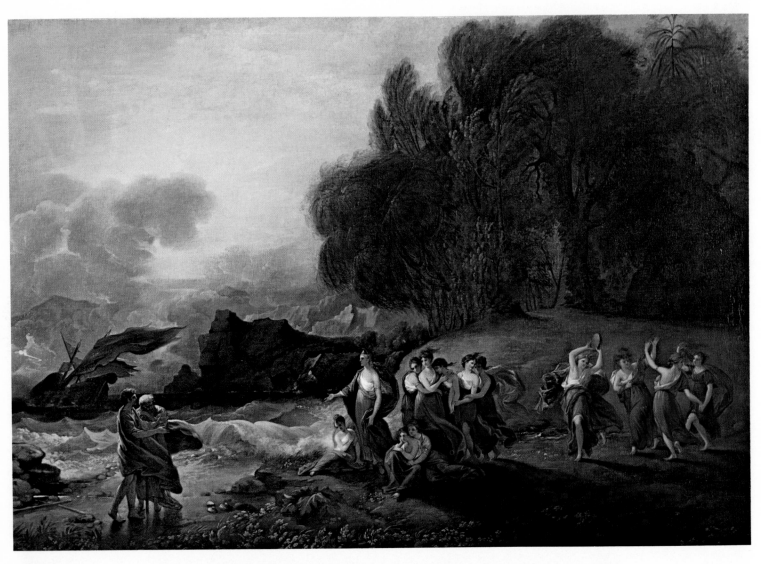

Plate II. Benjamin West. *Telemachus and Calypso*, c. 1809. Oil on canvas, 41¼ x 58¾ inches. Corcoran Gallery of Art, Washington, D.C.; Gift of Bernice West Byers, 1963.

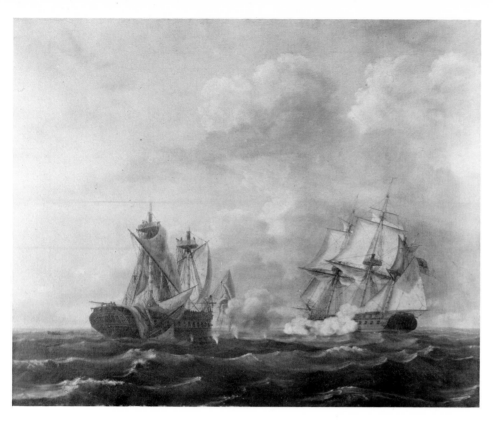

30. Thomas Birch. *"United States" and "Macedonian,"* 1813. Oil on canvas, 29 x 34½ inches. Historical Society of Pennsylvania, Philadelphia.

31. Michele Felice Cornè. *USS "Hornet" Sinking HMBS "Peacock," 1813,* c. 1815. Oil on canvas, 24½ x 38 inches. Webster Inc. Fine Art, Chevy Chase, Maryland.

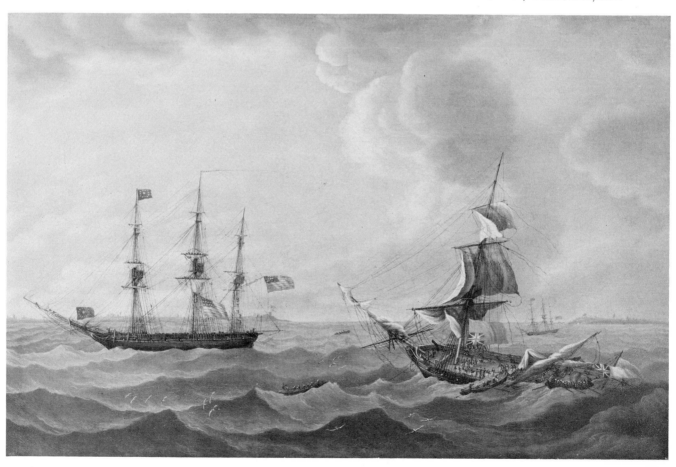

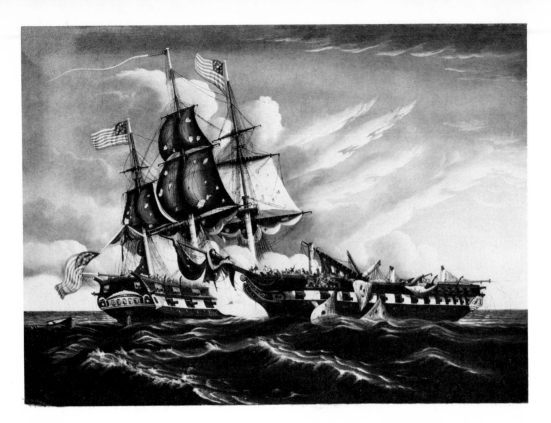

32. Thomas Chambers. *The "Constitution" and the "Guerriere,"* c. 1845. Oil on canvas, 24¾ x 34¼ inches. The Metropolitan Museum of Art, New York; Gift of Edgar William and Bernice Chrysler Garbisch, 1962.

33. Unknown artist. *Kerchief—"United States of America—Huzza for the Navy—War of 1812 Scenes,"* early nineteenth century. Printed cotton, 30 x 33 inches. The New-York Historical Society, New York.

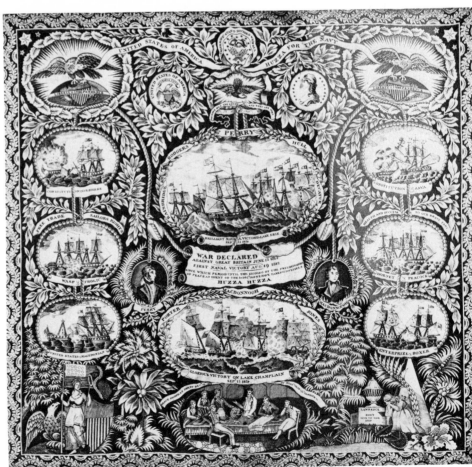

34

extreme statement but its moral was much more generally applicable to Americans of the opening quarter of the nineteenth century: only American prowess could make habitable the vastness of sea space, could bridge the gulf between the struggling pilot boat and the ship in Allston's *Rising of a Thunderstorm*.

4.
In Pursuit of the Romantic Sublime

Beyond the explicit naval nationalism of the battle paintings lay a more important identification of American experience with venturing into a sublime nature. Our landscape artists were already arguing the specifically American sublime in pictorial celebrations of Niagara Falls or the Catskill Mountains. Our marine painters rang the changes on our experience with the vast and turbulent sea. As the Allston *Rising of a Thunderstorm* and the left side of *Telemachus and Calypso* make clear, the impulse toward romantic voyaging was an international one. Forged out of a combination of late eighteenth-century aesthetic theory, romantic poetry, and the pictorial examples of Dutch seventeenth-century artists, the Vernets, and Turner, these works assert the supremacy of sublime venturing to test the powers of the lone ego and to face the forces of the universe alone and unmediated.[33]

The shipwreck theme had a special vogue in the period; it corresponded to an ever-present threat which even the mapping of the Atlantic coastlines could not eliminate. At the same time it had clear religious sources in both the Old Testament and the New. Joshua Shaw, like Turner, turned back to its Biblical source in *The Deluge* (exhibited 1813) before he came to America, but his little shipwreck study, *After the Storm* (Fig. 34), concentrates on the human drama of the foreground.[34] The Dutch seventeenth-century tradition was to have a continuing impact through the first half of the nineteenth century as well, and the English tradition, especially as it received climactic if idiosyncratic expression in the work of Turner, would be felt as Turner's works became better known to American artists, either directly, through prints, or through the writings of John Ruskin.[35]

Nevertheless, Americans began to develop their own characteristic modes of seascape in the second third of the nineteenth century. Our native artists developed a flexible visual vocabulary for making American seascape painting express states of mind and attitudes of the American imagination. Two works of Thomas Doughty, the *Beach Scene with Rocks, I* (Fig. 35) and *Shipwreck* (Fig. 36), both of 1834, clarify the different directions which our seascape painting would pursue in these years. The *Beach Scene with Rocks* is one of several small efforts on Doughty's part to capture the crystalline atmospheric clarity of the beaches of Nahant, north of Boston. Yet this impulse to define the outer coastal world eventuates in a radically bare horizontal format. The signs of humankind are there but subordinated: sketchy wagon tracks in the sand, a spar or two, a diminutive rowboat and equally diminutive sailboats and houses on the horizon. But it is the horizon itself that dominates and organizes the space. Beach, waves, and clouds articulate and emphasize rather than control the vast openness of seascape space; they make visually interesting rather than suppress our dominant experience of spaciousness. That experience is itself the major note and our art is organized to convey it. Horizontal format emphasizes the panoramic, the eye traveling laterally across open space rather than pulling toward some organizing vanishing point in the distance. Yet Doughty does not, like his colonial forebears in the view tradition, reassure with the signs of the human community. The sailboats and houses are mere daubs of paint adding slight variation to the horizontal line. Nor do his clouds give us the grand sculptural sweep of Allston's *Rising of a Thunderstorm* and offer an alternative to the horizontal feeling of space.

This sense of seascape as endless horizontality —modified to prevent tedium, but never fully dissipated—was to be repeated by a variety of American artists in the years to come. American artists of the nineteenth century had a special feeling for the horizontal format, the panoramic

34. Joshua Shaw. *After the Storm*, n.d. Oil on canvas, 10 x 14 inches. Addison Gallery of American Art, Phillips Academy, Andover, Massachusetts.

35. Thomas Doughty. *Beach Scene with Rocks, I*, 1834. Oil on cardboard, 12¼ x 17½ inches. Museum of Fine Arts, Boston; Bequest of Maxim Karolik.

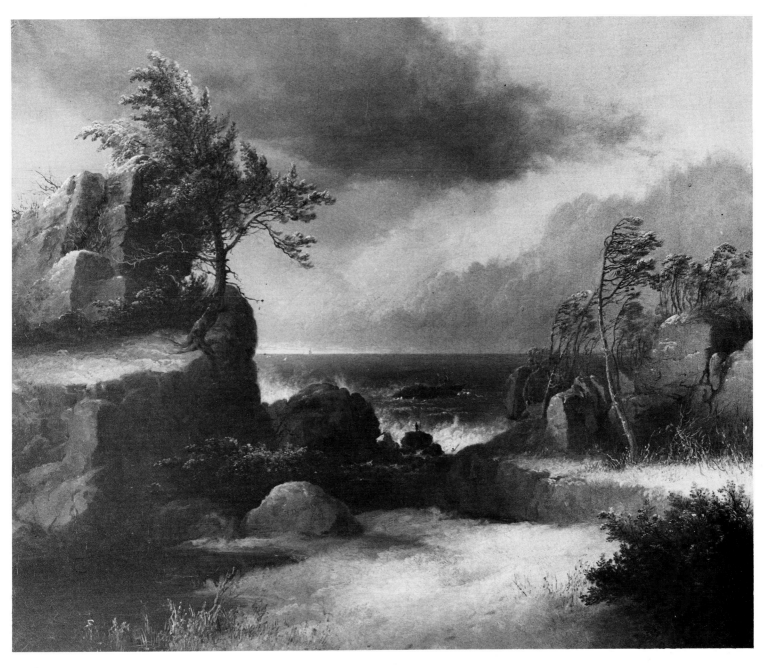

36. Thomas Doughty. *Shipwreck*, 1834. Oil on canvas, 25 x 30 inches. Fine Arts Gallery of San Diego, California.

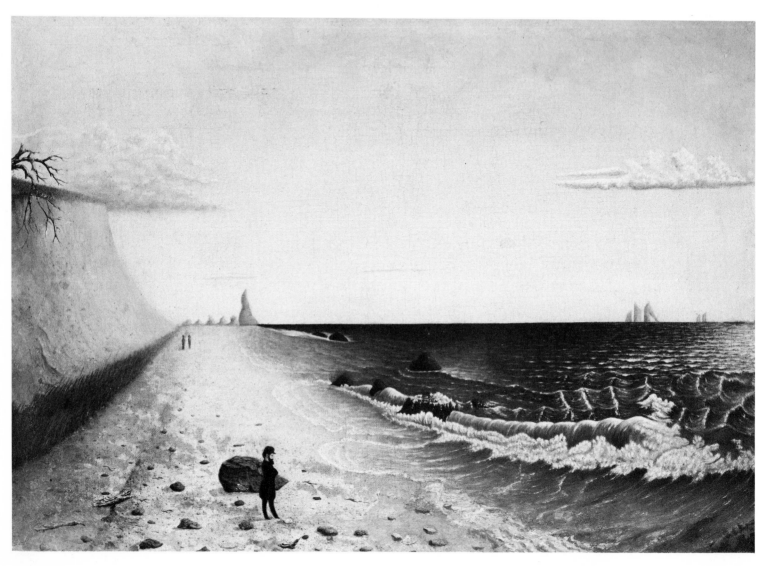

37. Unknown artist. *Meditation by the Sea*, 1850–60. Oil on canvas, 13½ x 19½ inches. Museum of Fine Arts, Boston; M. and M. Karolik Collection.

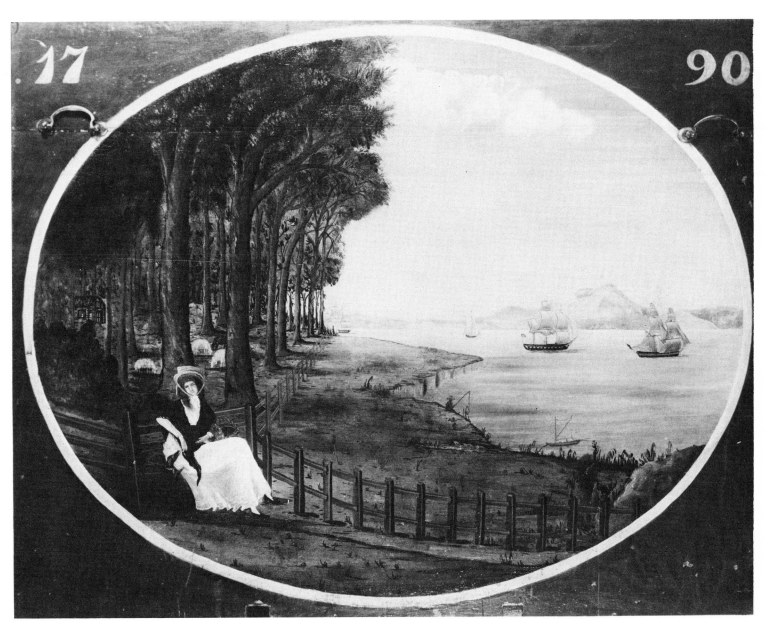

38. Unknown artist. *Contemplation Near the Sea*, 1790. Fireboard, oil on wood, 36½ x 59 Collection of Bertram K. and Nina Fletcher Little.

perspective.[36] Frederic Church's *Niagara* is perhaps the most famous example; the landscapes of the West from Catlin to Colman repeat the pattern. Our seascape artists found it especially congenial to the nature of their subject—coast, sea, and sky seen directly—and to the nature of their perception of seascape as the characteristic expression of their feeling for the vast, unmediated sublimity of the universe. Jasper Cropsey's version, the *Coast Scene* of 1855, sharpens our sense both of the particularities of the rock formations of the foreground and of the sweep of the clouds to the rear, and atmospherically gives us a specific sense of time.[37] By contrast, the folk artist reduces the pattern to an abstraction and emphasizes its conceptual basis. *Meditation by the Sea*, 1850–60 (Fig. 37), in both its use of the figure and in its pictorial organization, eliminates our sense of time and of particular place. The elegant tiny figure seems locked in contemplation of sheer horizontal space, not as outer location but as a fact of the mind. "Meditation and water are wedded for ever," proclaims Ishmael in the opening chapter of *Moby Dick,* as he contemplates the meaning of the vast open space on which he will embark in that greatest of all American seascapes. The anonymous little *Meditation by the Sea* of the same years articulates the point visually. One has only to compare it to a late-eighteenth-century fireboard on the same theme to see what has happened in the intervening sixty years. *Contemplation Near the Sea*, 1790 (Fig. 38), places the woman in a comfortable elliptical space shaded by trees and fenced off from the ships and harbor beyond. There is a presumptive intellectual connection between her thoughts and the ships' future wanderings, but she does not, like the little Byronically brooding man of the 1850s, meditate directly into the openness of sublime space; she looks back instead into the comfort of the grove.[38] *Meditation by the Sea* thus articulates directly through its bare open format what remains implicit in the variety of seascapes that stretch from Doughty to Cropsey to Fitz Hugh Lane, Winslow Homer, and beyond: the sense that the open horizontal format is an expressive language by means

of which the American romantic artist defined, confronted, and gave shape, though he could not ultimately control, the vast undifferentiated openness of the sea.

If the overwhelming emphasis on the horizontal is one way in which the American romantic artist explored sublimity, another lay in the more explicit definition of the might and power of the sea by measuring its consequences on the human world. Doughty's *Shipwreck* (Fig. 36) defines the sublime as an active force. Though he attempts to frame the violent action from the perspective of the land world, the trees to right and left twist and turn rhythmically, the storm cloud above hangs oppressively low, all squeezing and compressing, orchestrating space and focusing our attention on the awesome power of nature. Dramatic action rather than the size of the open space itself becomes the expressive vocabulary. Cornè, Thomas Birch, Thomas Cole, Lane, Chambers, Martin Johnson Heade, and a host of others did variants on the coastal shipwreck theme. Cole's little *Shipwreck Scene* of 1828 (Fig. 39) is less an event than it is a nineteenth-century emblem of the wreck of *Fortune,* with the individual waving from the rock, a traditional sign of the church and faith on which one must ultimately depend. Some of the shipwreck paintings are serial images, defining the event through time. Occasionally one finds a portrait with a shipwreck background. At the other extreme from the tiny Cole is Heade's grand six-foot *Coastal Scene with Sinking Ship* of 1863 at the Shelburne Museum.[39]

Not only the shipwreck itself, but also the stormy coastal scene or the storm-tossed ship at sea, frequently under lowering skies or at night, becomes a powerful dramatic statement of the conflict between human will and the power of natural forces. The ship and the lighthouse (a traditional emblem of hope and, within the Christian tradition, the beacon of faith) seem to struggle for their very pictorial existence in the murky middle-ground darkness of Robert Weir's *Seascape with Lighthouse* (Fig. 40), as the rhythmic waves thrash around threateningly in the foreground. In Thomas

39. Thomas Cole. *Shipwreck Scene*, (1828). Crayon on paper, 3¼ x 4⅛ inches. The New-York Historical Society, New York.

40. Robert Weir. *Seascape with Lighthouse*, 1869. Oil on canvas, 29 x 48 inches. Collection of Martin L. Gross.

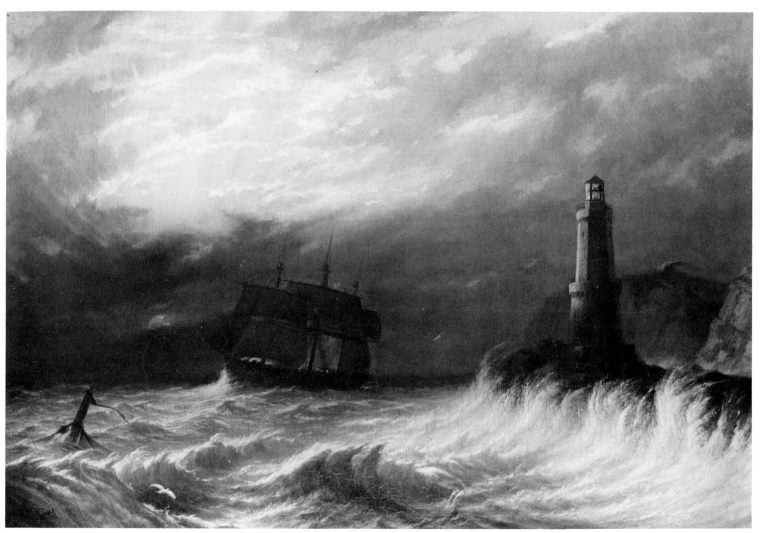

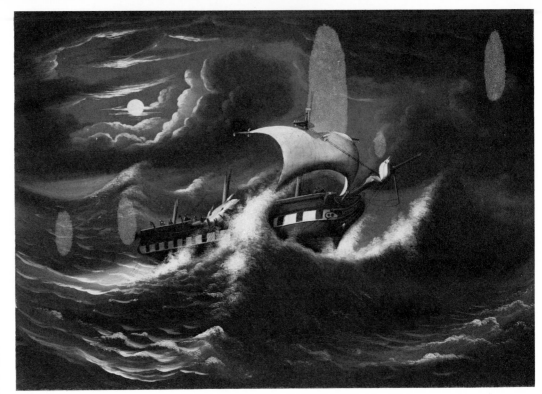

41. Thomas Chambers. *Storm-Tossed Frigate*, c. 1850. Oil on canvas, 21⅜ x 30⅜ inches. National Gallery of Art, Washington, D.C.; Gift of Edgar William and Bernice Chrysler Garbisch, 1967.

42. Rembrandt Peale. *Seascape — View Near Brighton*, (1859). Oil on canvas, 31½ x 44½ inches. The Newark Museum, Newark, New Jersey.

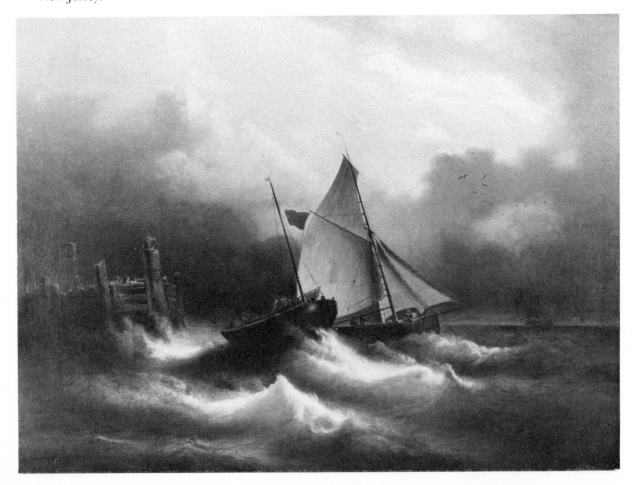

Chambers's *Storm-Tossed Frigate* (Fig. 41), the ship, rather than acting, as it frequently does, as a counterprinciple of human order and control in vast space, is swallowed up in the total pattern of clouds and moon and waves. There is no horizon, no clear separation between sea and sky, but a rhythmic interpenetration of the ship with the forces of nature.[40] Rembrandt Peale's *Seascape—View Near Brighton*, 1859 (Fig. 42), by contrast, reminds us that the tradition of dark sea and storm-tossed boat is by no means an American invention, though American artists had found it particularly congenial to their imaginative sense of themselves. The Peale work, done at the very end of his career, harkens back to the seventeenth-century Dutch tradition, picked up and developed by Turner, in his early work, and by Calcott and Copley Fielding in the first half of the nineteenth century. The typically Dutch *boeier* rides comfortably close to us

on the horizon, enclosed by light above and reflected from the waves below, locked into space in a stable manner rather than tossed at the mercy of overpowering nature. Peale creates a harmonious balance between the power of nature and the human will to order.[41]

In the history of American seascape as in the history of American art more generally, Thomas Cole occupies a special place. In his depiction of nineteenth-century America he was primarily the recorder of our sublime mountain scenes rather than our coasts. A trip to Maine in the 1840s produced an oil sketch of *Frenchman's Bay, Mount Desert Island, Maine* (Fig. 43), later incorporated into a larger *View Across Frenchman's Bay from Mount Desert Island, Maine, After a Squall* (1845) at the Cincinnati Art Museum. In the finished oil Cole dwarfed details into the horizontal format of the view tradition. The oil sketch is a much more vivid

43. Thomas Cole. *Frenchman's Bay, Mount Desert Island, Maine,* (1844). Oil on panel, 13½ x 22⅞ inches. Albany Institute of History and Art, Albany, New York.

rendering of Cole's experience of the coast. It is a dramatization of the conflict between the powerful, almost anthropomorphic forms of the extruding rocks and the inward-swirling waves, the tiny man and the tiny boat mere visual notions of the loss of the human scale in the great conflict going on within the forces of nature. But Cole was always drawn away from these pure natural allegories in his attempts to find a meaningful role for man in the vast expanse of natural space, and his two great allegorical series, *The Course of Empire* (completed in 1836) and *The Voyage of Life* (1839–40), define as mental experience what the *Frenchman's Bay* and his landscapes explore as facts of the external world. For our purposes, these series define the allegorical limits of the vocabulary of seascape in the American romantic imagination.

The Course of Empire depends for its structural organization upon the Claudian harbor view. Climactically in *The Consummation of Empire* and equally apparent in the last two panels, *Destruction* and *Desolation*, the urban view opens onto sea space. But there was a problem inherent in Cole's use of Claude Lorrain's harbor formula, with its U-shaped format framing the seascape vision, its classical buildings (or ruins), and its stable perspective vista, usually into a sunset, useful as this pattern had been to later artists including Turner, young John Vanderlyn, and Allston. The formal pattern carried a meaning that ran counter to American hopes and aspirations. The sense of lost grandeur and nostalgia of Claudian history or the picturesqueness of Claudian ruins, however balanced and ordered formally, engendered a cautionary lesson for Cole and his audience in *The Course of Empire*. The message of the series, though generalized and allegorized, was clear: the empire reared on commercial expansion risked destruction and desolation. As Henry Adams, ruminating on the decline and fall of Rome, was later to say, "Substitute the word America for the word Rome, and the question became personal." Claudian harborscapes seemed to lead American nationalism toward impasse.[42]

The Voyage of Life can be seen as a response to this dilemma. Turning to spiritual allegory, the Colean voyager now moves in his boat out of the cave of beginnings, *Childhood* (Fig. 44), into *Youth* (Fig. 45) defined by the comfortable conventions of the Claudian landscape. Most germane for the history of seascape and the American imagination, beyond the general trope of life as voyage, are the last two panels, *Manhood* and *Old Age* (Figs. 46 and 47). His early sketches and notes find him experimenting with various ways of defining his material. In one set of sketches, *Manhood* (Fig. 48) was to be the launching out over cataracts upon a tempestuous sea space, with the figure in *Old Age* (Fig. 49) in a sheltered cove, the horizontal expanse of the sea clearly beyond and competing and contrasting with the light from above. By the time Cole completed his first large finished version of the series, *Manhood* had been redefined as the terrifying plunge into the maelstrom which sluices seaward. The horizon, only a small note now, would reappear from earlier sketches (Fig. 50) as a strong organizing element in the 1842 replica (Fig. 51). *Old Age* is the full seascape. In a guide to the series, Cole articulated verbally the meaning of the allegory in general and in particulars. More important, however, is Cole's visual achievement. In *The Voyage of Life* Cole crystallizes American seascape as a spiritual journey and gives that journey its classic visual structure.[43]

The impulse to define seascape in spiritual terms had, of course, been present from the outset of American experience, from the first Puritan descriptions of the voyage to Thomas Smith's *Self-Portrait* which asked us to transcend the conflict of the world, defined by the naval battle, through grace, an act of the spirit. Allusions to this pattern persist in later works. The greatest Biblical source of sublime seascape was the Deluge, and just as Cole was working on his spiritual series, the aged John Trumbull completed a large canvas entitled *The Last Family Who Perished in the Deluge*, 1838–39 (Fig. 52). Thematically this work is linked to Cole's *Manhood* in its articulation of human powerlessness before the awesome majesty of a deity unleashing his wrath on the universe. But despite their similar-

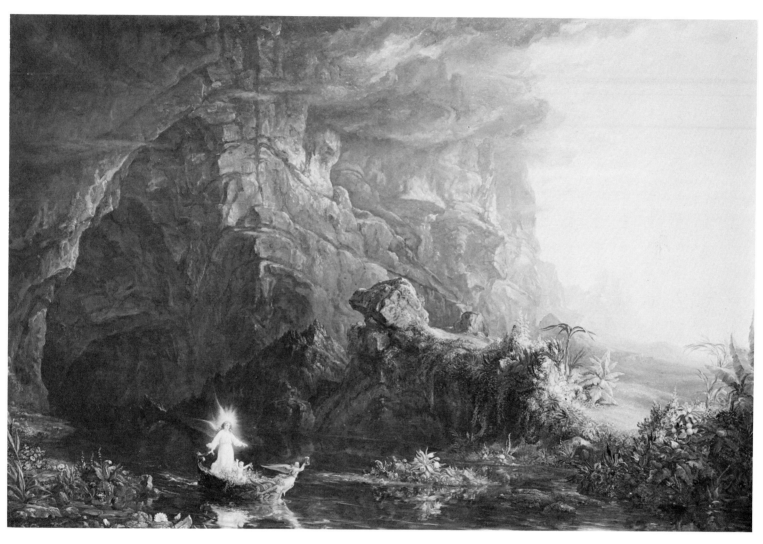

44. Thomas Cole. *The Voyage of Life: Childhood*, 1839. Oil on canvas, 52 x 78 inches.
Munson-Williams-Proctor Institute, Utica, New York.

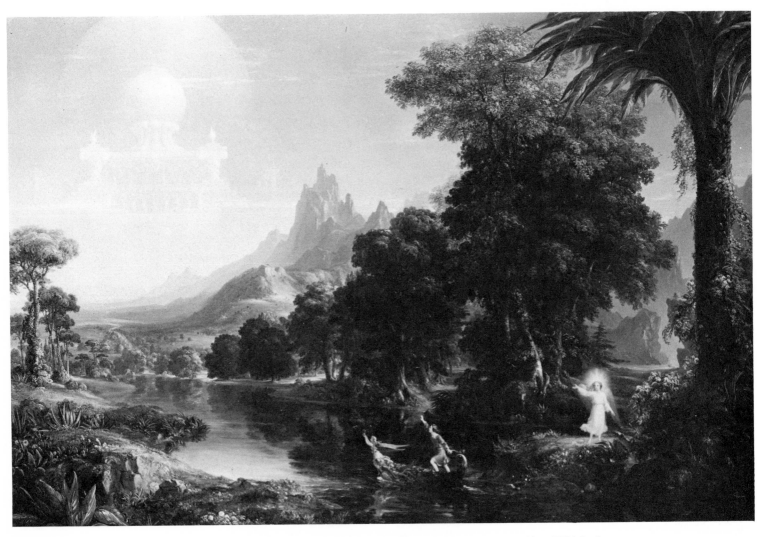

45. Thomas Cole. *The Voyage of Life: Youth*, 1840. Oil on canvas, 52½ x 78½ inches. Munson-Williams-Proctor Institute, Utica, New York.

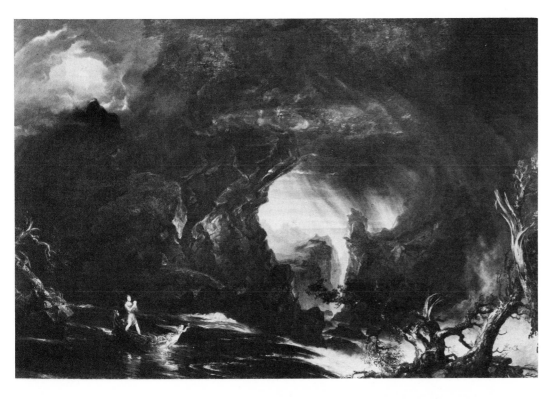

46. Thomas Cole. *The Voyage of Life: Manhood*, 1840. Oil on canvas, 52 x 78 inches. Munson-Williams-Proctor Institute, Utica, New York.

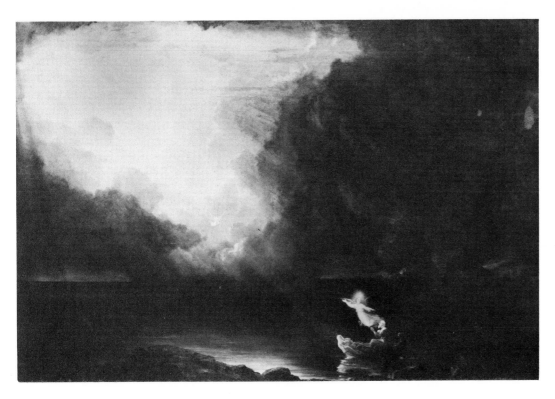

47. Thomas Cole. *The Voyage of Life: Old Age*, 1840. Oil on canvas, 51¾ x 78¼ inches. Munson-Williams-Proctor Institute, Utica, New York.

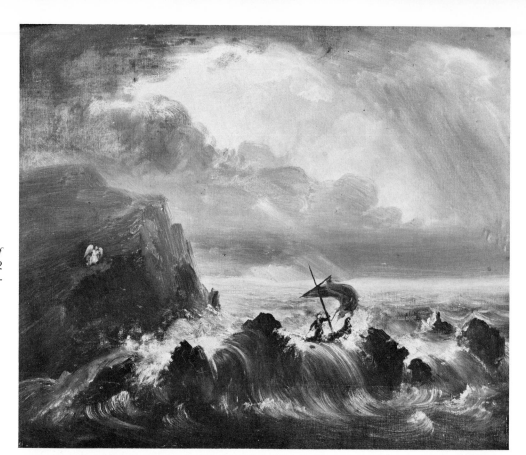

48. Thomas Cole. *Sketch for the Voyage of Life: Manhood*, (1839). Oil on panel, 12 x 13⅝ inches. Albany Institute of History and Art, Albany, New York.

49. Thomas Cole. *Sketch for the Voyage of Life: Old Age*, (1839). Oil on panel, 12 x 13⅝ inches. Albany Institute of History and Art, Albany, New York.

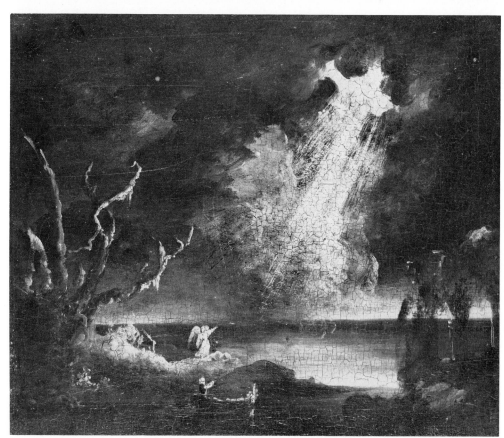

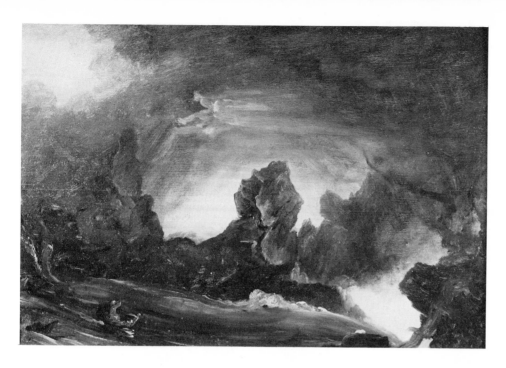

50. Thomas Cole. *Sketch for Manhood*, n.d. Oil on canvas, 11 x 16¾ inches. Munson-Williams-Proctor Institute, Utica, New York.

51. Thomas Cole. *The Voyage of Life: Manhood*, 1842. Oil on canvas, 52⅞ x 79¾ inches. National Gallery of Art, Washington, D.C.; Ailsa Mellon Bruce Fund, 1971.

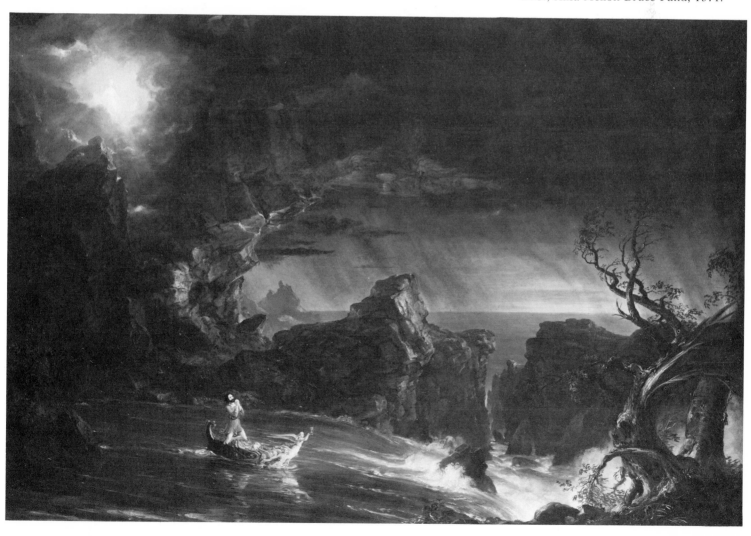

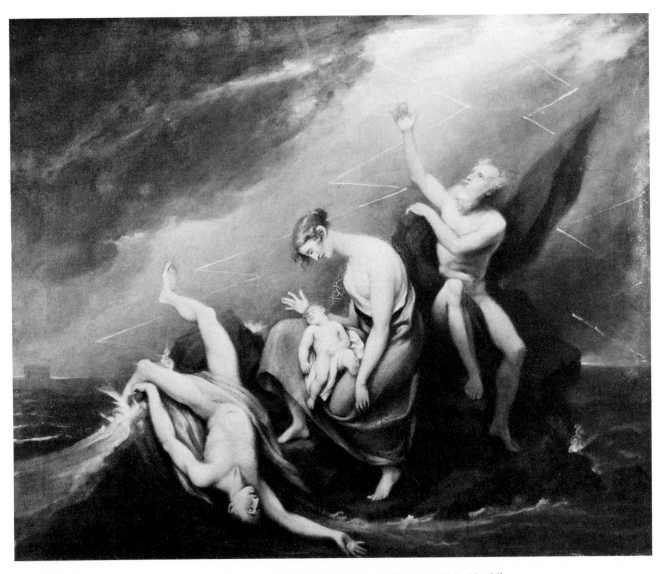

52. John Trumbull. *The Last Family Who Perished in the Deluge*, 1838–39. Oil on canvas, 41 x 50⅞ inches. Yale University Art Gallery, New Haven, Connecticut.

ity of theme and contemporaneity of execution, these works belong to different eras. The Trumbull work is still neoclassic in its carefully balanced ordering of the human trio, occupying the center of the canvas in a rather flaccidly sculptural manner. If the young man echoes the helpless Watson of Copley's most famous seascape, his patriarchal father balances the fall of youth with an appeal upwards to a deity articulated as lightning. The madonna and child figures stabilize the grouping in the center and offer a sentimental visual alternative to the darkened skies, the swirling waters, and the suggestion of the ark to the left on the horizon. However much the idea of the canvas is human helplessness before the sublime, Trumbull's pictorial language is stable and anthropocentric.

To look at *Manhood* and *Old Age* is to perceive immediately the radical gap between Trumbull's neoclassic and Cole's romantic versions of the spiritual sublime seascape. Not only is the human reduced to a tiny scale in the vast space, but the space itself speaks through light. In *Old Age* the rocky coast and the stretches of the sea to the horizon are blurred by the gloom, as rock flows into the sea and sea and horizon disintegrate into pure space. The space that Deity had first separated, and that art had tried to differentiate and make habitable, is reabsorbed in this apocalyptic moment. As symbolically implied in the *Rising of a Thunderstorm*, Cropsey's *Coast Scene*, and countless other American seascapes, the power of Deity is here defined explicitly as light.

Unlike his great contemporary Turner, Cole was unwilling to loosen his grip on the image, and so we must deal with the old man and the angelic figures rather than live fully in the swirls of brilliant paint itself, Turner's image of the sublime. But their romantic seascape modes are essentially the same. As Turner pushed sublime seascape in England to the point where the next step would only be back toward realism or into pure abstraction, so Cole in America defined thematically for the nineteenth century the spiritual end of the sea journey and clarified aesthetically the language of dissolving forms into a light that obliterates the boundaries of coast, sea, and sky.[44]

The attractiveness of the Colean apotheosis of sublime seascape to a variety of people cannot be denied. Not only the religious community who liked the "message" but also artists like Frederic Church, Edgar Allan Poe, Melville, Fenimore Cooper, and his later illustrator James Hamilton found Cole's specific formulation stimulating.[45] But there was a danger implicit in the Colean formulation of sublime seascape: given its ultimate direction, was there any place for man at all? (Woman, clearly, remained at home.) And was Cole's spiritual language so extreme as to be irrelevant to those who chose to find their seascape material not in noumenal abstract presentations of the human condition but in the phenomenal shapes of nineteenth-century America?

The work of Martin Johnson Heade should suggest some preliminary answers. Heade was in his own way a great American explorer of space. As his hummingbirds and orchids dwarf their exotic background landscapes to allow us the precise vision of the particular or his magnolia becomes through his visual presentation truly grandiflora, so at the other extreme Heade could open up the space of his seacoast scenes, dwarf boat and coast, and give us the subtle luminist gradations of open space in a work like *Thimble Island, Near New Haven*. His masterpiece, *Thunderstorm Over Narragansett Bay*, 1868 (Pl. III), can be seen as a secularized version of Cole's *Old Age*. The work combines the horizontal format of the romantic seascape tradition, dwarfs the human elements—the children, boats, and forms of the town to the left—and then, in Colean fashion, almost obliterates the distinctions between land, sea, and sky in the sublime action of the storm. The brilliance of the light is not under human control. The single sails and the gulls seem picked out arbitrarily against the enveloping darkness. But the moment is not one of transcendence out of the human; it is the absolute present. Heade has translated Colean metaphysics into a series of expressive aesthetic

gestures for nineteenth-century Americans, and thus he points our investigation back more directly into local American experience.

5.
Maritime Nationalism
In Search of a History

The cost of the Colean visionary voyage was the loss of a direct sense of the physical universe and of the American world in particular. That of course is part of Cole's intent, to loosen our hold on the physical as we move to the metaphysical. Or as Whitman later put it, at the ecstatic end of his metaphysical "Passage to India":

O my brave soul
O farther farther sail!
O daring joy, but safe! Are they not all the Seas of God?
O farther farther farther sail!

Yet however attractive these lyric outbursts, whether in paint or in poetry, may have been at moments to an American audience that was increasingly fatigued by doctrinal exegesis from the pulpit, for most American artists and their audience the costs were too great. The full visionary voyage meant a denial of the world they experienced and the great human achievements of romantic America. If the Colean voyage of life represents the apotheosis of romantic visionary voyaging, the contrasting tendency in American seascape art of the period was to extend the achievement of the War of 1812 battle painters by identifying sublime seascape with American national experience.

One response was to link seascape imaginatively not with a visionary transcendent future but with a sublime past, through dramatizing the historical appropriation of America by its discoverers. In the mid-1840s William Gilmore Simms, the Southern novelist, poet, and essayist, urged this. Speaking of the opening vista from the heights of Darien, Simms exclaimed:

The very conception of such a scene—the presence of the conqueror, not only in a world which he has conquered, but a world which, so far as he knows, has just come from the forming hands of God—looking down upon new oceans,—beholding a new and subject race, approaching him with a reverence which, in turn, almost makes him feel himself a God!—such a scene is a wondrous story in itself,—a story to burn upon the canvas, and breathe in life and beauty from the chiselled lips of stone![46]

In Simms's version, the aesthetic of the sublime is to be found in historic time through a peculiar combination of Wordsworthian perceptions of an innocent world of space opening up in grand vistas before the American explorer and the American nation, and the Southerner's imperialistic fantasies of conquest of both that space and its native inhabitants.

Our artists' response to this challenge was varied and complex. In the most abstract conceptual way, Edward Hicks had for some time been including in his many versions of *The Peaceable Kingdom* a vignette of the landing of William Penn, drawn from a print of West's painting of that subject. Quaker pietism, as one might suspect, would lead Hicks to use the geographical appropriation of space emblematically: the meeting of Penn and the Indians becomes a human counterpart of the foreground scene. Conflict is suppressed and subordinated to peace and plenty, the sea merely a means to arrive at a spiritual home.[47] George Catlin, already internationally famous for his Indian portraits and his record of the West, did a series on La Salle (Fig. 53) commissioned in 1847 by the king of France in which he calligraphically sketched human beings gesturing like little puppets before the vast and lurid sea and sky that stretch into the distance, a visual counterpart to the historian Francis Parkman's later ironic description of the moment:

On that day, the realm of France received on parchment a stupendous accession. The fertile plains of Texas; the vast basin of the Mississippi, from its frozen northern springs to the sultry borders of the Gulf; from the woody

53. George Catlin. *La Salle Claiming Louisiana for France, April 9, 1682,* (1847/48). Oil on canvas, 14⅞ x 22¼ inches (sight). National Gallery of Art, Washington, D.C.; Gift of Mr. and Mrs. Paul Mellon, 1965.

54. John Vanderlyn. *The Landing of Columbus on San Salvador, October 12, 1492,* (1839–46). Oil on canvas, 11 feet 10½ inches x 18 feet. The Capitol, Washington, D.C.

ridges of the Alleghanies to the bare peaks of the Rocky Mountains—a region of savannahs and forests, sun-cracked deserts and grassy prairies, watered by a thousand rivers, ranged by a thousand warlike tribes, passed beneath the sceptre of the Sultan of Versailles; and all by virtue of a feeble human voice, inaudible at half a mile.[48]

The greatest of all challenges was of course Columbus. John Gadsby Chapman, Hicks, Cornè, and a host of others essayed this theme. The weary and embittered classicist, John Vanderlyn, finally received the Congressional appointment to do the Columbus panel for the Capitol rotunda, hoping to recapture an American audience bored with his more ideal productions. The result (Fig. 54), like its companion, Robert Weir's pious *Embarkation of the Pilgrims*, is not a celebration of the space, of the "Admiral of the Ocean Sea," but of the appropriation of the land (with tiny figures already scram-

bling for gold in the left corner). It remained for James Hamilton in 1850 to remind his audience in *The Vision of Columbus* that whatever had happened subsequently, it had all begun as a voyager's seascape dream.[49]

By 1861, in the hands of John Quidor, the discovery theme had become pure grotesque. Following Washington Irving's text in the Diedrich Knickerbocker *History of New York*, which is itself a comic inversion of Aeneas's quest in Virgil, Quidor's version of the discovery theme in the *Voyage from Hell Gate to Communipaw* (Fig. 55) extends the Irvingesque mock-heroic parody and gives it one more turn of the screw. The strange forms that frame and enclose the little boat around the edge of the canvas, branches that reach out like claws into space and echo the agitated little shapes in the boat, form a parody of the U-shaped Claudian format, traditionally a stabilizing force. Slashing diagonally across the whole canvas in the deep space, from the framing tree through the rent in

55. John Quidor. *Voyage from Hell Gate to Communipaw*, c. 1861. Oil on canvas, 27 x 34 inches. Wichita Art Museum, Wichita, Kansas; Roland P. Murdock Collection.

the sail to the land on the horizon in the distance, the bolt of lightning turns terrifying what might at first be apprehended as a charmingly comic moment. This idiosyncratic combination of the conventions of both the Claudian beautiful harborscape and the sublime storm scene (a curvilinear version of Heade's *Thunderstorm Over Narragansett Bay*) disintegrates subject in a solipsistic world of the imagination which can find its counterpart only in Edgar Allan Poe's *Narrative of Arthur Gordon Pym*. At the other extreme, perhaps the ultimate historicizing of American seascape, as far as the popular imagination was concerned, was Emanuel Leutze's transformation of George Washington from the dignified impersonal figure of Stuart's image into the nautical hero of *Washington Crossing the Delaware*, 1851 (Fig. 56), the many prints of which made the work one of the most popular in America. A mid-nineteenth-century counterpart of *Watson and the Shark* in pictorial organization (with the ice floes substituting for the sublime shark), the boat becomes the symbol of the American community, with the eaglelike profile of Washington[50] and the flag looming against the sky.

The Celebration of Commerce

The importance of the historical seascapes of discovery and those of the Revolution and the War of 1812 lay as much in their wide popularity as in their intrinsic visual interest. Pictorially they were a retreat from the vastness of Colean space into a habitable human world with clear lines of demarcation between the human and the natural, where "the sublime" existed as a national ideal, not as something to be experienced visually. As works in public spaces like the Capitol rotunda, or as popular prints sold nationally, they reinforced American national pride. Behind this popularity lay frequently an aesthetic that ran counter to the domesticated Burkeanism of the sublime seascapists. When Robert Salmon showed his large panorama of the *Bombardment and Burning of Algiers* in Boston

in 1830, shortly after his arrival from England, the *Boston Daily Advertiser* remarked:

> There has never been within our recollection an exhibition in this city, which combined so much of deep interest and instruction as that now made by the accomplished artist, Salmon. His views are always correct, seeming to the eye like the present reality of the thing represented and it may be considered a service to the public, deserving of rich remuneration, that he has produced for our inspection a representation of the city of Algiers, and the circumstances attending a memorable attack thereupon, which conveys an idea of the place and the action, as correct as could be obtained in the bay itself.[51]

Such a view of art held the artist to the criterion of verisimilitude—"the present reality of the thing represented"—and brought the experience of art fully within the public ken. When coupled with the increasing call to make American art speak in local vernacular language, a new aesthetic emerged which was to exert a profound effect upon our seascape artists. Ralph Waldo Emerson offered it to the American public in perhaps its finest formulation in his "American Scholar" address in 1837:

> I ask not for the great, the remote, the romantic; what is doing in Italy or Arabia; what is Greek art, or Provençal minstrelsy; I embrace the common, I explore and sit at the feet of the familiar, the low. Give me insight into to-day, and you may have the antique and future worlds. What would we really know the meaning of? The meal in the firkin; the milk in the pan; the ballad in the street; the news of the boat; the glance of the eye; the form and gait of the body;—show me the ultimate reason of these matters; show me the sublime presence of the highest spiritual cause lurking, as it always does lurk, in these suburbs and extremities of nature; let me see every trifle bristling with the polarity that ranges it instantly on an eternal law; and the ship, the plough, and the ledger, referred to the like cause by which light undulates and poets sing;—and the world lies no

56. Emanuel Leutze. *Washington Crossing the Delaware*, 1851. Oil on canvas, 12 feet 5 inches x 21 feet 3 inches. The Metropolitan Museum of Art, New York; Gift of John Stewart Kennedy, 1897.

longer a dull miscellany and lumber room, but has form and order; there is no trifle; there is no puzzle; but one design unites and animates the farthest pinnacle and the lowest trench.[52]

Emerson's challenge to the American artist had important consequences for our seascape artists. Like the critic in the *Boston Advertiser,* he located the aesthetic field in the present, rather than in "antique or future worlds." Neither West's *Telemachus* nor Cole's heavenly apocalypse would do—indeed, even the spatially exotic Havana of Copley or La Salle's Mississippi Delta was antithetical to the antihistorical bent of Emerson's aesthetic. Furthermore, since to Emerson the "sublime presence" was not a spatial extension into vastness, but a quality inherent in the particularities of the local American world, this world was itself no "dull miscellany," no mere heaping up of factuality for its own sake. The Emersonian leap of faith asserted that form, order, design were intrinsic to "the present reality of the thing represented," if the artist could but find them. The care and balance of his statement makes it clear that Emersonian nationalism was no jingoistic flag-waving, no assumption that merely by virtue of being American such art was good. The task of the artist was to find the "eternal law" implicit in his material. But—given the release from history and from a metaphysic of sublime grace beyond the human—the danger remained that the imperialist fantasies (of a Simms, for example), of sheer appropriation of space by the American, would seem of itself a sufficient rationale for our seascape art.

In the meantime our artists turned to celebrate "the present reality of the thing represented" with eagerness and increasing skill. The harbor view tradition had had a continuing popularity since the colonial period. Our seascape artists were now mapping American space with increasing clarity and precision, as Thomas Birch's *View of the Harbor of Philadelphia from the Delaware River,* about 1835 (Fig. 57), makes evident. Birch exercises meticulous care in depicting the various kinds of boats in the harbor, shifts in scale and perspective, wharves and boatyard and monuments of the city and groups of trees balanced off neatly along the horizon line. The whole is at once accurate in particular and yet clearly organized with a modest, quiet power to give us the experience of the openness of harbor space which the ship dominates.

Robert Salmon's *Sailing Vessels in Boston Harbor,* 1829 (Pl. IV), is similar in kind though more complex in organization, partly because of the way in which light picks out and emphasizes certain areas. The accuracy of the ship portraiture, the prominence of the national and commercial flags, and the repetitious verticals of the multitude of masts must surely have been valued by its purchaser Thomas Handasyd Perkins, the wealthy merchant and Boston cultural leader. Perkins's taste, like that of other prominent Bostonians, tended in general to the neoclassical and the grand style (he was one of the subscribers to Allston's ill-fated *Belshazzar's Feast*), but his patronage of Salmon suggests the ways in which the classicism and order of design could be combined with the appeal to the practical interests of the American commercial aristocracy. Perkins would never realize his investment in the *Belshazzar's Feast,* but the "sublime presence," the "form and order" animating all things which Salmon found in the everyday experience of Boston Harbor, had its rightful place on the walls of Perkins's Brookline estate.[53]

The harbor view recorders moved west and south; they included able draftsmen in the tradition of view painters and printmakers like William James Bennett, who painted Detroit from the comfortable perspective of a bluff across the harbor (Fig. 58), and the anonymous vernacular artist of *The Plantation,* about 1825 (Fig. 59), whose conceptual patterning turns the American ship and water on which it rides (probably in fact some estuary) into the lower border, while the trees frame the sides. But, charming as *The Plantation* is, it is not merely a decorative design of purely visual interest; its organization is as much a statement of an economic pattern as Salmon's *Boston Harbor.* The rural world is framed by trees to suggest how the plantation was carved out of the wilderness; the

57. Thomas Birch. *View of the Harbor of Philadelphia from the Delaware River*, c. 1835 or 1840. Oil on canvas, 20 x 30 ¼ inches. The Newark Museum, New Jersey.

58. William James Bennett. *View of Detroit in 1836*, (1836). Oil on canvas, 17½ x 25 inches. Detroit Institute of Arts, Detroit, Michigan; Gift of the Fred Sanders Company in memory of Fred Sanders.

59. Unknown artist. *The Plantation*, c. 1825. Oil on wood, 19⅛ x 29½ inches. The Metropolitan Museum of Art, New York; Gift of Edgar William and Bernice Chrysler Garbisch, 1963.

open space moves us hierarchically past houses and barns and slave quarters to right and left toward its climax in the mansion. And the artist knows that all of this is built on a commercial foundation, dependent on the mill, the waterside commercial building, and the American seagoing vessel which will take the product (carefully kept out of view, and not to be confused with the allegorical grapes) to some world market. The limitation of seascape space attempts to partially repress that fact in a fantasy of rural bliss, where Salmon's *Boston Harbor* boldly proclaims its maritime commercial life through focusing our attention sharply and crisply on the nautical prowess of the ship in the foreground and letting the eye wander across the plane of water which stretches out beyond, from the docks to the left to the harbor islands in the center and the open seas to the right, glimpsed beneath the lifted sail. The artist's allocation of seascape space becomes his language for defining and interpreting the American present.

The harbor view tradition reaches an aesthetic climax in the art of the Gloucester painter Fitz Hugh Lane. Though Lane's oeuvre includes early topographical views of Boston, later scenes of the Maine coast, and some storm-tossed ships at sea (Salmon called them "fansey storms"[54]), he was above all the visual historian of his native town. A semi-cripple in a world where men "go down to the sea in ships," Lane turned the limitations of his disability into a series of stunning visual triumphs through his intricate spatial exploration of a single location seen from different perspectives and at different times of day and year. His Gloucester paintings are a serial image of the palpable physical present, meticulously defined, equivalent in the visual world to Thomas Cole's metaphysical *Voyage of Life* series.

To contrast the Newark Museum's 1848 view of the inner harbor (Pl. V) with the two 1850s works of the outer harbor, *Gloucester Harbor at Sunset* (Fig. 60) and *Ships in Ice Off Ten Pound Island, Gloucester* (Fig. 61), is to recognize the nature of Lane's achievement. As depictions of particular places and particular objects they are fine examples of their type, sufficient to pass muster with the most demanding of those critics who sought information ("an idea of the place and the action, as correct as could be obtained in the bay itself," in the *Boston Advertiser*'s earlier words). Yet they also confirm Emerson's belief that the world has form and order, and indeed that "one design unites and animates the farthest pinnacle and the lowest trench." Lane is a master of space—the seascape artist's visual language. In the inner harbor scene, the foreground organizes the complex commercial world of the shore into intricate patterns of diagonals, curvilinear shapes of the ribs, and lumpy eccentric shapes of logs and men. The strength of the pattern as well as the familiar details of this center of focus make it more than a "dull miscellany" of facts, however; the space is human and habitable. It is our shore world. Yet it gains its visual meaning by its juxtaposition to the finer and more delicate horizontals and verticals of the ships, the island, and the flat plane of the water extending out through this grid into space. The foreground frames the view beyond and encloses it, and the sunset stillness but gives further support to our feeling that what we have here is a Claudian harborscape, localized and turned from a romantic past into the American present.

The outer harbor scenes, by contrast, clarify our sense that seascape is an art of large space. The containment and control that dominate the grid pattern of the inner harbor scene become here a rendering of openness, of the ships as a principle of geometric order that organize pictorially, though they do not control physically or metaphysically the vastness beyond. In *Gloucester Harbor at Sunset*, the constructive power of the boat shapes to the right are only partially balanced against the smaller boat to the left, and the elliptical hole in space that begins with the ship's bowsprit opens up into the vastness. The little boat in the middle helps us to map the space, but it is clearly no barrier to the space that stretches to the horizon and beyond. *Ships in Ice* reverses the pattern, framing not at the edge but pyramiding out from the center. The tiny figures suggest at once the habitability of the space

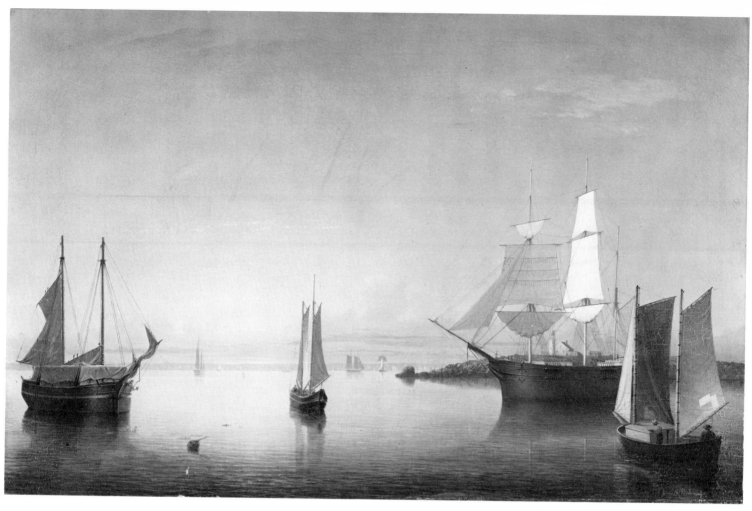

60. Fitz Hugh Lane. *Gloucester Harbor at Sunset*, c. 1859. Oil on canvas, 24½ x 38½ inches. Graduate School of Business Administration, Harvard University, Cambridge, Massachusetts.

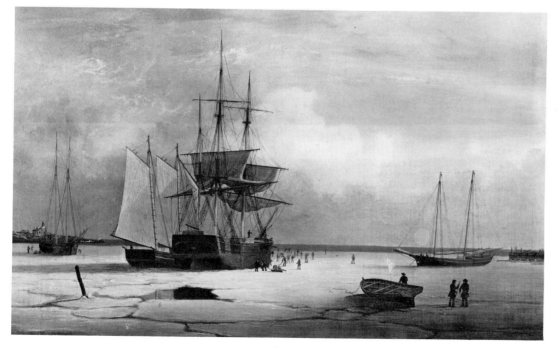

61. Fitz Hugh Lane. *Ships in Ice Off Ten Pound Island, Gloucester*, 1850s. Oil on canvas, 12 x 19¾ inches. Museum of Fine Arts, Boston; M. and M. Karolik Collection.

and, by their scale, our ultimate incapacity to control that space. Lane thus orchestrates space visually and conceptually to suggest inner and outer, containment and release, a series of absolutely located moments in our experience of the world. Our feelings of the infinitude of natural space are not the result of some transcendence of the spirit out of the Colean boat and up to the heavens; they emerge from our knowing absolutely our possible human locations as men and women within harbors or as voyagers out toward the openness of the sea.

The harbor view tradition thus reinforced the romantic sense of voyaging out into seascape space at the same time that it harnessed that impulse for national purposes, defined it as specifically American by situating it within a particular American harbor. By locking the ships into comfortable, habitable pictorial space, the artist eliminated our fears of annihilation in the sublime and gave his audience instead a sense of the order of the community as manifested, imaged, in its harbors.

The value of the ship portrait lay for its owner-audience in its likeness to the original, and the success of the portrait is in direct proportion to the visual accuracy of the observer-artist. But beyond this clear documentary value and its corollary implications of economic power, we may note the artist's emphasis on the human appeal of these works. By contrast to the sublime seascapes, these ships fill the canvas, fully inhabiting their pictorial space, frequently drawing the spectator in through their low perspective and placing smaller ships at a distance on the horizon line, as if abhorring the vacuum of open sea space. J. G. Evans's *The Ship "St. Mary's" Entering the Harbor at Mobile* (Fig. 62) is a crisp example in oils; the Currier & Ives version of James Buttersworth's painting of the *Clipper Ship "Great Republic,"* 1853 (Fig. 63), a fine lithographic example. By decoratively filling in the horizon line the artist reassures us that the space is habitable; the glories of the great republic stand supreme here, in both a literal and a metaphysical sense.

As pastoral, with its inland stream, is the contrasting mode of the seascape vision, so, we may suggest, are the innumerable Hudson River steamboat portraits by the prolific James Bard the inland equivalent of the ship portraits. They share the same general aims of accuracy and meticulous detail with portraits of seagoing vessels, but they differ aesthetically in feeling and in their handling of space. The emphatic note in the Bard steamboats is horizontal, with the successive bands of water, contrasting white band of the steamboat itself, stretching almost across the canvas, and the alternating band of dark hills behind, with the sky band adding variety through being broken up by still essentially horizontal cloud groupings. The total effect is placid, unthreatening, reassuring, not the vitality-in-repose of the *Great Republic* or the *St. Mary's*. What frequently gives these boats their imaginative appeal is the pictorial note of fancy in the outsized passengers occasionally visible on the decks and the whiplash design of the outsized banners. The names of the boats emblazoned there also suggest the complexities of the vision: *Rip Van Winkle,* who ran away from work and slept through progress; *Metamora* (Fig. 64), named after George Winchester Stone's immensely popular romantic Indian melodrama about "The Last of the Wampanoags." One may smile at the disjuncture involved in the linking of these mechanical contrivances, symbols of human ingenuity and "progress," with mythic avatars of American folk identity. Yet they represent the powerful if contradictory impulses of romantic America: the need to "civilize" or to conquer and enslave the nonwhite races, and the need to glorify and ennoble the untamed, the unaccommodated, the wild, and the free. Melville's recognition of this fact led him to place the Indian Tashtego, the African Daggoo, and the South Sea Islander Queequeg aboard the American commercial whaler *Pequod.* That peculiar conjunction of extension into the wild and free limitless space with imperialist dreams of conquest, which Simms had articulated in his vision from Darien, was finding other visual and verbal shapes.

This glorification of the actual, of the visible world of things in their particularity, so ably carried out in much ship portraiture, was no mere accident of its occasion, but rather an expression of the

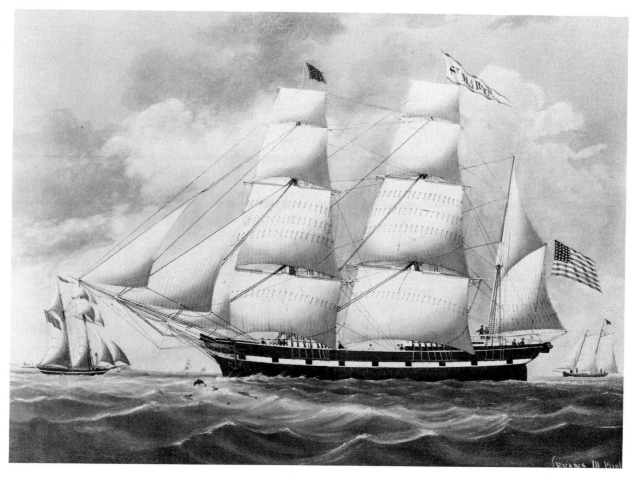

62. J. G. Evans. *The Ship "St. Mary's" Entering the Harbor at Mobile,* 1860s. Oil on canvas, 29 x 36 inches. Hirschl and Adler Galleries, New York.

dominant aesthetic of the era in its anticlassical turning away from Reynoldsian notions of "general nature" to a sharp sense of the intrinsic value of the particular when correctly seen. Two years before the *Great Republic* print, the American sculptor and aesthetician Horatio Greenough argued: "I contend for Greek principles, not Greek things. If a flat sail goes nearest wind, a bellying sail, though picturesque, must be given up." Aesthetic catego-

ries like the sublime and picturesque must be sacrificed to the beauty of the observable. Greenough's most important statement on this theme was published in 1843 in the *United States Magazine and Democratic Review,* a center of political and literary nationalism that called itself "Young America" and included among its votaries Simms and young Herman Melville. "Observe a ship at sea!" says Greenough.

Mark the majestic form of her hull as she rushes through the water, observe the graceful bend of her body, the gentle transition from round to flat, the grasp of her keel, the leap of her bows, the symmetry and rich tracery of her spars and rigging, and those grand wind muscles, her sails. . . . What Academy of Design, what research of connoisseurship, what imitation of the Greeks produced this marvel of construction? Here is the result of the study of man upon the great deep, where Nature spake of the laws of building, not in the feather and in the flower, but in winds and waves, and he bent all his mind to hear and to obey. Could we carry into our civil architecture the responsibilities that weigh upon our ship-building, we should ere long have edifices as superior to the Parthenon, for the purposes that we require, as the Constitution or the Pennsylvania is to the galley of the Argonauts.[55]

63. Currier & Ives (N. Currier); after James E. Buttersworth. *Clipper Ship "Great Republic,"* 1853. Lithograph, 15 15/16 x 23 7/16 inches. The Metropolitan Museum of Art, New York; Bequest of Adele S. Colgate, 1963.

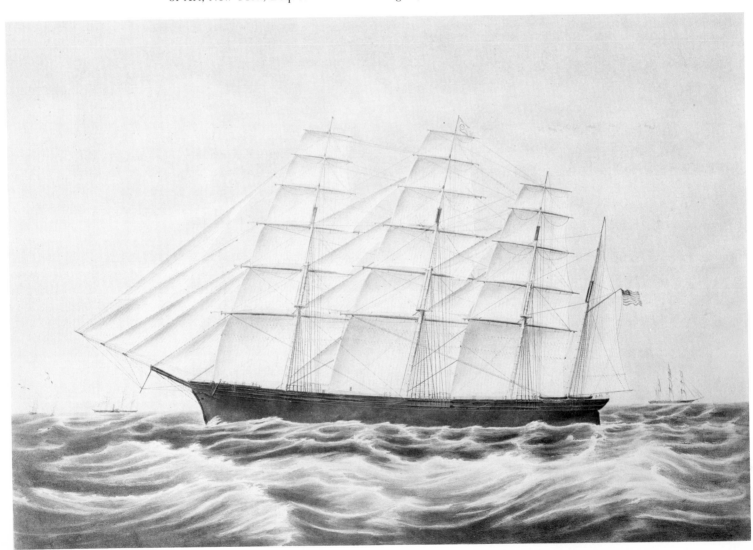

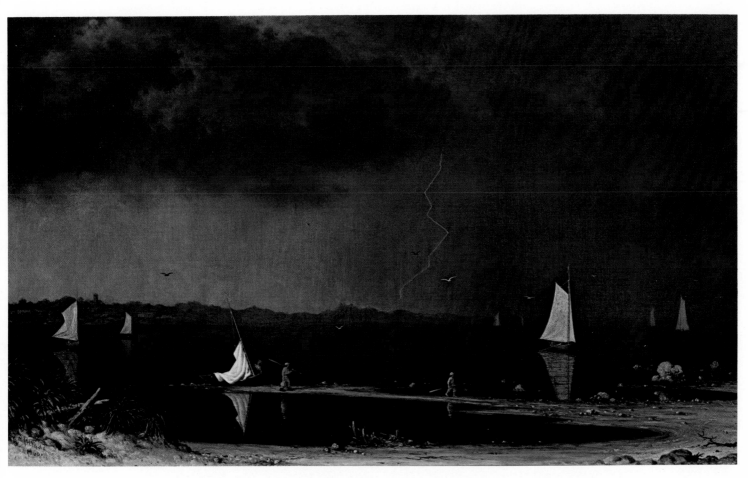

Plate III. Martin Johnson Heade. *Thunderstorm Over Narragansett Bay*, 1868. Oil on canvas, 32⅛ x 54¾ inches. Collection of Ernest Rosenfeld.

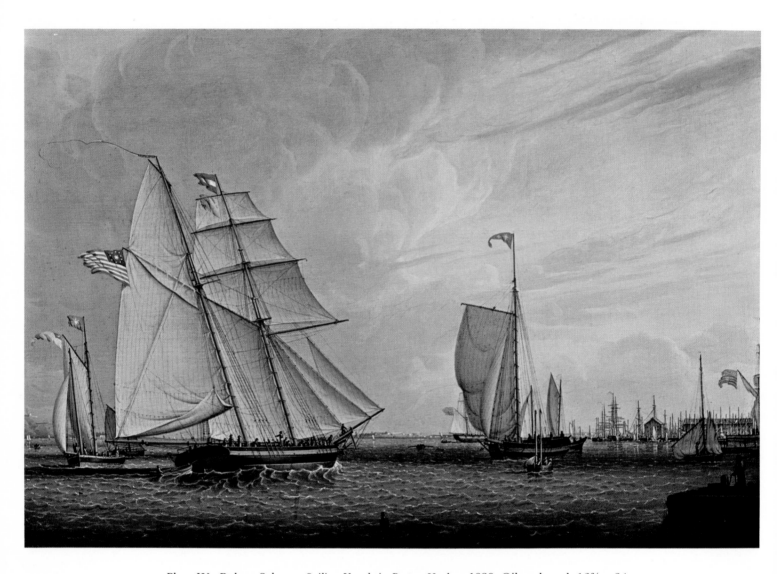

Plate IV. Robert Salmon. *Sailing Vessels in Boston Harbor*, 1829. Oil on board, 16⅜ x 24 inches. Hirschl and Adler Galleries, New York.

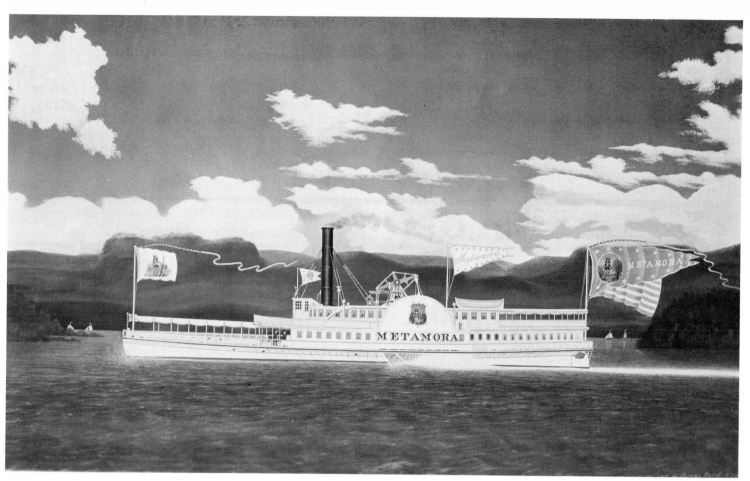

64. James Bard. *Steamboat "Metamora,"* n.d. Oil on canvas, 33 x 53 inches. The New-York Historical Society, New York.

65. Robert Salmon. *South Sea Whale Fishing,* 1831. Oil on panel, 16½ x 23¾ inches. Museum of Fine Arts, Boston; Gift of Joseph P. B. Henshaw.

The passage is worth quoting at length because it crystallizes the aesthetic of the visual seascape as Cole's *Voyage of Life* renders the visionary. Greenough's injunctions are an appeal to sight: "*Observe* a ship at sea! *Mark* the majestic form. . . ." He searches visually in the observable world for its intrinsic aesthetic qualities ("the graceful bend of her body, the gentle transition from round to flat"). Greenough too seeks ultimately to know the laws of nature as they are written "upon the great deep" (his language is consciously Biblical), but he has confidence, like Emerson, that the transcendent is a sublime presence inherent in the things of the world. Furthermore, the ship as an American national image symbolized, again in Emerson's "American Scholar" terms, the triumph of the present over "antique and future worlds."

Given this nationalistic urge it was only a step to the glorification of American exploration and American whaling which were extending United States national presence and the American flag to the far corners of the earth. Seascape art became a handmaiden of American commercial manifest destiny. In the hands of Robert Salmon it is a meticulous depiction of the process of hunting and cutting in the great leviathan in the South Seas (Fig. 65).

Our artists would follow American ships to the poles. The Currier & Ives *Clipper Ship "Red Jacket"* (Fig. 66) is shown "in the ice off Cape Horn on her passage from Australia to Liverpool August 1854," a massive statement of American engineering skill pictorially dominating the strange and exotic Antarctic ice world. Yet it inhabits the space more fully and comfortably than do the *Ships in Ice Off Ten Pound Island* of Lane. Whatever the geographical facts may be, Lane's feeling for the openness of seascape space dominates his canvas, while the Parsons lithograph becomes one more emblem of American maritime power. By contrast, the images of the Arctic which Frederic Church, in the 1850s and 1860s, and William Bradford, in the seventies and eighties, brought back minimize or even eliminate completely the human and emphasize the exotic sublimity of the Arctic regions. They are further extensions of our nationalist vision of the sea.[56] Bierstadt and Coulter would project the vision from the Atlantic to the Pacific coasts. But the point was clear: seascape was made to serve American national purposes, a series of visual metaphors of our national destiny into space.

The Domestication of Seascape

At the other extreme stands the domestication of seascape to the world of the shore: images that tell us that the American sea was to be known and understood not only through its extension outward but also through its impact on home and hearth. The contrast between John Carlin's *After a Long Cruise (Salts Ashore)*, 1857 (Fig. 67), and Richard Caton Woodville's *The Sailor's Wedding*, 1852 (Fig. 68), begins to suggest the pattern. The Carlin seems, like the small *Negro Boys on the Quayside* (Fig. 69), to be another version of Fitz Hugh Lane's inner Gloucester harbor with the human element enlarged in scale so as to dominate the ships in the background; in the Woodville, the sea exists only as an idea in the proud figure of the sailor about to be wed. Yet within their context of the 1850s they suggest a great deal about the meaning of the sea to the American people. The Carlin *After a Long Cruise* is not merely a whimsical genre piece; behind the comic disorder of the drunken sailors stands the threat of the sea. The metaphysically inclined might link the sublime disorder of the sea with the unmediated power of deity and read spiritual apocalypse out of it. From the point of view of the land world, the life at sea all too easily encouraged sailors to drunkenness and lust and was thus a threat to the order of society.

The temperance movement, for example, found rampant and aggressive commercial life, so vividly portrayed in Salmon's *Boston Harbor* view or the ship portraits, as part of a disturbing diversion of America's moral energies, a laying up of treasures upon earth alone. Many of the illustrated temperance tales and tracts published during the period warned against the profligate life at sea and urged men to the more stable Christian morality centered

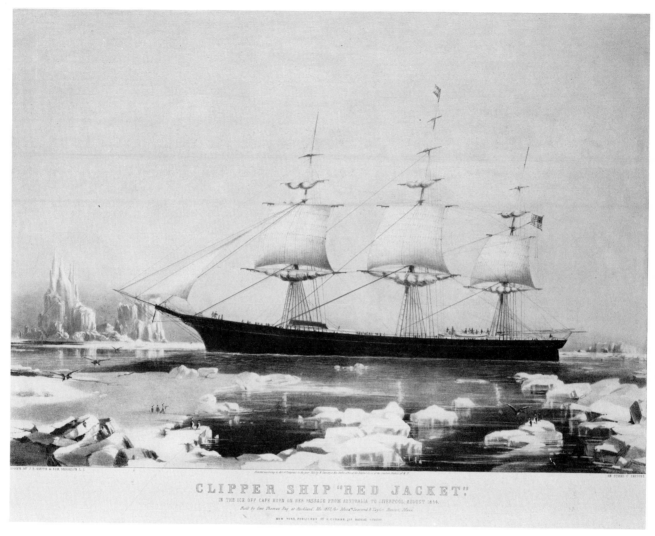

CLIPPER SHIP "RED JACKET."

IN THE ICE OFF CAPE HORN ON HER PASSAGE FROM AUSTRALIA TO LIVERPOOL. AUGUST 1854.

66. Currier & Ives (N. Currier); on stone by Charles Parsons. *Clipper Ship "Red Jacket,"* 1855. Lithograph, 16⅛ x 23 11/16 inches. The Metropolitan Museum of Art, New York; Bequest of Adele S. Colgate, 1963.

in the family. The symbolism of the sublime sea-scape could be turned to this purpose. At the outset of his career young Fitz Hugh Lane did a litho-graph for a sheet music cover of "Alcohol Rocks": a shipwreck scene become cautionary tale with *Intemperance* cast up on the rocks while the good ship *Temperance* sails powerfully along in an offshore breeze.[57] The moral was blatantly obvious, even to Edgar Allan Poe, who played with the sea-as-intemperance motif in the opening pages of

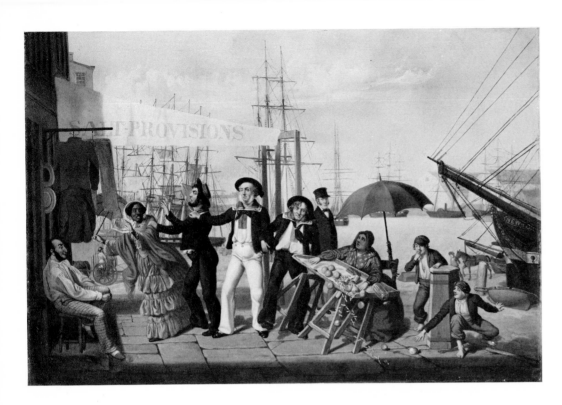

67. John Carlin. *After a Long Cruise*,
1857. Oil on canvas, 20 x 30
inches. The Metropolitan Mu-
seum of Art, New York; Pur-
chase, Maria DeWitt Jesup Fund,
1949.

68. Richard Caton Woodville. *The
Sailor's Wedding*, 1852. Oil on
canvas, 18⅛ x 22 inches. The
Walters Art Gallery, Baltimore,
Maryland.

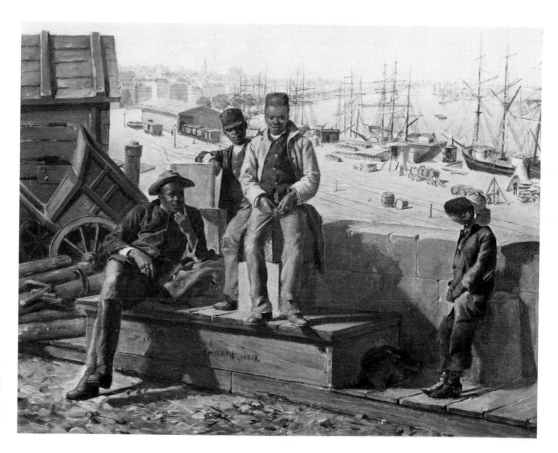

69. David Norslup (?). *Negro Boys on the Quayside*, n.d. Oil on panel, 10¾ x 13¾ inches. Corcoran Gallery of Art, Washington, D.C.; Purchase, Gallery Fund and William A. Clark Fund.

the *Narrative of Arthur Gordon Pym,* when his pair of youthful pranksters are almost drowned by embarking on a drunken spree on board the little boat of the imagination, *Ariel.* This is the context in which Carlin's *After a Long Cruise* measures the cost upon the land world of the life of the sea, setting it off from Woodville's *Sailor's Wedding,* which fully encloses the sailor with symbols of home and hearth, of community white and black, and harnesses the proud tar to the lovely modest woman whose role it is to tame him for the land world.

What should emerge from a view of these two genre seascapes is a sense that the sea impinged in important ways upon the land world of pre–Civil War America. Images of seascape proliferated in a variety of media as rich and varied expressions of the popular imagination, not only in oil paintings on canvas, in watercolors or lithographs, but in sculpture in marble and wood in full figure and bas-relief, in scrimshaw carving on whalebone, on wall frescoes by Rufus Porter and others, on political banners, in fabrics from rugs to quilts to the kerchiefs we have already seen, on sheet music, sailing card advertisements, as transfer patterns on porcelain and trophies for yachting races—the list is almost endless. For our purposes the point is not merely the variety of media, but the fact that these works explore the full range of the expressive and

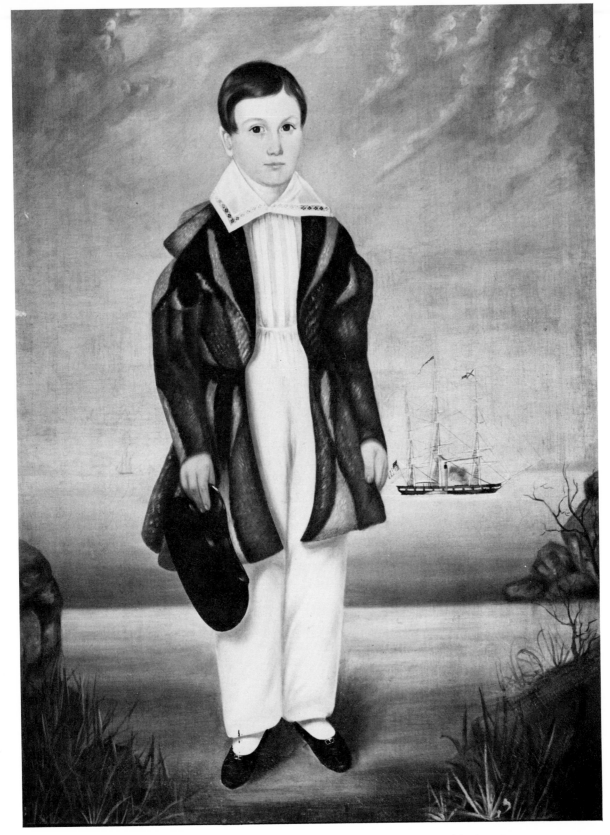

70. Isaac Sheffield. *James Francis Smith*, 1837. Oil on canvas, 48 x 35½ inches. Lyman Allyn Museum, New London, Connecticut.

symbolic vocabulary of seascape as it had been developed in pre–Civil War America.[58] The stark conflict between man and the terrors of the deep, first dramatically stated in *Watson and the Shark*, reappears not only in lithographic whaling prints, on the vernacular, carved bas-relief of the tailpiece of the whaleship *Mary and Susan*, in tiny scale on scrimshaw drawn on whale's teeth, on mile-long whaling panoramas for public view in theaters, and on an eight-foot whaling scene on a hooked rug for a household interior.

At the other extreme, the symbolic seascape that defined status and role by carefully framing it within the orderly context of the land world, used in countless colonial portrait window views as well as in the *Moses Marcy* wall panel, reappeared in a proliferation of portraits of merchants and sea captains by trained artists and, increasingly, by such folk painters and semiskilled craftsmen as Isaac Sheffield. Unusual among this group is Sheffield's exotic portrait of five-year-old *James Francis Smith*, 1837 (Fig. 70), who is shown bedecked in his penguin-skin coat with his father's ship the *Chelsea*, on which he had traveled from the South Sea Island of Desolation, behind him, as the inscription proudly tells us. The charmingly simple figure fills the large canvas; it is the dress, the ship, and the inscription that give the work its imaginative outreach into the seascape world. Such symbolic uses of the sea appear on genealogies and family records (Fig. 71), and in mourning pictures as well, the sea held under control through its careful enclosure. The women and girls of the Pardes Thurston mourning picture (Fig. 72) seem landlocked images, cut off from the terrors of the shipwreck to their right. They are a sentimental vernacular version of the melodramatic land-sea alternatives of West's *Telemachus and Calypso*. The allegory of Cole's *Voyage of Life* is translated into vernacular in the Edmond Parker mourning picture (Fig. 73) in a series of static and reassuring images: the ship in the background which suggests a harbor view is rather a well-known symbol of the craft that will convey the soul from its earthly grave to its heavenly resting place, symbolized here (as in the Cole series) by the angel in the sky.

Not all women were confined to the land world. The simple figurehead of the domestic woman (Fig. 74), frequently carrying a Bible or clutching flowers, could be seen as a guiding force cutting the waves beneath a ship's bow, or she could stand as either the symbolic *Syren* or the elegant and saucy *Prima Donna* on a sailing card (Fig. 75). Mythological figures like Neptune, whom Copley had copied as a young man working from engravings, could reappear on a lunette-shaped housing of a steamboat, or as the *Storm King* or *Neptune's Favorite* on sailing cards. The cards, intended to announce and drum up trade for a particular voyage, run the gamut pictorially from finely etched clipper portraits like *The Romance of the Sea* to complex images of clippers juxtaposed to Indians in the *Queen of the Pacific* (the dreams of conquest of sea and red men persisted through the period). The image of the sailor was also adapted to commercial purposes. He could be fashioned in wood by a local signmaker to hang above a shop door or elegantly carved in the finest marble by Emma Stebbins in Rome, on commission for the coal merchant August Heckscher, as one of an allegorical pair, to symbolize *Commerce* (Fig. 85)—the other figure, a miner, symbolized *Industry*.

Not only was seascape domesticated and framed by the land; the hieratic image of the United States, the soaring eagle, was constantly appropriated to seascape purposes. John James Audubon's eagle, named by him "The Bird of Washington," which had appeared in the plates of the *Birds of North America*, reappears in an oil of 1836–39 in the traditional format of seascape portrait with cliff, sea, and ship in the background (Fig. 76). An anonymous artist, probably adapting another of Audubon's eagle plates, places his *Screaming Eagle* (Fig. 77) on a barren rock with open sea and lurid sky beyond—a political emblem, no doubt, but set in a seascape space in such a way as to figure as a sublime Americanized version of the last panel of the *Voyage of Life* (Fig. 47). Perhaps most impressive of all on a colossal scale, commensurate with the ship it was to lead into international waters, is the 1853 figurehead for the ill-fated first version of the clipper ship *Great Republic* (Fig. 78). The sheet

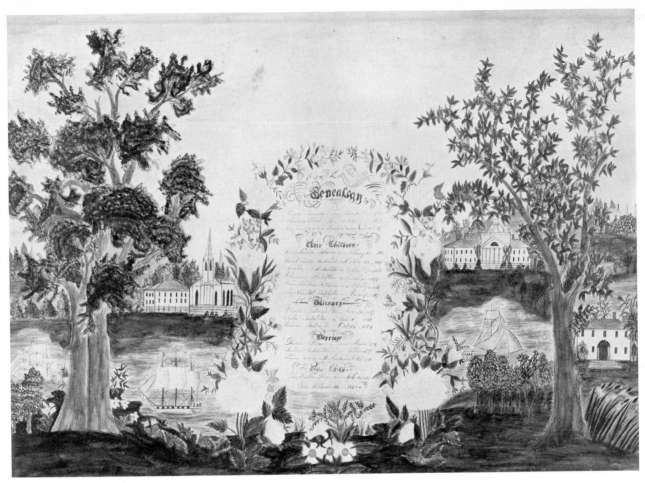

71. Unknown artist. *Batcheldor Genealogy*, nineteenth century. Ink and watercolor on paper, 10¼ x 28 inches. Museum of Fine Arts, Boston; M. and M. Karolik Collection.

music of W. W. Rossington's popular song, "Bird of the Ocean Blue," the lithographic cover of which shows the eagle soaring over an American ship on a high sea with cliffs to the right and lightning flashing to the left, captures the popular image. The verses of the song are full of dreams of conquest and nationalistic fervor. The refrain runs:

Bird of the ocean blue, stormy winds are
 blowing

Skies darkling over thee, mountain seas are
 flowing
Spread thy wings to the blast, hope of the
 brave,
Bird of the ocean blue, queen of the wave.

Given the astonishing range and imaginative flexibility of the tradition, our examples could proliferate endlessly without changing the central point: Once a visual vocabulary had been de-

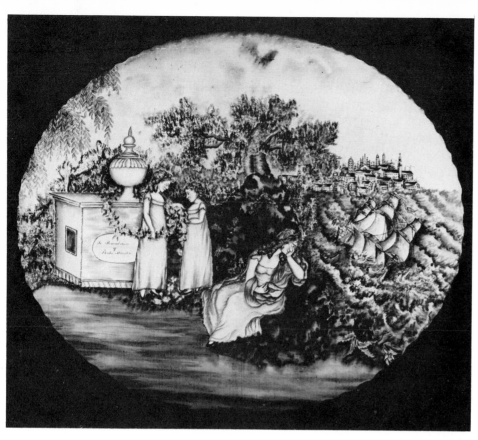

72. Elizabeth Thurston. *Mourning Picture—Pardes Thurston*, 1810–25. Watercolor on silk, 20¼ x 24 inches. Abby Aldrich Rockefeller Folk Art Collection, Williamsburg, Virginia.

73. Unknown artist. *Mourning Picture—Edmond Parker*, c. 1825. Watercolor on paper, 20¼ x 24¾ inches (sight). Old Sturbridge Village, Massachusetts.

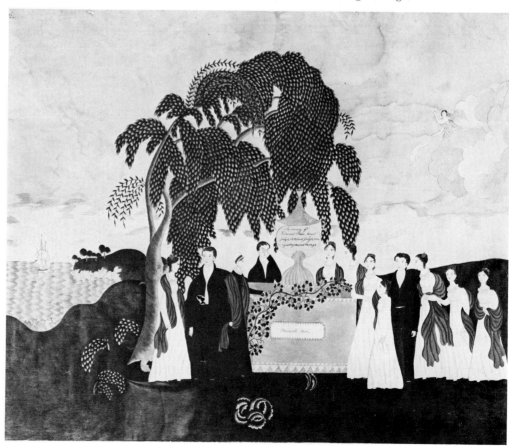

veloped for expressing the variety of American feelings about the meaning and significance of the sea, this vocabulary was adopted and adapted to a wide range of uses. The sublime panorama of whaling could become a domestic rug (Fig. 79) or the great leviathan himself, spouting forth a sea captain, lifted to the heights of a New England barn as a wooden weathervane. The precision of ship portraiture could be shaped to decorative uses in framed images done in yarn (Fig. 80) or silk. A quiltmaker could turn the compass rose, so crucial to the sailor for locating himself directionally in space, into pure geometric design, or she could play off the imagery of land and sea in more representational terms, the pattern falling carefully on the bed in such a way that the horizontal plane of the bed supports the imagery of the land, a tree of life, with the ships and interior border falling vertically around the land portion and themselves enclosed and controlled finally at the edges by further imagery of land (Fig. 81).

The *Land and Sea Quilt* in this way may be the ultimate domestication of seascape, but the same kind of response appears in the scrimshaw products of the sailor's leisure time aboard a whaler, his way of filling up those endless boring hours of waiting that were punctuated by the brief excitement of the chase and hours of filthy unromantic labor of cutting in, trying out, and stowing the commercial product. In the artifacts carved, incised, and colored on the whalebone he expressed both his practical needs, in tools of his trade like carved fids and knife handles, and his links to the land and women in jagging wheels or pie crimpers and in elaborate swifts for winding skeins of wool. Imagery that appeared on whale's teeth or baleen corset busks also ran the gamut from abstract designs to portraits of ships, views of Nantucket cottages, scenes from the chase to sentimental female figures taken from copies on board of *Godey's Lady's Book* or shipwreck narratives (Figs. 82, 86, 87, 88). To take one final example, the whole range of seascape symbolism—from a ship portrait, the primitive eagle, the sailor with an American flag, the compass rose, and Hope with a liberty

74. Unknown artist. *Female Figurehead,* c. 1870. Wood, 60 inches high. Mystic Seaport Inc., Connecticut.

75. Nesbitt & Co., Printers. *Clipper Ship Cards: Neptune's Favorite*, 1859. 3¾ x 6½ inches. *Fanny S. Perley*, 1858. 4½ x 7 inches. *Storm King*, 1860. 6½x 4 inches. *Queen of the Pacific*, 1858. 7 x 4¾ inches. *Prima Donna*,1861. 7 x 4⅛ inches. *Syren, June 1863*, 1863. 6½ x 4 inches. Printing, letterpress. The Seamen's Bank for Savings, New York.

76. John James Audubon. *Washington Sea Eagle*, 1836–39. Oil on canvas, 48 x 36 inches. Private collection.

77. Unknown artist. *Screaming Eagle*, mid-nineteenth century. Oil on canvas, 25 x 30 inches. New York State Historical Association, Cooperstown.

78. S. W. Gleason and Sons. *Figurehead from the "Great Republic,"* c. 1853. Wood, 30 x 60 inches. Mystic Seaport Inc., Connecticut.

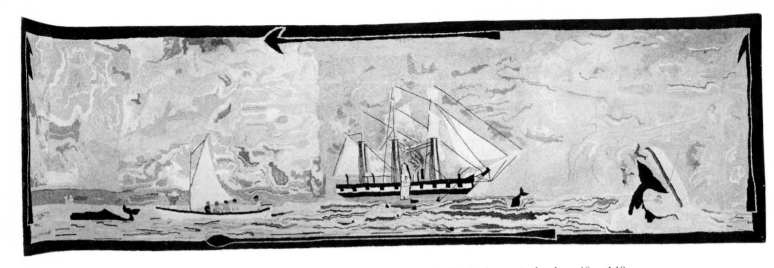

79. Unknown artist. *Whaling Panorama*, 1875–1900. Hooked rug on burlap, 40 x 140 inches. Collection of Barbara Johnson.

80. Unknown artist. *Barque Flying the American Flag*, 1860s. Wool yarn on canvas, 51½ x 23½ inches (sight). Mystic Seaport Inc., Connecticut.

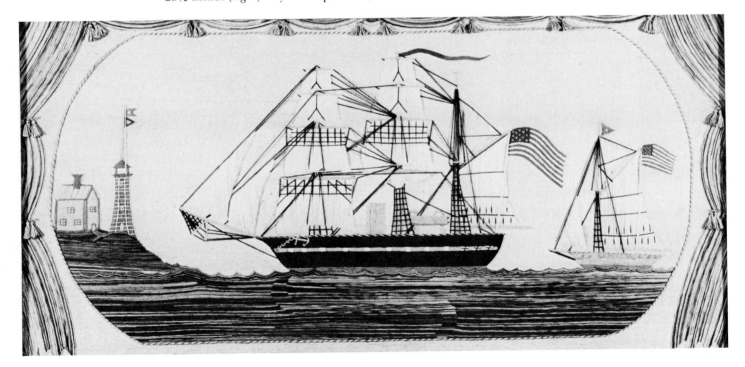

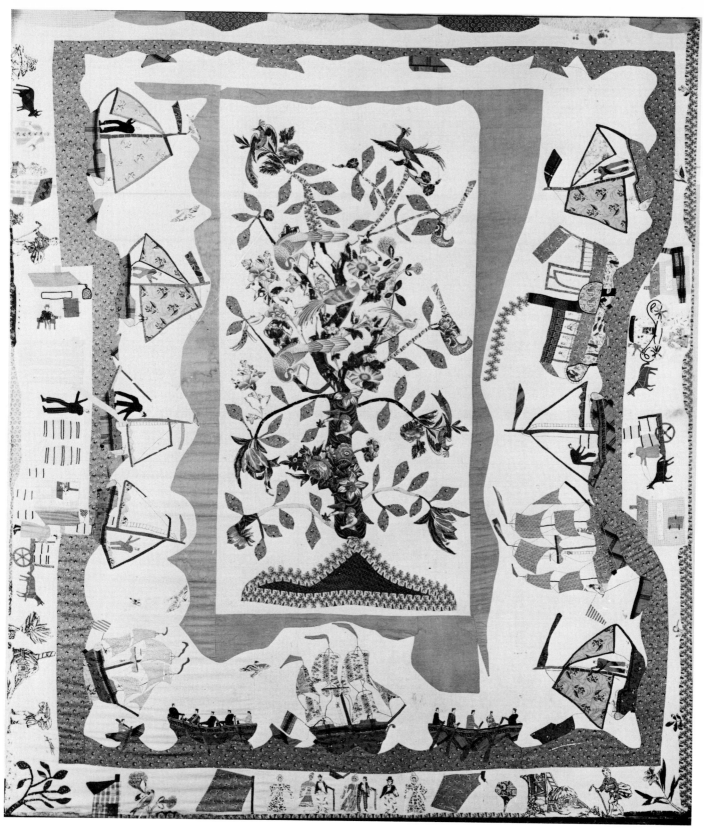

81. Hannah Stockton (attributed). *Land and Sea Quilt,* c. 1830. Appliqué, cotton on muslin, 103 x 91 inches. New York State Historical Association, Cooperstown.

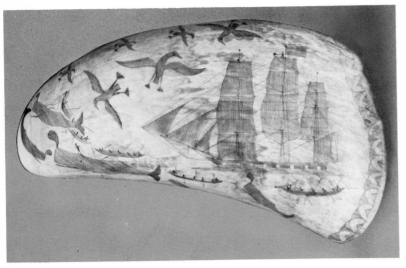

82A. Unknown artist. *Sperm Whaling in the South Pacific*, c. 1825. Engraved whale's tooth, 7¼ inches long. Collection of Barbara Johnson.

82B. Reverse of *Sperm Whaling in the South Pacific*.

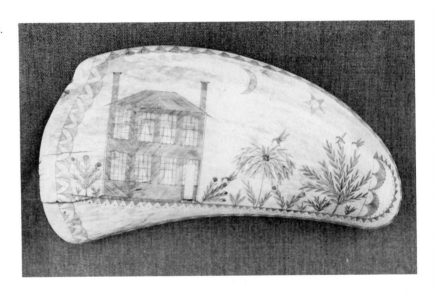

cap—could be combined with land images—the floral garlands, the crossed pipes of peace and plenty, and Masonic emblems—and compressed into a single whale's tooth scrimshaw image (Figs. 83 A,B) just as the War of 1812 had gathered together earlier onto the souvenir scarf or Terrence Kennedy could gather into the rounded form of a political banner the land and the sea (Fig. 84), the symbolic and the realistic, the seascape of the outer world and the seascape of the mind and the

80

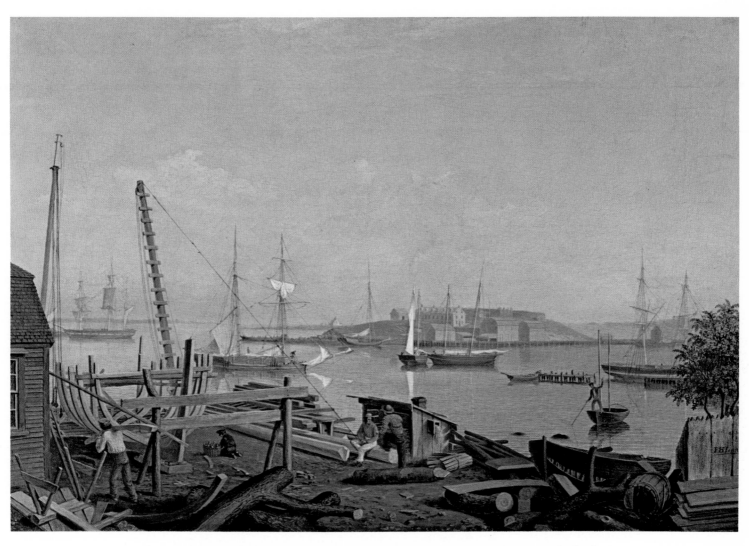

Plate V. Fitz Hugh Lane. *Harbor Scene (Gloucester Harbor, the Fort and Ten Pound Island)*, (1848). Oil on canvas, 20 x 30 inches. The Newark Museum, New Jersey.

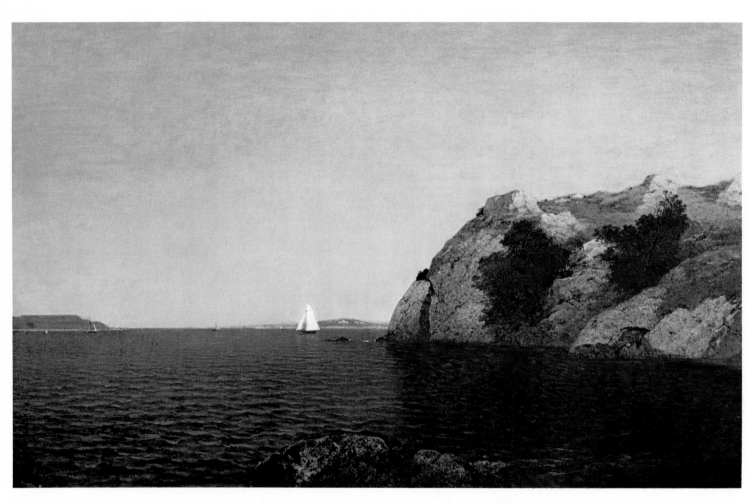

Plate VI. John F. Kensett. *Marine Off Big Rock,* 1864. Oil on canvas, 27½ x 44½
inches. Cummer Gallery of Art, Jacksonville, Florida; Bequest of Ninah
M. H. Cummer, 1958.

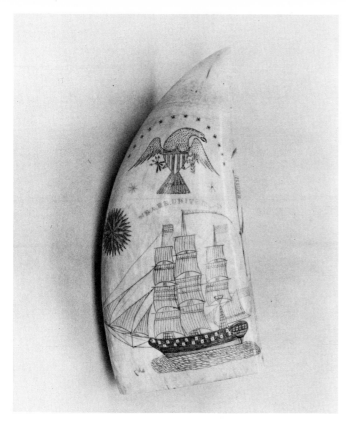

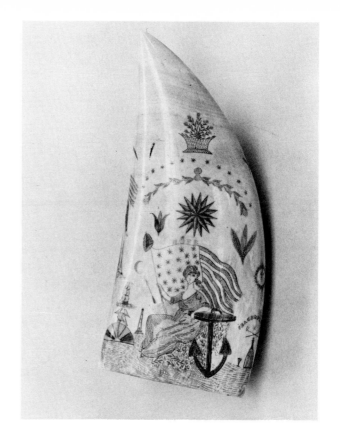

83A. Unknown artist. *Three Masted Ship "Boston,"* 1850s. Engraved whale's tooth, 6⅛ inches high. Mystic Seaport Inc., Connecticut.

83B. *Hope,* reverse of *Three Masted Ship "Boston."*

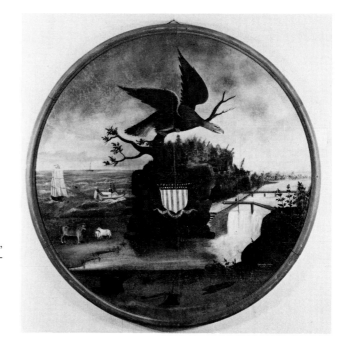

84. Terence Kennedy. *Symbolical Painting,* n.d. Oil on canvas, 65 inches in diameter. New York State Historical Association, Cooperstown.

85. Emma Stebbins. *Sailor (Commerce)*, 1860. Marble, 28¾ inches high. Heckscher Museum, Huntington, New York; Gift of Phillip M. Lydig, Esq.

86. Unknown artist. *The Sailor Boy*, n.d.. Engraved whale's tooth, 5⅛ inches high. Collection of Barbara Johnson.

87. Unknown artist. *Unity Busk*, c. 1840. Engraved whalebone, 1¾ x 12½ inches. Collection of Barbara Johnson.

imagination, reconciling in one single artistic gesture the disparate strands of American seascape as a visual tradition.

6.
Scenic America: Intimate Seascape and Opening Vistas

"The Civil War," said Henry James in 1879, "marks an era in the history of the American mind." There are, as one might expect, a number of pictorial reflections of the war in our seascape art: Albert Bierstadt's panoramic *Bombardment of Fort Sumter* or Conrad Wise Chapman's depictions of the Confederate flag over Sumter, celebratory paintings of naval conflicts like the engagement of the new ironclads, the *Monitor* and the *Merrimac*, or ship portraits of Union or Confederate vessels. Of undoubted importance, the new weekly and monthly magazines contained articles illustrated with wood engravings that gave the news of the war a visual shape (Winslow Homer's *Approach of the British Frigate "Alabama,"* which appeared in *Harper's Weekly* of April 25, 1863, is but one case in point). But perhaps because the Civil War was an internecine struggle, indeed a family conflict, it produced nothing near the nationalistic splurge of art that the War of 1812 had engendered. What is remarkable aesthetically is less the paintings of the war itself than the transformation in American attitudes toward seascape that was occurring in the years around the war.[59]

James located this transformation as one of the American mind. "It introduced into the national consciousness a certain sense of proportion and ·relation"—his terms are aesthetic—"of the world

88. Unknown artist. *Houses and Trees Busk*, c. 1840. Engraved whalebone, 1 9/16 x 13 inches. Collection of Barbara Johnson.

being a more complicated place than it had hitherto seemed, the future more treacherous, success more difficult."

> The good American, in days to come, will be a more critical person than his complacent and confident grandfather. He has eaten of the tree of knowledge. He will not, I think, be a skeptic, and still less, of course, a cynic; but he will be, without discredit for his well-known capacity for action, an observer.[60]

The implications of James's remarks are far reaching. He pictured the transformation as a fall from innocence. The sublime confidence in material goals and its expression in celebratory paintings of our national experience with the sea and our ideal aspirations toward union with the universe at the end of the voyage of life which had characterized our seascape art in the pre–Civil War era seemed no longer adequate. Instead our art would reflect a more complex response, focusing less on active engagement than on observation, less on imaginative identification with the sea as subject than on the way in which it is framed, "a certain sense of proportion and relation." In the years immediately after the war the sense of the treacherousness of the future would be partially suppressed in a series of lovely escapist fantasies at the seashore, though by the time of James's writing, 1879, his remarks were just about to find visual confirmation in the dark and gloomy seascapes of the following decade.

The roots of the transformation lay in the decade just before the war, and in this sense the war was more a catalyst and symbol than an aesthetic cause. American artists in the 1850s were avidly reading the works of John Ruskin. Their attention was being refocused again from the grand style of Joshua Reynolds, with its notions of general nature, toward the precise and particular. Ruskinian "truth to nature" meant fidelity to the specific structure of rock and leaf and tree as the first if not the final way of giving allegiance to the living presence of Deity in the universe. Whatever else Ruskin may have intended, his writings sent a group of our artists to the coast, not as Byronic egotists facing

the sublime but as modest recorders, intent upon capturing with fidelity their observations of the external world. Some, like John William Hill and his son John Henry Hill, William Trost Richards, and Charles Herbert Moore, were later labeled—or mislabeled—Pre-Raphaelites for their efforts. But they all shared in this redirection of seascape space.[61]

Both the Hills, father and son, and Aaron Draper Shattuck explored the Maine coast in the 1850s, as did Frederic Church. Church's early *Beacon Off Mount Desert*, 1851 (Fig. 89), is a large-scale statement in the earlier sublime mode, sharper in its details than the *Old Age* of his teacher Cole, but handling particulars like the beacon, rocks, and ships on the horizon as realistic versions of the Colean symbolism of the little *Shipwreck Scene* of 1828 (Fig. 39). The works of the Hills and Shattuck are radically different in kind. The small Shattuck oil of *Whitehead Cliffs—Monhegan Island, Maine*, 1858 (Fig. 90), is soft and atmospheric, opening us to the experience of light on the angularities of the carefully defined rock formation, the sea view squeezed into a corner. The equally soft *Peaks Island Beach—Across Casco Bay to Portland Light* (Fig. 91) opens up the space horizontally. In scale and execution, both have a more intimate feeling of a place observed, located not in the absolute geometries of a Fitz Hugh Lane but modestly encountered, accurately seen, with attention, in the *Whitehead Cliffs*, to the specific formations of rocks that Ruskin had urged and, in the *Peaks Island Beach* as well, to the sense of atmosphere filling the space. Shattuck's contacts with John Frederick Kensett in just these years (as early as 1854 he sold a painting to Kensett) suggest affinities between the *Peaks Island Beach* and Kensett's Newport views beginning at just this time.[62]

When they went to the Maine coast in the 1850s, the Hills' efforts were even more modest in scale, but one should not confuse the two tiny watercolors by John William and John Henry Hill, both entitled *Sea Coast, Maine* (Figs. 92, 93), with the preparatory oil and watercolor sketches that artists had always done as notations, later to be worked up into large finished oils. These works are complete statements

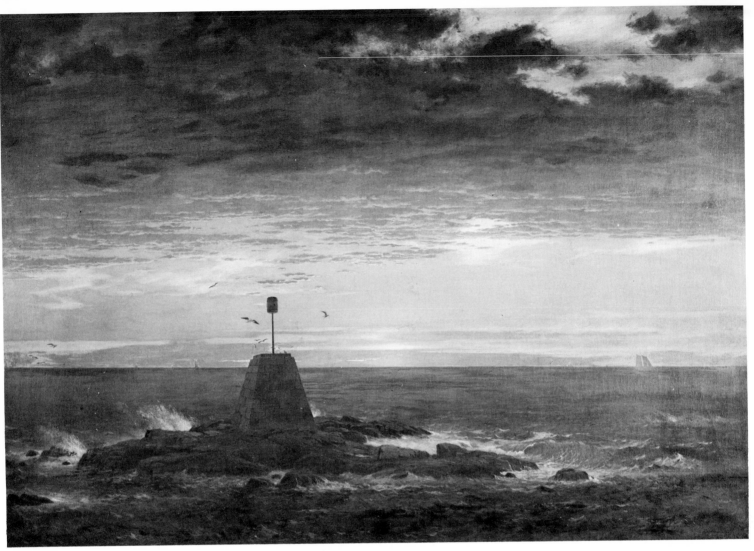

89. Frederic E. Church. *Beacon Off Mount Desert*, 1851. Oil on canvas, 31 x 46 inches. Collection of Mrs. Vanderbilt Webb.

90. Aaron Draper Shattuck. *Whitehead Cliffs—Monhegan Island, Maine*, 1858. Oil on canvas, 9 x 14 inches. Collection of Katherine S. and Eugene D. Emigh.

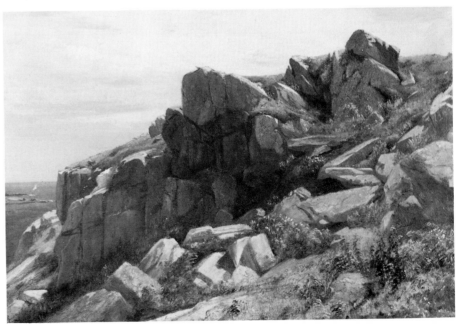

in themselves. Writing to John Henry Hill in 1879 about a proposed European itinerary, Ruskin advised him "take a small sketch book; always choose subjects with some human interest in them, abbey, castle, or village. Finish every drawing from corner to corner—don't go blotting or scrawling, and charge low prices and you will soon make an easy, honestly useful living." The Hills' reading of Ruskin in the mid-1850s had already made that advice clear, with one notable qualification: space itself was the American artist's subject, not humankind in time and history. The tiny scene of rocks, carefully observed, of grass and sea and a delicately tinted sky, finished "corner to corner" was enough. In their modesty these works, like other so-called "Pre-Raphaelite" American works of the late fifties and sixties, were an implicit condemnation of the sublime grand style of Cole and Church.[63]

Similar in character is the little *Boat on a Beach* by the young R. Swain Gifford (Fig. 94). Raised in the shadow of New Bedford whaling, trained early with the Dutch emigré Albert van Beest to do large-scale coastal scenes and whaling views, Gifford in this early work suggests again that modest moment in the early 1860s. Rather than using the little boat as a small prop in a larger sweep of beach as countless artists before him had, he makes the boat rest comfortably close to us where it becomes part of a delightfully colorful rendering of tangible atmosphere. A watercolor of the same decade, *"Fish Rock," Coast of Mendocino, California,* shows that he could, when he wished, preserve that atmospheric sense of intimacy with a larger and bolder subject. In its sense of scale, the *Fish Rock* is closer to the Hills' versions of the coast of Maine than it is to the grandiose California *Seal Rock* by Albert Bierstadt.[64]

Beyond their small-scale rendering of habitable space, these works also suggest the transformation of media that was crystallizing in the years around the Civil War. Watercolor, in the work of the Hills, is not the ancillary medium, fit only for amateur "young lady" artists and for the preliminary sketches of serious artists in oil that it had been earlier. The founding of the American Society of Painters in Water Colors in 1866 signalized a change in attitude. The works of the two Hills, the small coastal seascapes of William Trost Richards, and climactically the work of Winslow Homer, as well as John La Farge, John Singer Sargent, James A. M. Whistler, and on to John Marin and Maurice Prendergast in the twentieth century, are ample testimony to the new dignity of watercolor as a medium for American seascape paintings. We have already noted the new emphasis on graphic art, stimulated by the rise of the illustrated magazine. Currier & Ives was only one of many outlets for graphic seascapes in the post–Civil War years: the gamut ran from illustrated books, like the 1869 edition of Longfellow's *Building of the Ship,* to news illustrations like the *Harper's Weekly* series on the wreck of the *Atlantic* in 1873, to the finely executed etchings that flourished especially in the 1880s.[65]

The transformation of oil painting suggested by the soft atmospheric quality of Shattuck is one which we associate with the idea of Impressionism. What counts for us is not the specific question of the influence of French painting of the 1860s and '70s upon particular American artists then or later, but the shared international experimentation with a more atmospheric sense of the sea and coast. Artists here and abroad began to employ looser brushwork, a lighter palette, a strong sense of the surface of the canvas itself as a painted object whereon the eye of the observer received the artist's visual impression of the objects in the natural world. Cole's vigorous brushwork in the oil sketch of *Frenchman's Bay* had been an attempt to express the quality of conflict between sea and coast; his *Voyage of Life* is completed as a religious experience in the *mind* of the spectator. The outer harbor scenes of Salmon and Lane and the ship portraits of Bard and Buttersworth are attempts at impersonal statements of the quality of the objects in the natural world, the surface licked clean of the presence of the artist and the creative act of painting itself.

The new approach is demonstrated in the extreme in the case of Whistler. After a brief experience of doing meticulous renderings of coastal profiles and maps for the U.S. Coast and Geodetic Survey in the 1850s, he turned, in works like *The*

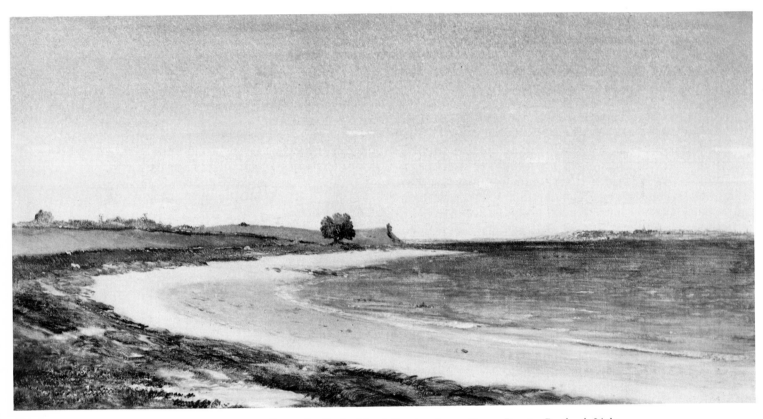

91. Aaron Draper Shattuck. *Peaks Island Beach—Across Casco Bay to Portland Light,* (1858). Oil on canvas, 9 x 18 inches. Collection of Katherine S. and Eugene D. Emigh.

Sea, about 1865 (Fig. 95), to calligraphic experimentation with seascape as almost pure pictorial design. Whistler stripped the traditional horizontal format to a bare minimum, reduced it to a few gestures in pigment that suggest waves and clouds, the two ranges united by the supple sinuous curve of the thinly painted sail which by its transparency insists upon itself as a new layer of paint binding together decoratively the upper and lower sections of the surface of the canvas.

Not all of our artists would explore the new ways with pigment. William Bradford's *Shipwreck Off Nantucket* of 1859-60 (Fig. 96) is hard and crystalline, while Robert Loftin Newman's later *Shipwreck* (Fig. 97) is soft and evanescent, the boat and passengers almost dissolving in the green pigment of the surrounding sea. Bierstadt's *Wreck of the "Ancon" in Loring Bay, Alaska*, 1889 (Fig. 98), makes the event a function of the sharp yellow wheel housings against the predominant blue tonalities of water and sky, laid in with a watercolorist's sense of delicacy and played off against the vigorous opaque brushwork of the trees and bushes to the right. Even Thomas Eakins, in a rare nautical work, would turn away from his strongly sculptured vision to picture sailboats in *On the Delaware* (Fig. 99) as subtle gradations in a monochromatically blue field. In the closing decade of the nineteenth century and the opening decade of the twentieth, the full impact of broken brush technique would be felt in the works of William Merritt Chase, Childe Hassam, John Twachtman, Robert Henri, and John Sloan. What characterizes all of this work technically is their feeling for light and atmosphere, a powerful sense that seascape space is habitable to our visual perceptions. Not an abstract human contemplating ideas near the sea, not an American celebrating his national destiny, but, in Jamesian terms, a human consciousness registering his or her perceptions of the world of the coast and the sea—therein lies the revolution in our seascape art, as in "the American mind" more generally, in the last third of the nineteenth century.

The process is encapsulated in the career of John Singer Sargent. Born in Florence in 1856 and trained in Paris, Sargent visited the United States for the first time in the mid-1870s. On his return trip to Europe he painted on board ship the *Atlantic Storm*, a powerfully dark atmospheric rendition of sublime nature with a Turnerian sense of the contrast of light and dark and a dramatic point of view. The mood and feeling of this work was uncharacteristic, looking backward to romantic seascape. At the end of the decade, his *Oyster Gatherers of Cancale* (1878) and the brilliant little sketch of *Boys on a Beach, Naples (Innocence Abroad)* (1878–79) are light-filled exercises in French broken brush technique, reassuring lyrical images of the visual stability of the European coast.[66]

If we turn from Ruskinian roots and the transformation of media to thematic materials and their organization into spatial images, we confront certain new approaches and certain continuities with pre–Civil War themes. Both theme and pictorial organization are to varying degrees reshaped in terms of that "certain sense of proportion and relation" which to James characterized the post–Civil War era. In the work of Shattuck and the Hills before the war there is already a scaling down, a limitation of seascape space to the human measure. Their modest artistic exploration of the Maine coast previsioned in the 1860s a widespread interest in pictorializing the coastal spas that flourished in the postwar years. Gloucester, Nahant, Mt. Desert and Monhegan Islands and Appledore on the Isle of Shoals, Atlantic City, Rockaway Beach, and, above all, Newport attracted American painters, as did the European coastal spas visited by Americans—Etretat, Trouville, Cancale, and elsewhere on the French coast or the Isle of Capri off the Neapolitan coast. These mostly sun-filled works, sometimes peopled with elegant bathers and strollers, offer a stunning contrast to the stark and lonely seascapes of the pre–Civil War era. They stand as emblems of a holidaying people, scenes of a nation that had just gone through the grimmest ordeal of her history, and they serve as a gentle soporific after the nightmare realities of a Timothy O'Sullivan *Harvest of Death* daguerreotype of the battlefield after Gettysburg. They are also an escape from the consequences of the war and the

92. John Henry Hill. *Sea Coast, Maine*, c. 1857. Watercolor on paper, 2½ x 4½ inches. Private collection.

93. John William Hill. *Sea Coast, Maine*, c. 1857. Watercolor on paper, 2 9/16 x 4 inches. Collection of Barbara Novak.

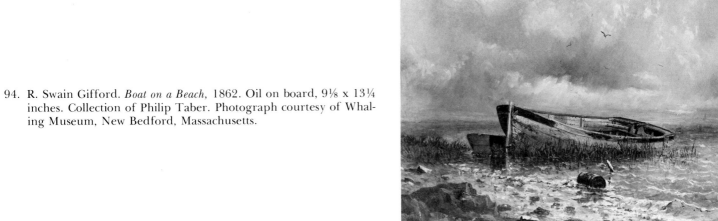

94. R. Swain Gifford. *Boat on a Beach*, 1862. Oil on board, 9⅛ x 13¼ inches. Collection of Philip Taber. Photograph courtesy of Whaling Museum, New Bedford, Massachusetts.

95. James Abbott McNeill Whistler. *The Sea*, c. 1865. Oil on canvas, 20¾ x 37¾ inches. Montclair Art Museum, New Jersey.

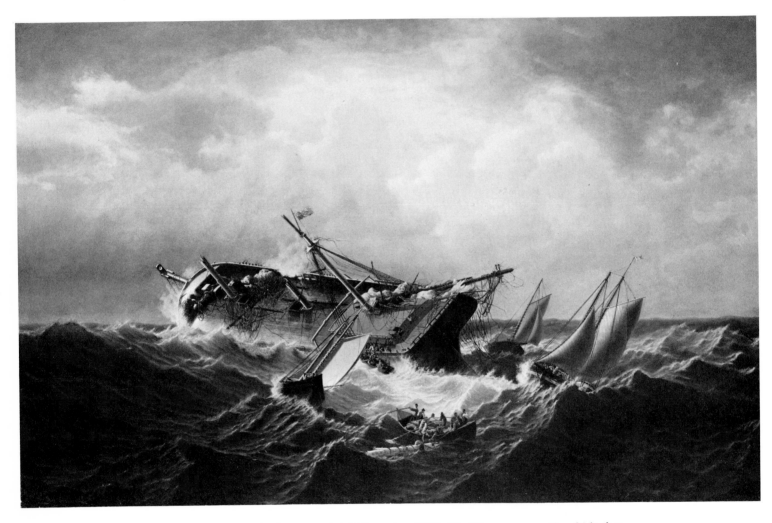

96. William Bradford. *Shipwreck Off Nantucket,* 1859–60. Oil on canvas, 40 x 64 inches. The Metropolitan Museum of Art, New York; Purchase, John Osgood and Elizabeth Amis Cameron Blanchard Memorial Fund, Fosburgh Fund Inc. Gift, and Maria DeWitt Jesup Fund, 1971.

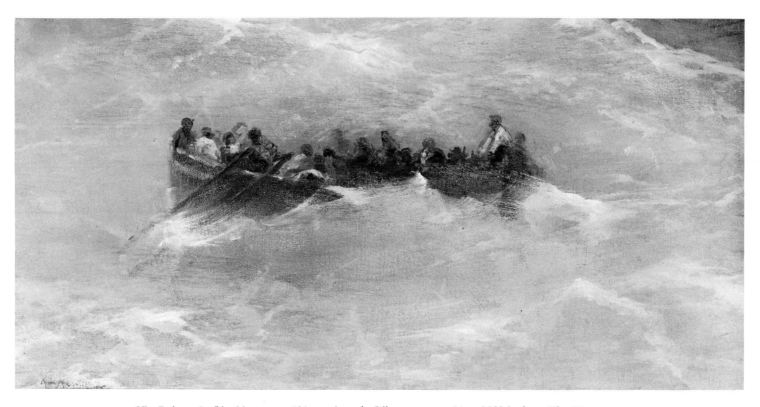

97. Robert Loftin Newman. *Shipwreck*, n.d. Oil on canvas, 11 x 23½ inches. The New Britain Museum of American Art, New Britain, Connecticut; Harriet Russell Stanley Fund.

transformation of the United States more generally during this era into an urbanized, industrialized nation. The stench of poverty and dirt of the city is left behind in the cleanliness of these coasts for the wealthy inhabitants of these seascapes who can afford, like Silas Lapham's family in William Dean Howells's novel of 1884, to place themselves at least temporarily beyond the reach of the poor and the working class. The extraordinary Newport mansions that were built in this era are only the most famous and most extreme case of the holidaying mood that expressed itself as well in a variety of American seascape paintings from the 1860s on.

Young Albert Blakelock's *Rockaway Beach, Long Island, New York*, 1869–70 (Fig. 100), catches the mood beautifully. Built upon the same structural pattern as the 1850s *Meditation by the Sea* (Fig. 37), the space is articulated by the buildings, flags, and people gaily splattered along the perspective vista, in a rich impasto technique that adds brilliance of color on which the eye can feast itself as it travels along these playfully interrupted structural lines. Born in 1847, Blakelock was very much of the postwar generation. Sanford Gifford, twenty-four years his senior, belonged like Kensett (1816–72) to the older generation in training and point of

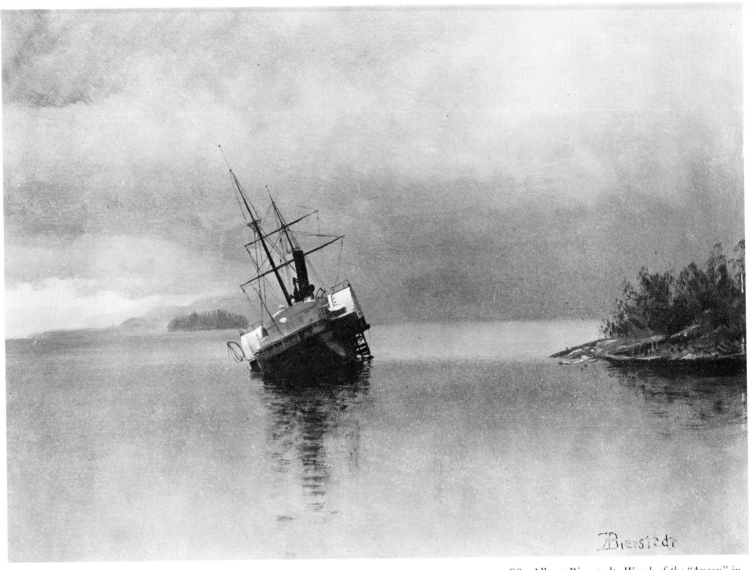

98. Albert Bierstadt. *Wreck of the "Ancon" in Loring Bay, Alaska,* (1889). Oil on paper mounted on panel, 14 x 19¾ inches. Museum of Fine Arts, Boston; M. and M. Karolik Collection.

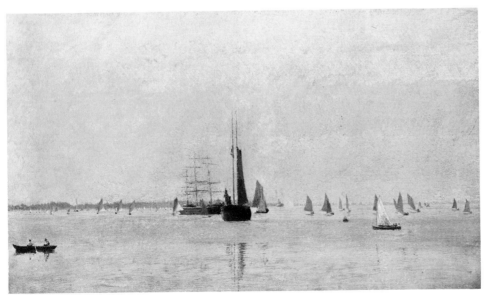

99. Thomas Eakins. *On the Delaware,* 1874. Oil on canvas, 10 x 17 inches. Wadsworth Atheneum, Hartford, Connecticut; Gift of Henry Schnakenberg.

100. Ralph Albert Blakelock. *Rockaway Beach, Long Island, New York*, 1869–70. Oil on panel, 11¾ x 20 inches. Museum of Fine Arts, Boston; M. and M. Karolik Collection.

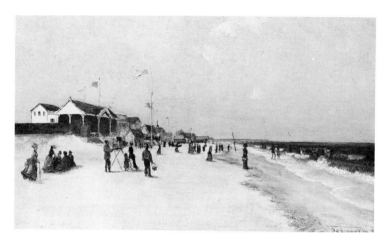

101. John F. Kensett. *Coast Scene with Figures*, 1869. Oil on canvas, 30 1/16 x 60¼ inches. Wadsworth Atheneum, Hartford, Connecticut; Ella Gallup Sumner and Mary Catlin Sumner Collection.

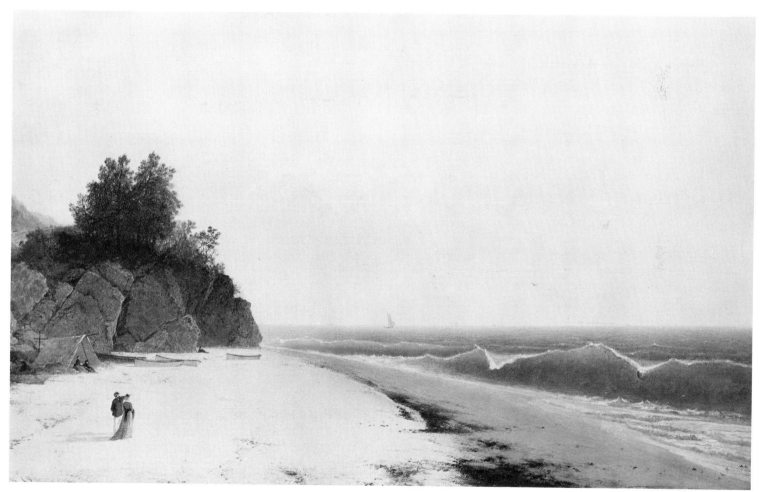

view. Both adopted older approaches to the coastal scenes they painted in the 1860s. Kensett focused on Newport in these years. In the 1869 *Coast Scene with Figures* (Fig. 101) the sense of vastness implicit in its open format is modified to the left by the emphasis on the structure of the rocky cliffs which protectively close us in and provide an architectural surround for the group of lounging tourists. Though small, these figures are in grouping, stance, and attitude a far cry from the lone little man in the 1850s *Meditation by the Sea*.[67] Kensett's finest works in the mode, like the *Marine Off Big Rock*, 1864 (Pl. VI), are bold luminist simplifications. The almost surreal clarity of the atmosphere, the sharp focus on the texture of the rocks, the powerful recessive plane of the water, and the sure handling of color, moving from darker to lighter hues as we approach the horizon, give us an abstract feeling of absolute and unthreatening location in the space of the canvas.

In two little light-filled scenes of the New Jersey coast of the mid-1860s, Sanford Gifford explored the open horizontal format with a softer brushstroke. *Sandy Hook*, 1865 (Fig. 102), places a jauntily dressed young tourist couple looking out at the sketchily painted parade of sailboats on the horizon. In his view of *Long Branch Beach*, 1867 (Fig. 103), he works against the openness of the perspective by playfully locating the beach houses to the right and the grouping of figures squarely in the middle of the vista. Because of this grouping we have access to the sea, through the beached boat, protection against the intensity of the sunlight, through the delightful curve of the tent, and a way both to the water and to the bluffs, through the little figures farther back. Like the simple sweep that organizes and catches up natural space and the signs of human activity, neatly balanced at the left and right edges of the paper in the foreground, gently cradling us, in William Trost Richards's little watercolor *Atlantic City—Beach Dunes and Grass* of the same years (Fig. 104), Gifford's modest seascapes combine the elements of the older format with the new feeling of intimacy and charm, a sense that the horizontal conventions of the seascape tradition do not necessarily make the sea alien to humans. On the contrary, the space is made visually available for the amused observation of the postwar vacationer.

Among the younger artists for whom the Civil War marked a passage into maturity as persons and as painters, Winslow Homer is the key figure. He had illustrated *The Bathe at Newport* for *Harper's Weekly* as early as 1858. In 1869 came his first seascape oil, the brilliantly light-filled *Long Branch, New Jersey* (Fig. 105) which reduces the sea to a minor note and focuses our attention as observers on the bluffs, the wooden structures leading down to the beach, and above all on those two women, themselves clearly decorative objects and observers of the scene. Homer's graphic versions of Long Branch scenes underline the point. Fashionable men and women control and structurally organize seascape space. His Gloucester watercolors of 1873 reinforce our sense of the visually habitable world (innocents at home as well as abroad). The 1873 *Boys Wading* (Fig. 106) or those other innocents jauntily perched on the deck in *Sailing the Catboat* (Fig. 107), like a host of others, give order and form to the carefree activity of this leisurely nautical world. Unlike Robert Weir's *Seascape with Lighthouse* (Fig. 40), where ships and lighthouse stand against the sublime turbulence of the sea, in *Sailing the Catboat* we are invited to identify with the activity in the nearby boat. The powerful V-shape of sail and leaning boy on the hull gives the boat stability; the lighthouse merely balances decoratively the right edge of the paper.[68]

And yet there is another, less optimistic note that appears in Homer's coastal scenes in the 1870s. A pair of graphics of *Low Tide* and *High Tide* for *Every Saturday* offers a contrast between a beach which children control, spatially as well as thematically, and a starker vision of three women turned away from one another on a lonely stretch of beach. The action of the sea had begun to have richer meaning for Homer. It could isolate humankind—and especially women—as well as bring children out to play. In a small oil done at the same time, *On the Beach* (Fig. 108), one group of children who were to reappear in the crowded scene of the *Low Tide* graphic are found at the

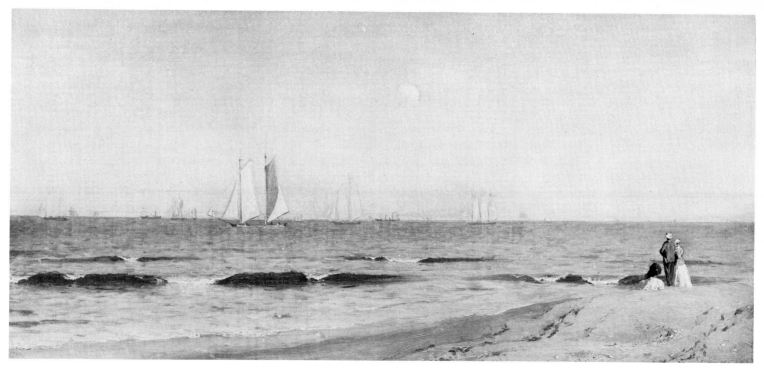

102. Sanford Robinson Gifford. *Sandy Hook*, 1865. Oil on canvas, 8⅞ x 19½ inches. Whitney Museum of American Art, New York; Gift of Dr. Allan Roos and Mrs. B. Mathieu Roos.

103. Sanford Robinson Gifford. *Long Branch Beach*, 1867. Oil on canvas, 9 x 19½ inches. Whitney Museum of American Art, New York; Gift of Dr. Allan Roos and Mrs. B. Mathieu Roos.

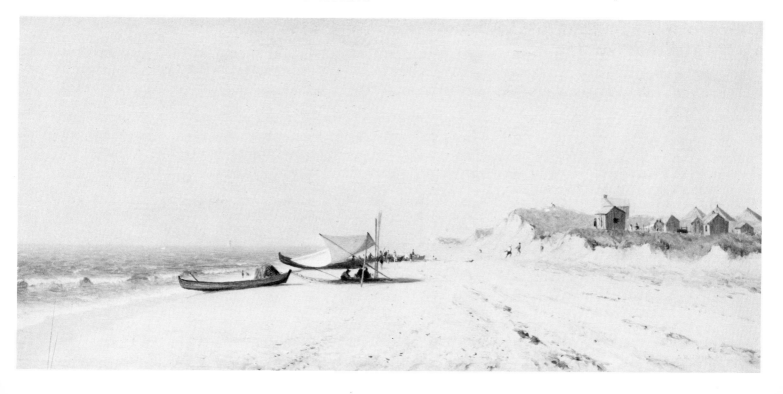

left-hand edge of the canvas; the powerful roll of the waves dominates and gives the work, for all its richness of paint, a certain austerity and a feeling that the humans are somehow intruders upon the natural process and seascape space. The starkness of the horizon works against the interpenetration of beach and shore edge created by the reflections on the sand and the figures. The quality of the paint surface makes the sand luminous and fluid, the waves solid, and the sky something between opaque and luminous—thus further complicating our perceptions. Modest in scale, this little work looks ahead to Homer's great achievements in seascape in the 1880s and beyond.

Another coastal scene of the 1870s, the 1872 *On the Beach—Two Are Company, Three Are None* (Fig. 109) published in *Harper's Weekly*, amplifies our sense of the direction of Homer's seascape art. Superficially it seems a coy anecdotal work, but Homer's developing pictorial language makes it

104. William Trost Richards. *Atlantic City—Beach Dunes and Grass*, c. 1870. Watercolor on paper, 7¾ x 12½ inches (sight). Whitney Museum of American Art, New York; Gift of Mr. and Mrs. Ralph Spencer.

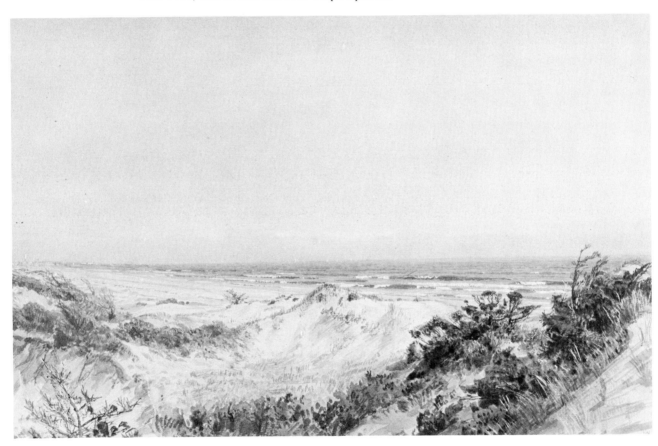

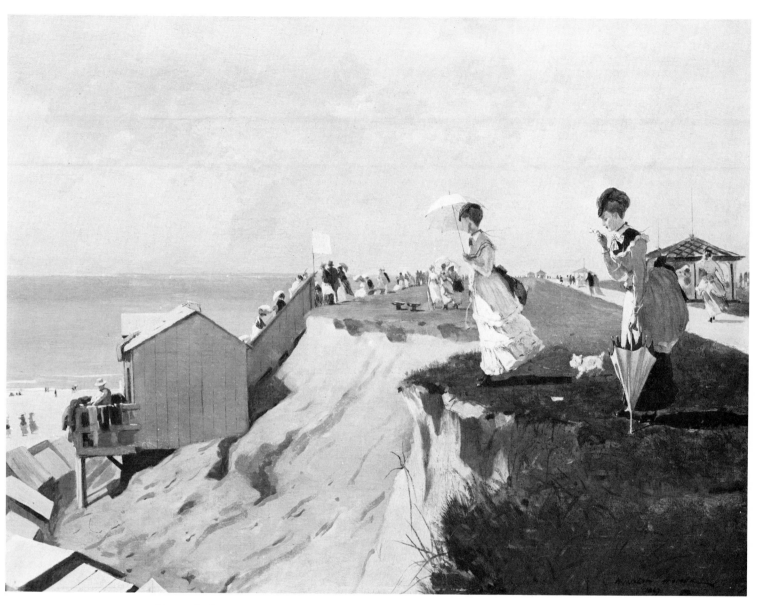

105. Winslow Homer. *Long Branch, New Jersey*, 1869. Oil on canvas, 16 x 21¾ inches. Museum of Fine Arts, Boston; Charles Henry Hayden Fund.

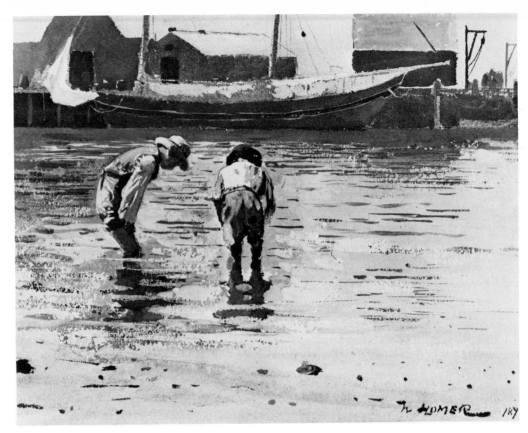

106. Winslow Homer. *Boys Wading,*
1873. Watercolor on paper, 9½
x 13⅛ inches. Colby College
Art Museum, Waterville, Maine;
The Harold T. Pulsifer Memo-
rial Collection.

107. Winslow Homer. *Sailing the Cat-
boat,* c. 1873. Watercolor on
paper, 7½ x 13¾ inches. Col-
lection of Mr. and Mrs. Arturo
Peralta-Ramos. Photograph
courtesy of Wildenstein and Co.
Inc., New York.

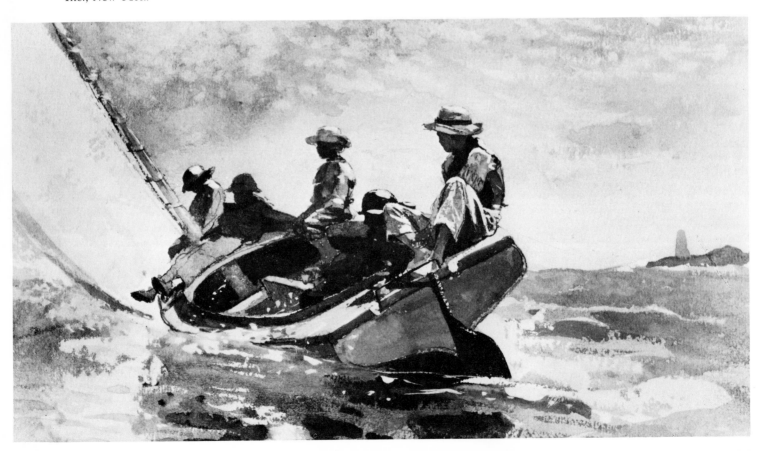

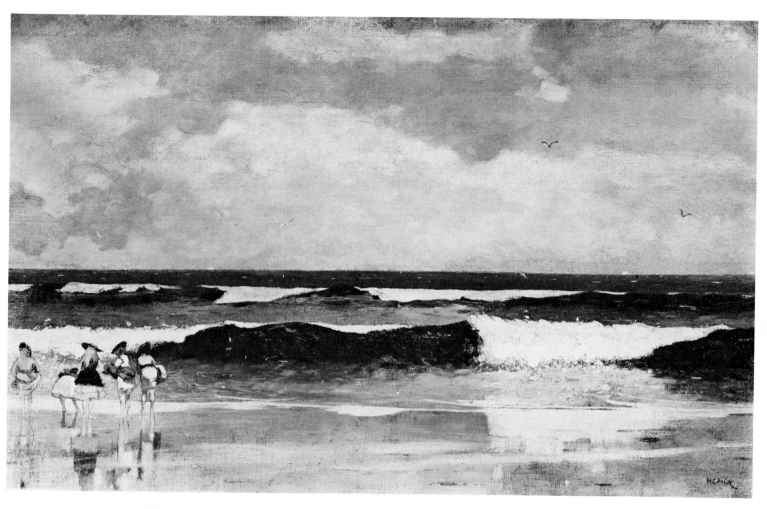

108. Winslow Homer. *On the Beach*, c. 1870. Oil on canvas, 16 x 25 inches. Canajoharie
Library and Art Gallery, Canajoharie, New York.

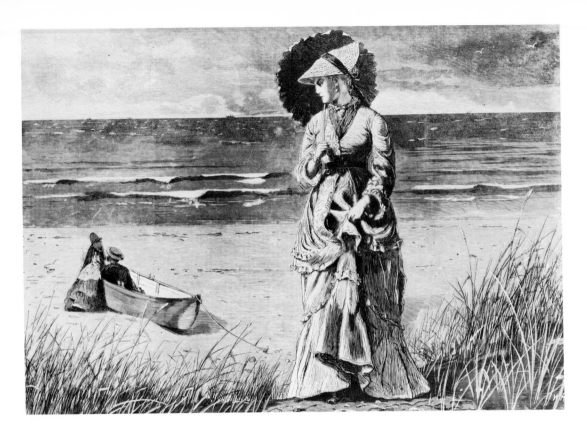

109. Winslow Homer. *On the Beach—Two Are Company, Three Are None.* Wood engraving in *Harper's Weekly,* August 17, 1872; 9⅛ x 13¾ inches. Whitney Museum of American Art, New York.

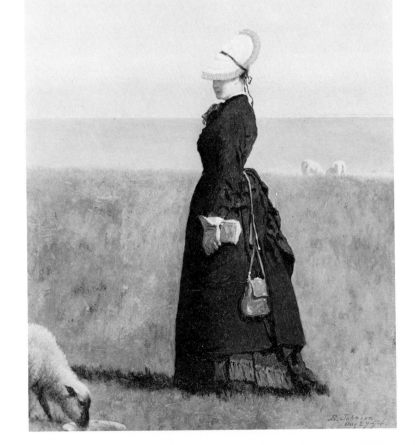

110. Eastman Johnson. *Lambs, Nantucket,* 1874. Oil on board, 19⅛ x 13¾ inches. Private collection. Photograph courtesy of Hirschl and Adler Galleries, New York.

102

somehow premonitory. The comfortable land-locked lovers gaze out as observers on the horizontal band of the sea, with its tiny ships on the horizon, but it is the isolated figure of the woman who binds land and sea together. Dressed as decoratively as any of the women in the *Long Branch* works, her massive organizing power turns her from a decorative object or a sentimental rejected maiden into a principle of human strength against both the idle lovers and the starkness of the sea. The importance of her verticality in the face of the horizontal sea can be quickly grasped by comparing this work to Eastman Johnson's *Lambs, Nantucket* of

1874 (Fig. 110), which sacrifices the sea as a countervailing independent force to the more conventional pastoral image of the pretty maiden. The more somber note of the Homer graphic thus further strengthens our sense of Homer's growing recognition of the sea as power and juxtaposes to this the strength of the independent woman, a strength which he would ultimately find symbolized in the massive fishwives of Tynemouth.

Both Homer's 1870 *On the Beach* oil and the 1872 wood engraving also emphasize the continuity of pictorial language with the horizontally organized more open seascapes of the pre–Civil War era,

111. George Loring Brown. *View of Norwalk Islands, Norwalk, Connecticut*, 1864. Oil on canvas, 21½ x 43 inches. Addison Gallery of American Art, Phillips Academy, Andover, Massachusetts.

112. William S. Haseltine. *Rocks at Nahant*, 1863. Oil on canvas, 21¾ x 39¾ inches. Collection of Henry Melville Fuller.

from Doughty's Nahant *Beach Scene with Rocks* on. Some works of the 1860s and later, like George Loring Brown's *View of Norwalk Islands, Norwalk, Connecticut*, 1864 (Fig. 111), are comfortable though more atmospheric extensions of the earlier tradition of the panoramic vista, though here with ample resting places for the eye along both the foreground *repoussoir* and the sweep of the horizon. Some, like William Haseltine's *Rocks at Nahant*, 1863 (Fig. 112), continue the coast and rocks formula, though by sharply clarifying the structure of these rocks they become interestingly habitable places on which to scramble, not the formidable barriers to a sublime sea. James Suydam's *Paradise Rocks, Newport*, 1865 (Fig. 113), and Worthington Whittredge's *A Breezy Day* and *Third Beach, Newport, R.I.* (Figs. 114, 115) show us how the horizontal

format of seascape can be made humanly comfortable by containing and controlling the amount of sea which we experience, by making us traverse as observers large stretches of land which thus tame the starkly simple effect of the horizontal organization. A. T. Bricher's lovely crisp *Time and Tide* (Fig. 116) controls the open space by moving us out in careful gradations toward the horizon, which in turn is roofed over by the cumulus grouping above. The space is indeed large, yet somehow not threatening. If, as Jeffrey Brown puts it, *Time and Tide* deals "with the vastness and power at the perimeter of human comprehension associated with the 'Sublime,' "[69] the observer still operates from the relative comfort of the crystalline shore which laps only gently at our feet.

The same cannot be said of Frederic Church's

113. James Suydam. *Paradise Rocks, Newport*, (1865). Oil on canvas, 25⅛ x 45⅛ inches. National Academy of Design, New York.

114. Worthington Whittredge. *A Breezy Day—Sakonnet Point, Rhode Island*, c. 1880.
Oil on canvas, 25⅜ x 38½ inches. Amon Carter Museum of Western Art,
Fort Worth, Texas.

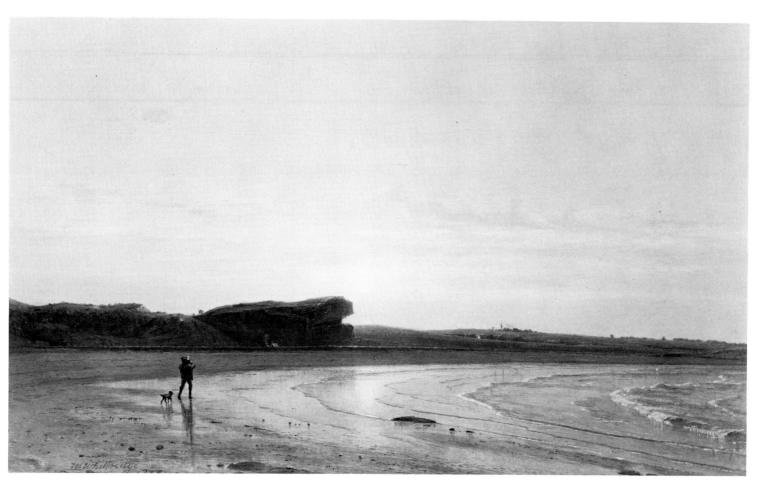

115. Worthington Whittredge. *Third Beach, Newport, R.I.*, 1865. Oil on canvas, 18 x 30 inches. Private collection. Photograph courtesy of Kennedy Galleries, Inc., New York.

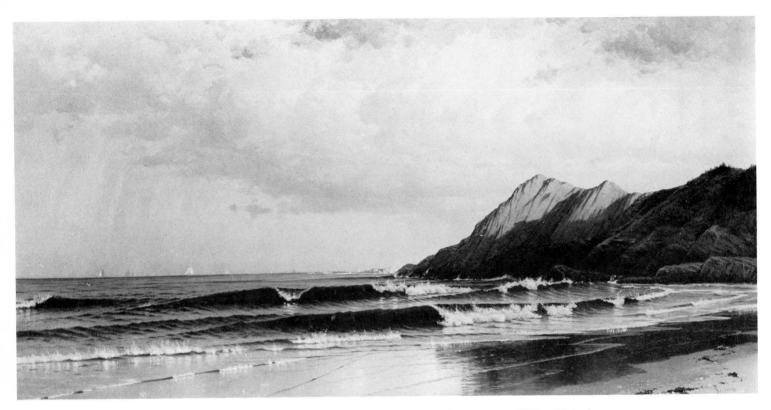

116. Alfred T. Bricher. *Time and Tide*, c. 1873. Oil on canvas, 25½ x 50 inches. Collection of Mr. and Mrs. Robert C. Vose, Jr.

sublime *Sunrise Off the Maine Coast* of 1863 (Fig. 117); for the waves crash about us, we have no real foothold on the foreground rocks, the brilliance of the light is almost supernatural as it picks out the powerful silhouettes of rock shelf. *Sunrise Off the Maine Coast* is, in form and content, a sublime inversion of Homer's *Long Branch*: a threatening image of the power of the sea as daylight attempts to break through. We apprehend it not from the comfort of a brilliantly lit cliff but look at the gloomy land from the point of view of the sea itself. Church reminds us thus of the continuity of the sublime seascape into the post–Civil War era.

7.
Tragedy and Apocalypse

The idea of the awesome power of the sea comes to the fore again in the postwar era—though indeed, it had never been completely lost—in a range of expressive pictorial forms. Some artists would treat the sublime as a geographical extension into space. William Coulter in his immense *The "Hartford"—Admiral Farragut's Flagship Entering the Golden Gate* (Fig. 118) extends American seascape to the Pacific coast. Yet in many ways this work feels like an act of nostalgia, rather than the strident note of

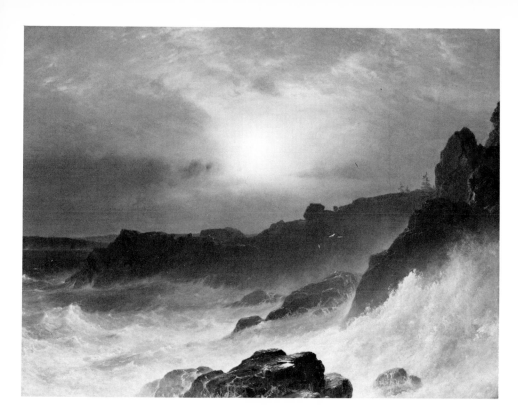

117. Frederic E. Church. *Sunrise Off the Maine Coast*, 1863. Oil on canvas, 36 x 48⅛ inches. Wadsworth Atheneum, Hartford, Connecticut; Bequest of Clara Hinton Gould.

118. William Coulter. *The "Hartford"— Admiral Farragut's Flagship Entering the Golden Gate*, 1887. Oil on canvas, 55 x 88 inches. Hirschl and Adler Galleries, New York.

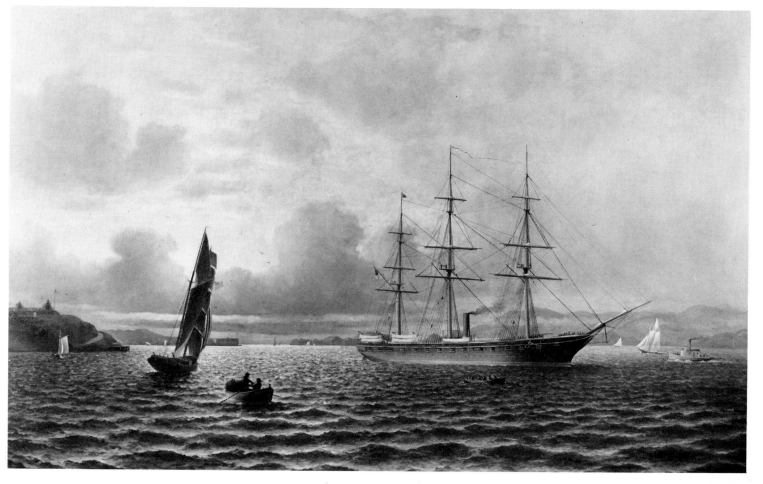

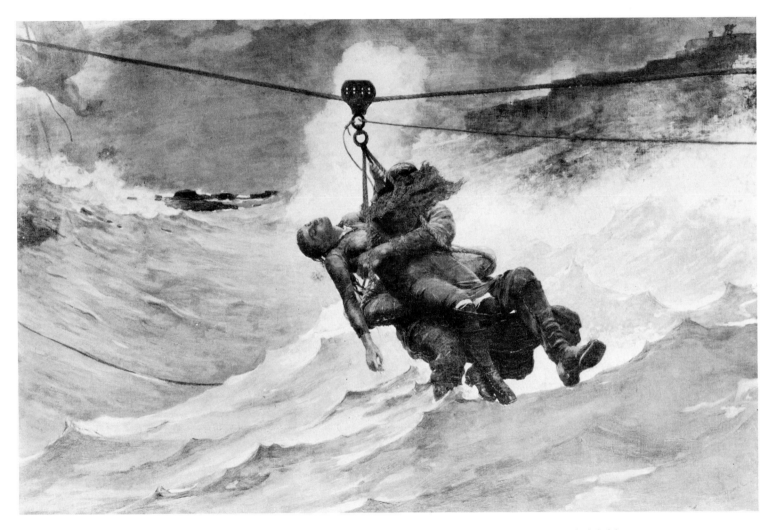

119. Winslow Homer. *The Life Line,* 1884. Oil on canvas, 28¾ x 45 inches. Philadelphia Museum of Art; George W. Elkins Collection.

American conquest of new space which had characterized pre–Civil War American nationalism. If it realizes the old American dream of the passage to India,[70] still it is a sunset vision. In the meticulousness of its portrayal of the ship it suggests that ship portraiture was being carried on in the era of steam by artists like Antonio Jacobsen, student and inheritor of the tradition of Bard. In the ways in which the ship is locked within the harbor space it suggests the Salmon-Lane harbor view tradition: the tiny boats move from both our foreground space and the right edge toward the commanding form of that late nineteenth-century Argonaut, and the whole pattern is set upon the receding plane of the water itself which leads in the farthest reaches into the open sea. Yet the broken brush technique which gives vitality to the surface of the water is late nineteenth century, and the sunset view, for all its loveliness of hue and tone, suggests inevitably a dying, the end of something: a vision? a dream? a world? The painting finally lacks controlling energy; the stasis of the ship at rest is in conflict with the vitality of the waves—a discordant note somehow, which suggests, however unintentionally, the loss of the older coherent optimistic vision.

What is nostalgia in Coulter becomes a tragic consciousness in the hands of other artists of the era, for despite the successful attempts of some of our artists to make seascape space humanly available, others returned to the sense of men and women's inevitable precarious position before the vastness of the sea. The shipwreck scenes of Bradford, Bierstadt, and Newman offer in their several ways traditional symbols of the overwhelming power of the sea. Winslow Homer reduces this sublime vision to a series of stunningly simple images in his works of the 1880s, translating an old theme into a new pictorial language. *The Life Line*, 1884 (Fig. 119), reduces ship and shore to minor notes at the upper corners of the canvas, economical images of the gap which the breeches buoy has bridged; yet this is intellectual knowledge, not felt experience for the viewer. The rope seems visually to be arbitrarily stretched across the top of the canvas to create pictorial order; the pulley is out-

lined by the wave which is (intellectually understood) the force against which it is working; and our attention is sharply focused on the human drama in the center of the canvas.

Homer's pictorial gestures, here as elsewhere in his works of this decade, are fundamentally ironic. His careful ordering of pictorial space becomes an act of human will in the face of natural chaos. That space which in fact threatens our couple with extinction becomes pictorially a source of illumination and enclosure. The active male is half-hidden, depersonalized by the red scarf that blinds him, at least to our view; the passive female is sensuously attractive and visually fully available, the powerfully sculptured forms of her body enclosed by the man in a parody of sexual possession. As in *Fog Warning* (1885), which renders the threat of obliteration by nature ironically by locking the dory carefully into pictorial space, or in *Undertow* (1886), which depicts the hidden dangers of the pull of the sea through a grotesque parody of pedimental sculpture, Homer in *The Life Line* transforms the sublime seascape by contrasting our intellectual knowledge of the overwhelming danger and threat of the sea (the sublime as idea) to our *experience* of visual certainty.

Homer's ironic pictorial mode thus establishes and controls a dissonant relation between theme and form. Clarity of form and structure, rather than confirming our sense of the habitability of our seascape universe, only serves to underline the abyss between the human will to form and order and the universal chaos of the sea. As Stephen Crane, a literary seascape artist close to Homer in his approach in "The Open Boat," put it in a little untitled poem of 1899:

> A man said to the universe:
> "Sir, I exist!"
> "However," replied the universe,
> "The fact has not created in me
> A sense of obligation."

This chilling sense of the vast indifference of the universe to the human condition prompted both

Homer and Crane into gestures of aesthetic assertiveness, to use form as a defensive ironic strategy. The aesthetic structure, the formal ordering of images on the canvas, gives what life and God and the universe withhold from man and woman.

Homer's seascapes of the middle eighties are thus humanly focused. His last works in the mode, and especially the great Prout's Neck series including *Cannon Rock*, 1895 (frontispiece), evidence a progressive withdrawal from the human drama before the sheer weight of natural forces. Human beings rarely intervene in the struggle between rock and wave, as if the artist had finally conceded human impotence. *The Gulf Stream*, 1899 (Fig. 120), is an exception in that it returns to a narrative context, but it is not Homer at his best, despite the painting's continuing popular appeal. Poorly painted, harsh in color, melodramatically overstated and terribly derivative in both its symbolism and its structure, *Gulf Stream* is a curious pessimistic melange of *Watson and the Shark* (Pl. I) and the *Rising of a Thunderstorm at Sea* (Fig. 24). The sharks, the dismasted boat, the lonely and exhausted black man, the bloody water, the distant spout to the right and ship to the left (so mechanically balanced) shout at us in the older romantic rhetoric about how much humans are at the mercy of the sublime. What Homer had learned in his finest work, including the moving little related watercolor, *After the Tornado*, of the same year, was to translate his sense of the sublime into radically simple, even stark, tragic pictorial statements of the brute power and force of the sea.

Bierstadt in his several versions of the California seascape, *Seal Rock* (Fig. 121), also learned to condense his material: the charming forms of the seals, the powerful sculpture of the rocks, and the single wave which begins as iridescence and ends in a theatrical splash that throws the rock into relief. William Bradford could create meticulously detailed scenes of marine disaster like the *Shipwreck Off Nantucket*, 1859–60 (Fig. 96). Later in his career he brought back from his Arctic experiences not only numerous paintings of coast and rocks and seals and ships, carefully plotted in the manner of earlier harbor views, but also, like Church (Fig. 122), some bold and vibrant images of icebergs (Fig. 123), simple but powerful statements, beyond the human scale, of the sublimity of nature. William Trost Richards, after his early experience with intimate-scale coastal scenes like the *Atlantic City—Beach Dunes and Grass*, turned in his later years to massively meticulous renderings of waves and coastal rocks. He never lost his Ruskinian sense of the importance of the structure of natural objects, and these become images of natural order and permanence against which to measure the change and flux of sea and light. Some of these scenes are American, others of the coast of Cornwall or *Sleive League, Donegal, Ireland*, 1893 (Pl. VII). What mattered to Richards, clearly, was not the mapping of a geographical location but the opportunity it offered for the interplay of the forces of nature. They are the pure poetry of the visual, deceptively simple in appearance because they are realistically rendered, but involving complex juxtapositions of hard and soft, concave and convex, form and echo forms, now rendered sharp and harshly clear in the foreground, now dissolving into softer sweeps through distance, scale, and the hazy atmosphere.

Obscurity and indefiniteness had always been characteristics of the aesthetic theory of the sublime; clarity and definitiveness betokened a mappable universe. To the romantic mind the night world had a special value, as the time of dreams, of imaginative play beyond the reach of the literal and the constrictions of a burdensome factuality. In the Colean paradigm, life is a voyage from obscurity into the full sunlight of youth through the painful darkness of manhood—the dark night of the soul, as it were—toward a spiritual rebirth in an obscure physical universe as man is drawn toward the pure light (Figs. 44, 45, 46, 47). In terms of the cycle of culture in *The Course of Empire*, however, evening was the nostalgic darkness of *Desolation* after the full sunlight of the *Consummation*. To Elihu Vedder the dark and stormy sky over a barren coast held the force of *Memory*, 1870 (Fig. 124).[71]

Given this inheritance of symbolic language, the

112

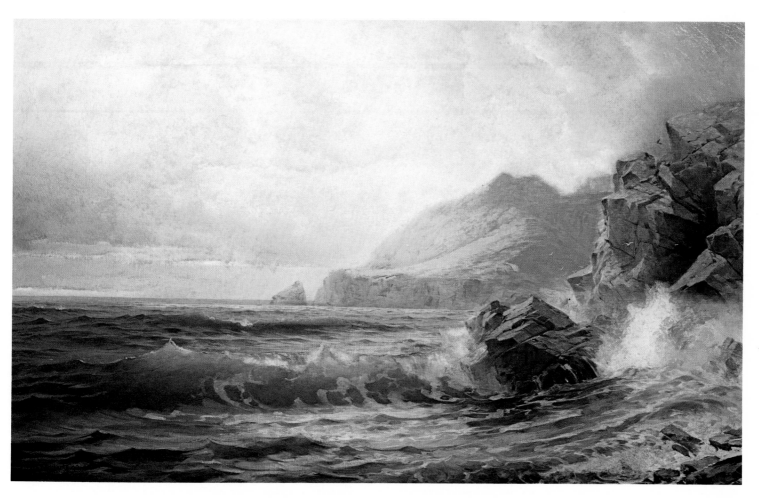

Plate VII. William Trost Richards. *Sleive League, Donegal, Ireland,* 1893. Oil on canvas, 19¾ x 32¼ inches. Whitney Museum of American Art, New York; Gift of the Historic Art Associates.

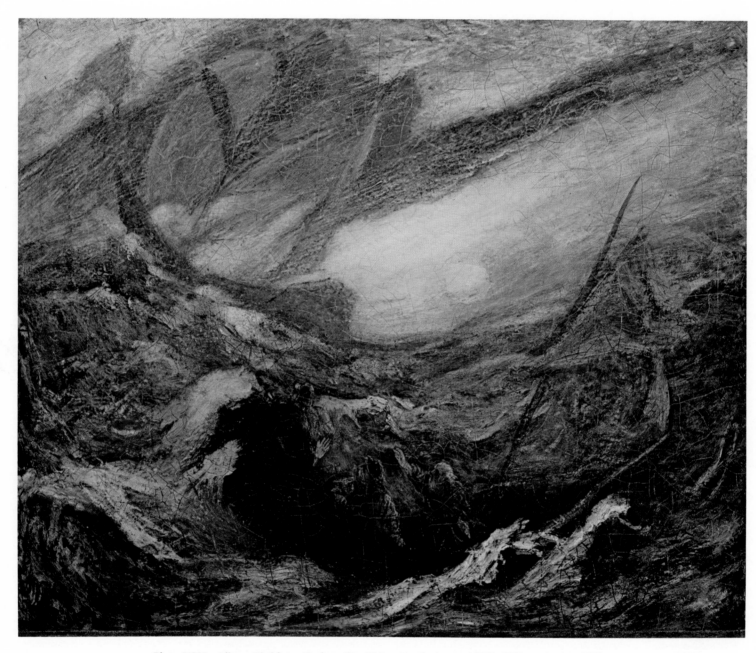

Plate VIII. Albert Pinkham Ryder. *The Flying Dutchman,* c. 1887. Oil on canvas, 13⅝ x 16¾ inches. National Collection of Fine Arts, Smithsonian Institution, Washington, D.C.; Gift of John Gellatly.

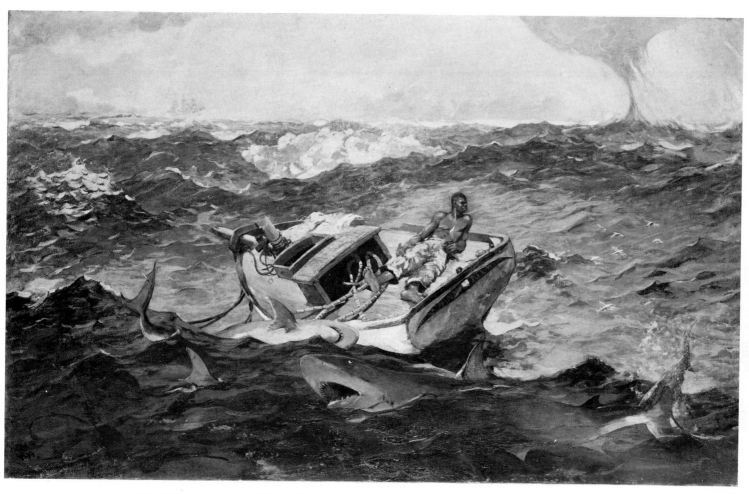

120. Winslow Homer. *The Gulf Stream,* 1899. Oil on canvas, 28⅛ x 49⅛ inches. The Metropolitan Museum of Art, New York; Purchase, Wolfe Fund, 1906.

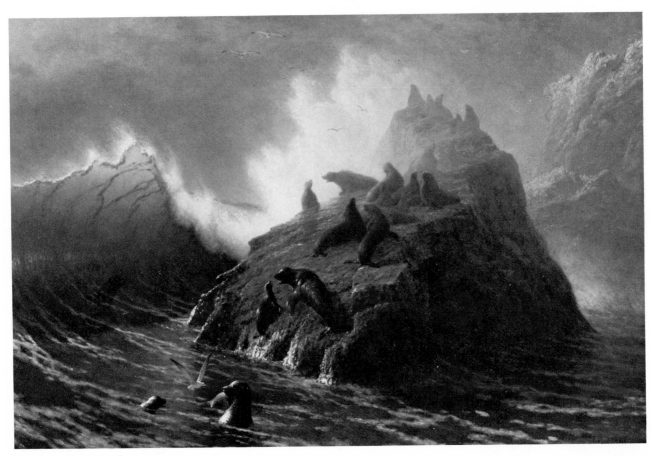

121. Albert Bierstadt. *Seal Rock,*
n.d. Oil on canvas, 30 x 45
inches. The New Britain
Museum of American Art,
New Britain, Connecticut.

122. Frederic E. Church. *The Icebergs*
(The North), 1861. Chromo-
lithograph, published by C.
Risdon in 1863, 21 x 35⅜
inches. Olana Historic Site,
New York State Division for
Historic Preservation, Depart-
ment of Parks and Recreation.

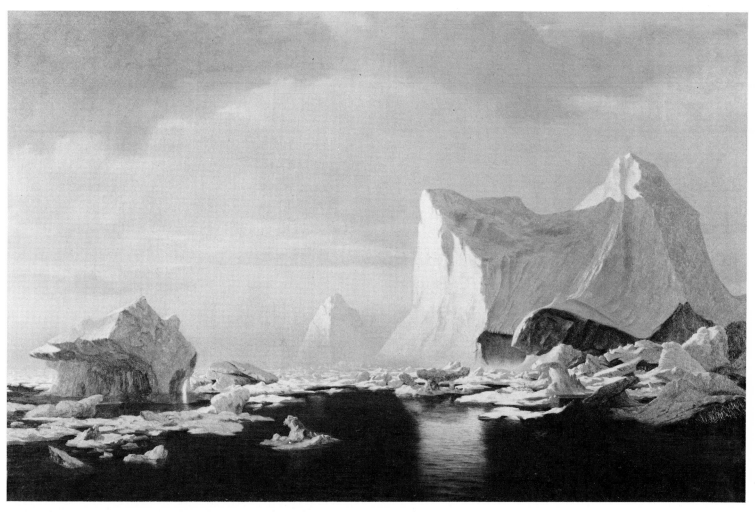

123. William Bradford. *Icebergs in the Arctic*, 1882. Oil on canvas, 28 x 48 inches. Private collection.

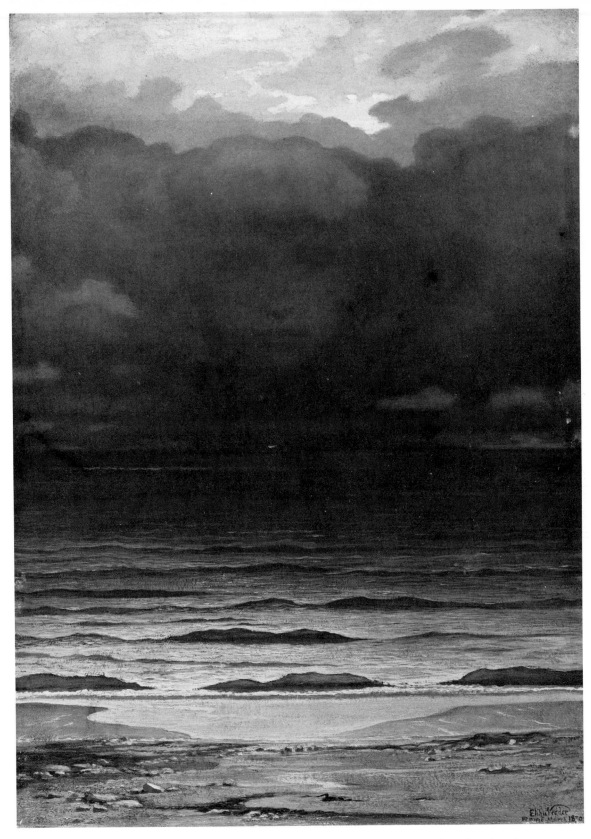

124. Elihu Vedder. *Memory*, 1870. Oil on mahogany panel, 21 x 16 inches. Los Angeles
County Museum of Art; Mr. and Mrs. William Preston Harrison Collection.

seascapes of the last decades of the nineteenth century come into focus as highly problematic. Coulter's sunset scene of the Golden Gate seems less an optimistic celebration than a Claudian nostalgic recollection of fading beauty. Homer, of course, does not draw explicitly upon the earlier religious symbology, yet one feels, in his work of the 1880s and after, the darkness either present or to come as threat to men and women. There often seems to exist in his work the imminent fear of annihilation in the sea which men confront with bells and sextants in an attempt to at least demarcate what they cannot stave off. But the darkness comes in the pure sunset seascapes of George Inness and Blakelock and Thomas Moran, late-nineteenth-century versions of Cole's *Old Age* —without the religious resolution of the allegory in an angel-studded heaven. Moran gives us a blazing vision of sunset on the waves in his *Seascape*, 1906 (Fig. 125), a late token of his long-standing indebtedness to Turner. Inness, in *Sunset Over the Sea*, 1887 (Fig. 126), dissolves the forms in a play of pigment, the few lone gulls merely accentuating the emptiness of forms and the fullness of light. Blakelock, in *The Sun, Serene, Sinks into the Slumberous Sea* (Fig. 127), builds up the surface of the canvas with paint so that the sky glows with color, yet unlike Inness, he preserves the horizon more or less intact.

The master of the nocturnal seascape of these years was Albert Pinkham Ryder. Like Cole, he occupies a special place in the history of American art, though his life and work have been the subject of too much vague mythologizing. From the perspective of American seascape painting, Ryder is neither the lonely Melvillian mystical "isolato" nor an abstract expressionist who uses embarrassingly literary titles for many of his works. On the contrary, he was the explorer of various approaches to seascape which the American imagination offered during the nineteenth century: the coastal scene, the ship at sea, and the symbolic seascape. The early *Gay Head* begins at least with a specific location, the *Smuggler's Cove* and the shore scenes suggest romantic narratives, and, perhaps finest of all within the coastal grouping, the *Moonlit Cove* (Fig.

128) reduces to a few essentials—the rocky cliff, the beached boat, and the sea and sky—a genre which had been practiced by a multitude of artists including Doughty, Lane, Heade, and Bricher. But where earlier artists used the stranded boat as a prop to break the line of beach, Ryder makes it fully an image of enclosure, containment, echoing the larger enclosure of the cove, and both offering protection from the open sea which is confined to one corner of the canvas. The moonlight ties together sky, sea, and boat, and adds depth to the image of the boat through the shadow thrown below and on the delicate line of the gunwale.[72]

The ship-at-sea motif in Ryder has countless variants as he experimented with ways of giving depth to his space through placing the boat on a diagonal plane, as in the Metropolitan Museum's *Moonlight Marine* or *Toilers of the Sea*, by varying the relationships of sail and moon and clouds, or by placing his ship parallel to or at the horizon in silhouetted form, as in the Guennol Collection *Moonrise, Marine* or the Carnegie Institute *Marine* (Fig. 129). The last of these occupies its space on the horizon elegantly, set like a more modest nocturnal version of a Buttersworth ship portrait, locked into space by the clouds and moon which wedge the mainsail and offer a counterpoint of rounded shapes against the rising points of the sails. Indeed, most of Ryder's ships inhabit their pictorial space fully. They have that postwar "sense of proportion and relation" of which James spoke, and are, in spatial terms, a far cry from the tiny pilot boat and equally tiny ships of Allston's *Rising of a Thunderstorm at Sea* or countless other romantic seascapes. If they resemble any pre–Civil War work in pictorial organization it is Chambers's *Storm-Tossed Frigate* (Fig. 41), which also works toward an integrated design, though Ryder consciously suppresses detail to give us only the essential forms in these paintings.

Finally there are Ryder's symbolic (or "literary," to use the accusatory term) seascapes: *Constance, Lord Ullin's Daughter*, the great *Jonah*, and the equally fine smaller gem, *The Flying Dutchman* (Pl. VIII). Ryder's impulse to turn to sources in Chaucer, Campbell, the Old Testament, and

125. Thomas Moran. *Seascape*, 1906. Oil on canvas, 30 x 40 inches. The Brooklyn Museum, New York; Gift of the Executors of the Michael Friedsam Estate.

126. George Inness. *Sunset Over the Sea*, 1887. Oil on wood panel, 22 x 36 inches. The Brooklyn Museum, New York; Gift of the Executors of the Michael Friedsam Estate.

127. Ralph Albert Blakelock. *The Sun, Serene, Sinks into the Slumberous Sea*, n.d. Oil on canvas, 16 x 24 inches. Museum of Fine Arts, Springfield, Massachusetts; Bequest of Horace P. Wright.

119

128. Albert Pinkham Ryder. *Moonlit Cove*, 1880–90. Oil on canvas, 14 x 17 inches. The Phillips Collection, Washington, D.C.

129. Albert Pinkham Ryder. *Marine*, c. 1890. Oil on panel, 12⅞ x 10⅛ inches. Museum of Art, Carnegie Institute, Pittsburgh, Pennsylvania.

130. Robert Loftin Newman. *Christ Stilling the Tempest,* before 1900. Oil on canvas, 14 x 18 inches. Virginia Museum of Fine Arts, Richmond.

Wagner links him, as we have seen, to a rich tradition in American seascape art, where the sea serves some purpose beyond the visual. In those paintings the sea could become an emblem of strife, the sign of one's profession or trade, the place to realize one's national destiny in the present or to view it in the past, or (climactically in Cole but equally in the mourning pictures) a religious symbol of the voyage of the soul toward union with deity in the universe. Ryder's friend Robert Loftin Newman could move with relative ease from scenes like the delicate *Shipwreck* (Fig. 97) in the outer world to their religious resolution in the visual encrustations—alas, now like Ryder, sadly deteriorated—of *Christ Stilling the Tempest* (Fig. 130).[73]

Indeed, seascape in American art from its beginnings to the twentieth century has always been both an outer and an inner phenomenon, a record of our perceptions of the external world and a mode of giving aesthetic shape to our conceptions. Ryder was as much the illustrator-interpreter of his texts as, for example, Swain Gifford and W. J. Hennessy were of Longfellow's *Building of the Ship* or James Hamilton and F. O. C. Darley were of Cooper's *The Pilot*. In Wagner's great early opera, *The Flying Dutchman*, the sublime power of the sea is juxtaposed to the pull of the land, of home and hearth, and redemption occurs at the end through the Dutchman's love of angelic Senta (the two transfigured lovers soaring upward at the end of the opera over the wreck of the ship in a manner close to the last panel of the *Voyage of Life*). Ryder emphasizes not the Wagnerian resolution; in fact his vision includes no land whatsoever, and no woman. Instead he has the phantom ship sweeping away at the upper left as three figures in a small boat register amazement. The human struggle of the figures in the pitching boat cradled in the turbulent sea is powerfully contrasted to the interpenetration of cloud and sail on the Dutchman's vessel, and the whole illuminated by the glowing golden ball of fire in the sky. Ryder, in other words, refocuses the drama from its Wagnerian land-sea and sin-redemption structure to clarify the difference between struggling human voyagers (Daland and his crew in the boat, enticed perhaps by golden dreams of wealth) and the spirit ship of the wanderer who forever seeks redemption on land but sees himself and is seen by Ryder as passing into the sublime void.

To insist upon Ryder's firm place within an American tradition is by no means to deny his special genius as an artist, though it is clearly a denial of the isolated nature of his achievement. His tendency to generalize his images separates him from those who sought to celebrate particular American sea experience and links him with those who emphasize seascape as an inner exploration, an ultimate search. The conflict of Watson with the terror of the deep is resolved in Copley's world by the human community in a boat. Ryder's Jonah, like Cole's old voyager, must face a deity bathed in light; Ryder's Dutchman sails into the glow of the internal, and hence eternal, light which shines through the rich glazes of paint. In this final sense Ryder's technical achievement, with all its limitations, lies in his emphasis on the quality of the paint itself to shape sublimely obscure images, and to create thereby a whole visual world.

8.
The End of an Era

However idiosyncratic his particular method, Ryder shares with his contemporaries at the end of the century in Europe and America an emphasis on pictorial surface. Ryder's glazing, like Blakelock's or Newman's or his French contemporary Monticelli's, brings the light to the surface from below. William Merritt Chase, Robert Henri, and Childe Hassam sought to lay glowing fresh color on the surface of the canvas to capture and depict the light from without. All of them called renewed attention to the act of painting itself in the shaping of a seascape vision.

Perhaps nowhere is this point more wittily made than by John Frederick Peto in a rare seascape still life of about 1890 (Fig. 131), for what Peto has done, within the tradition of the trompe l'oeil, is to insist that seascape like all art is an act of the artist, an arrangement of space. Peto has gathered two

coast scenes, the upper one a powerful rocky coast, and controlled the sublime potentialities by superimposing upon them the simpler gay sailboat painting. The disposition of images and space within the individual seascapes, so important to their artistic meaning, is echoed and wittily repeated by Peto's redistribution of these images within his own pictorial space. Previous artistic choices are reconsidered and redefined by the new artist, and the somewhat tattered appearance of the individual elements is itself a message that we are dealing with a pictorial past, not a present reality.[74]

The works of Chase, Hassam, and Henri emphasize the immediacy of the present moment as its evanescence is captured in rapid strokes of paint. In the 1890s Chase did a series of horizontal format scenes of the area around his summer home (and school of painting) at Shinnecock, Long Island. He also explored the coasts of Europe pictorially, as did other Americans resident or traveling abroad: Sargent, Whistler, Haseltine, Theodore Robinson, Alden Weir. Chase's large *Beach Scene, Zandvoort, Holland,* 1888 (Fig. 132), is a splendid example of his coastal marines, with its bravura

131. John Frederick Peto. *Still Life (Patch Painting),* c. 1890. Oil on canvas, 17⅛ x 14⅛ inches. Davis and Long, New York.

132. William Merritt Chase. *Beach Scene, Zandvoort, Holland,* (1888). Oil on canvas, 59 x 80 inches. Private collection.

133. William Merritt Chase. *Sidewheeler "America" in Port*, c. 1895. Oil on panel, 10 x 15⅜ inches. Webster Inc. Fine Art, Chevy Chase, Maryland.

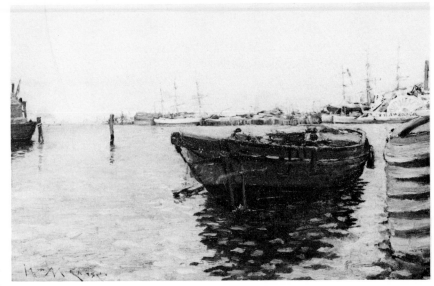

134. Childe Hassam. *Headlands*, 1908. Oil on canvas, 24¼ x 29¼ inches. Fogg Art Museum, Harvard University, Cambridge, Massachusetts; Gift of Archer M. Huntington.

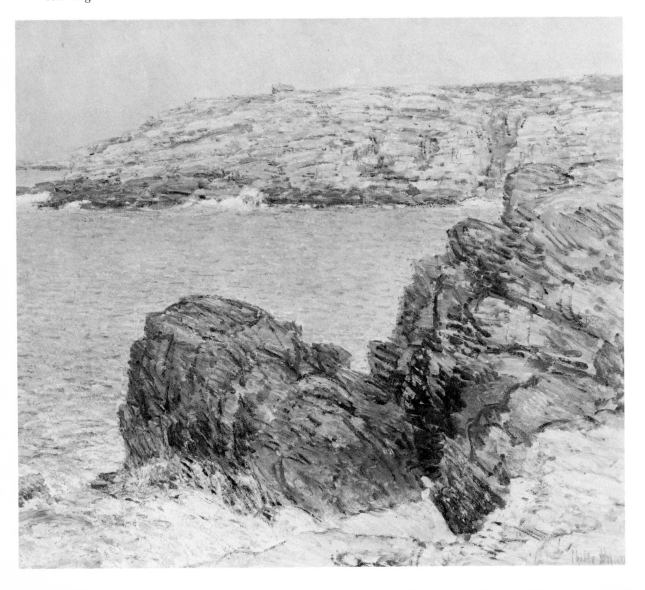

brush strokes, the shifts from thin to thick slashing strokes which focus attention on the pictorial surface. On a modest scale, Chase also essayed the harbor view. The *Sidewheeler "America" in Port*, about 1895 (Fig. 133), offers a striking contrast to Ryder's *Flying Dutchman*. Day and night, the rectilinear order of the harbor world and the swirling curves of the sublime sea, the palpable atmosphere of a particular day and the glowing *luce di dentro*, the boats near and far as renditions of specific kinds of marine craft and the generalized and idealized image of the phantom ship—these two works epitomize the different directions in which the American seascape tradition had moved in the nineteenth century.

In the gay seaside spaces of Hassam's *Headlands*, 1908 (Fig. 134), the rocks of Appledore are turned into strokes of paint, disintegrating the geologic forms which the Ruskinians had labored so hard to record. Henri, in the *Girl Seated by the Sea*, 1893 (Fig. 135), depersonalizes the female form as Homer had in 1869 in *Long Branch* (Fig. 105). At the other extreme and on the other coast, Arthur Mathews in San Francisco explored the range of imaginative uses of the sea, producing charming scenes of the Monterey coast, allegorical seascape portraits like *California,* and, perhaps most boldly, art nouveau mythological pieces like *The Wave*[75] (Fig. 136). By contrast to the sensuously emerging beauty of this work, John Sloan's *The Wake of the Ferry, II,* 1907 (Fig. 137), seems grim indeed. It is a major statement of urban America; Sloan's dark palette emphasizes the heavy enclosure that separates the viewer and the observer on the boat from the grimy world of the water beyond. Henri's girl seated by the sea or Hassam's rocks seem to have

135. Robert Henri. *Girl Seated by the Sea*, 1893. Oil on canvas, 18 x 24 inches. Collection of Mr. and Mrs. Raymond J. Horowitz.

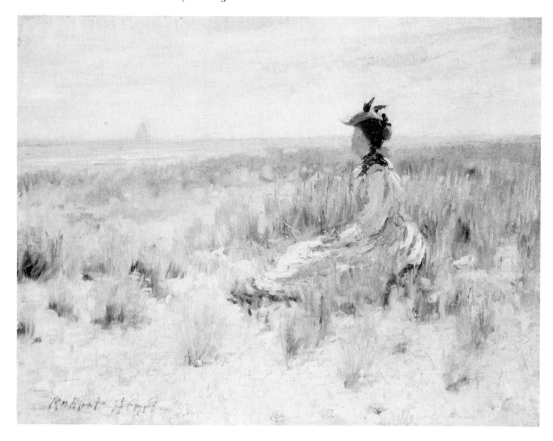

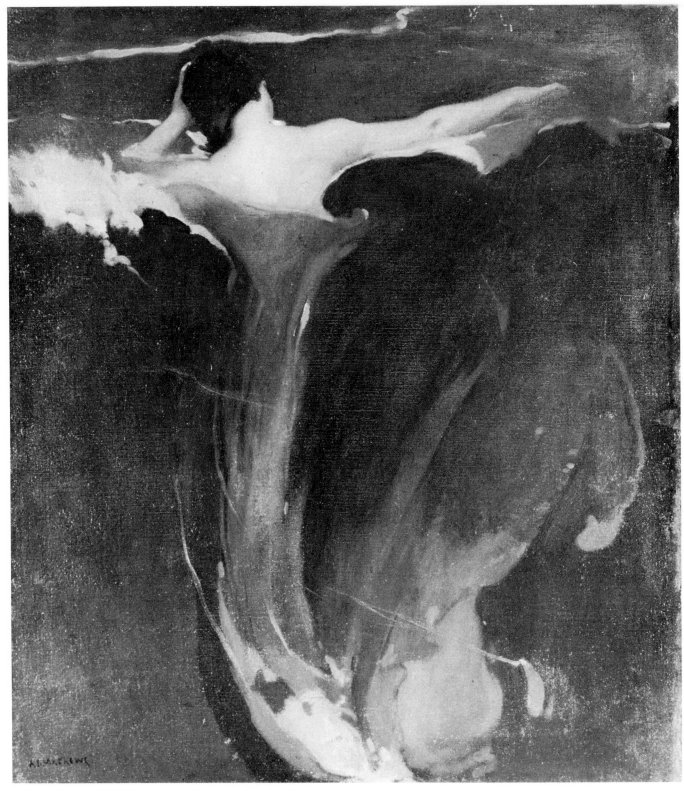

136. Arthur F. Mathews. *The Wave*, n.d. Oil on canvas, 25½ x 22½ inches. The Oakland Museum, Oakland, California; Gift of the Art Guild of the Oakland Museum Association.

137. John Sloan. *The Wake of the Ferry, II*, 1907. Oil on canvas, 26 x 32 inches. The Phillips Collection, Washington, D.C.

little in common with the denizens of the urban seascape except in their rich use of paint.

The tradition of seascape in America is not, then, a linear progression but a rich and complex one, accommodating a variety of imaginative pictorial visions of the nature of our experience as individuals and as a people. This rich variety would continue well on into the twentieth century: the gay cubist marine scenes of the Maine coast by John Marin pitted against the grim waves of Marsden Hartley; or, within Hartley's own career, the exploration outward in *The Wave,* a reinterpretation of the Prout's Neck vision of Homer, contrasted to *The Fisherman's Last Supper,* his homage to the symbolic seascape world of Ryder. Jackson Pollock's admiration for Ryder is well known: his 1934 *Seascape* an early work in the manner of Ryder, his *Full Fathom Five* (1947) a reinterpretation at once literary in its title and exploring beyond the visual seascape into the experience of pure paint. The tradition of American seascape was to have continuing vitality even after the great age of sail had long since disappeared.

What has been lost is the sense that a whole culture participates and is in turn defined by its relation to the sea. Americans still flock to the beaches for summer vacations, and those with the leisure to do so cross the seas on the great ocean liners which have replaced the sailing vessels of an earlier era. Immense tankers carry the oil that fuels our society from Middle Eastern seaports, and our navy still maneuvers around the world, though since Pearl Harbor the battleship seems obsolescent and the aircraft carrier its replacement. As a nation of explorers, we have turned from Argonauts into Astronauts, the language of seascape adapted to the outer spaces of our universe.

Seascape offered our artists a challenge to individual expressiveness and a shape for their feelings about their location in the physical universe and its relation to our metaphysical quest for ultimate meaning. It offered the American people a mirror of their experience and put them in touch with the largest rhythms of the natural world, with their historic past, and with their personal experience. It imaged their commercial and national aspirations, their sense of dislocation in the universe, and their hopes of spiritual succor. Whether space travel, our last movement into the sublime, will produce an imaginative tradition which is in any way as rich as that which seascape has given Americans remains to be seen.

Notes

1.
The Origins of American Seascape

1. See John Wilmerding, *A History of American Marine Painting* (Salem and Boston: Peabody Museum and Little, Brown and Company, 1968).
2. Typology, as a system of Biblical exegesis, originated as an attempt by early Christian theologians to reconcile the Old Testament with the New by reading the Old Testament events as "types," literal prefigurations of the "antitype," the story of the life, death, and resurrection of Christ. It was extended in later centuries to finding types in the world, in later human history, secular and natural, and had considerable importance for early American patterns of thought and aesthetics. For its application to America, see Sacvan Bercovitch, ed., *Typology and Early American Literature* (Amherst: University of Massachusetts Press, 1972); for its specific application to American seascape, see Roger B. Stein, "Seascape and the American Imagination: The Puritan Seventeenth Century," *Early American Literature*, 7 (Spring 1972), 17–37. A typological gravestone, with the ark of Noah (type), the dove holding an olive branch in a cross (a type in the Noah story of the Holy Spirit antitype), all related to the life and death of an eighteenth-century man, is the Eliakim Hayden gravestone (1797), Essex, Connecticut, reproduced in Allan I. Ludwig, *Graven Images* (Middletown, Connecticut: Wesleyan University Press, 1966), pl. 91e.
3. Kenneth Clark, *Landscape into Art* (1948) describes a parallel development and includes (pl. 1 and pl. 4a of the 1956 Pelican ed.) a Hellenistic fresco of the *Boat of Ulysses Drawn to the Island of Circe* and the *Landing of Duke William of Bavaria* from the *Hours of Turin* (1414–17).
4. The medieval inheritance is conveniently summarized in Robert R. Cawley, *Unpathed Waters* (Princeton: Princeton University Press, 1940), pp. 1–70.
5. See Dallas Pratt, "Discovery of a World: Early Maps Showing America," *Antiques*, 96 (December 1969), 900–906, and 97 (January 1970), 128–34.
6. William T. Davis, ed., *Bradford's History of Plymouth Plantation, 1606–1646* (New York: Charles Scribner's Sons, 1908), p. 95; for a recent discussion of the Foster map, see Richard B. Holman, "Seventeenth-Century American Prints," in *Prints in and of America to 1850,* ed. John D. Morse, Winterthur Conference Report 1970 (Charlottesville: University Press of Virginia, 1970), pp. 37–43.
7. See Laurens J. Bol's monumental *Die Holländische Marinemalerei des 17. Jahrhunderts* (Braunschweig: Klinkhardt & Biermann, 1973).
8. I. N. Phelps Stokes, *The Iconography of Manhattan Island, 1498–1909* (New York: Robert Dodd, 1915), I, 139–40 and passim. Information on the frame was kindly supplied by Richard Koke, Curator, New-York Historical Society.
9. See Stokes, *Iconography,* I, 239–51, 272–74; for Burgis's other work, see *American Printmaking: The First 150 Years* (New York: Museum of Graphic Art, 1969), p. 19, and Morse, ed., *Prints in and of America,* pp. 80–82.
10. For Cooper, see Pennsylvania Academy of the Fine Arts, *Philadelphia Painting and Printing to 1776* (1971), p. 12. The Leitch passage is quoted in *Art in South Carolina* (Columbia: South Carolina Tricentennial Press, 1970), p. 78; for an earlier Bishop Roberts watercolor *Prospect of Charles Town* (1735–39), see *ibid.,* p. 10.
11. See G. N. D. Evans, *Uncommon Obdurate: The Several Public Careers of J. F. W. Des Barres* (Salem and Toronto: Peabody Museum and University of Toronto Press, 1969).
12. For the Dutch seventeenth century, see Bol, cited above (n. 7); for the English eighteenth century, see David Cordingly, *Marine Painting in England 1700–1900* (London: Studio Vista, 1974). For the American literary parallels, see my essay on Puritan seascapes cited above (n. 2); Roger B. Stein, "Pulled Out of the Bay: American Fiction in the Eighteenth Century," *Studies in American Fiction,* 2 (Spring 1974), 13–36; and Thomas Philbrick, *James Fenimore Cooper and the Development of American Sea Fiction* (Cambridge: Harvard University Press, 1961), pp. 1–41.
13. For a convenient summary of the situation in painting and the graphic arts, see the two Winterthur Conference reports: Morse, ed., *Prints in and of America to 1850,* and *American Painting to 1776: A Reappraisal,* ed. Ian M. G. Quimby (Charlottesville: University Press of Virginia, 1971). For some interesting examples of fireboards and overmantels of the last decades of the eighteenth century, see *Land and Seascape as Observed by the Folk Artist: An Exhibition from the Collection of Bertram K. and Nina Fletcher Little* (Williamsburg: Abby Aldrich Rockefeller Folk Art Collection, 1969), pls. 2, 8, 9, 32, 38, 45, and 48 (referred to hereinafter as Little Collection, *Land and Seascape*).
14. *XVIIth Century Painting in New England,* ed. Louisa Dresser (Worcester, Massachusetts: Worcester Art Museum, 1935), pp. 130–38 and passim.

15. The Renaissance emblem is neither an illustration of an external event nor is it a symbol in the modern sense, though we have often wrongly used the terms interchangeably. Coleridge characterized the modern sense of the symbol as "a translucence of the special in the individual, or of the general in the special, or of the universal in the general. Above all by the translucence of the eternal through and in the temporal. It always partakes of the reality which it renders intelligible." (*Complete Works of Samuel Taylor Coleridge*, ed. W. G. T. Shedd. New York: Harper & Brothers, 1884, I,438). My argument here is that it is the older Renaissance emblem tradition, linked sometimes to Biblical typology, that informed much American seascape art. For the European background of the emblem tradition, see Mario Praz, *Studies in Seventeenth Century Imagery*, 2nd ed. (Roma: Edizioni di storia e letteratura, 1964); Rosemary Freeman, *English Emblem Books* (London: Chatto and Windus, 1948), esp. pp. 9–36; John Pope-Hennessy, *The Portrait in the Renaissance*, Bollingen Series XXXV.12 (New York: Pantheon Books, 1963), chap. v, "Image and Emblem"; and for a brilliant discussion of one of the more complex seascape emblem portraits, Frances Yates, "The Allegorical Portraits of Sir John Luttrell," in *Essays in the History of Art Presented to Rudolf Wittkower*, ed. Douglas Fraser et al. (London: Phaidon, 1967), pp. 149–60.

16. The frequently quoted Smibert letter to his London agent is available in Henry W. Foote, *John Smibert* (Cambridge: Harvard University Press, 1950), p. 88; a set of the Lemprière prints to which he referred is available in the Print Room of the Victoria and Albert Museum. These prints were sold by the engraver William Henry Toms, from whom John Boydell took lessons. For Boydell's later role, see n. 28 below. For the American use of mezzotints, see Waldron P. Belknap, *American Colonial Painting* (Cambridge: Harvard University Press, 1959); for the *Hallett* portrait in particular, see the *Catalogue of American Portraits in the New-York Historical Society* (New Haven: Yale University Press, 1974), I, 321–22.

17. The pattern in the portrait is repeated in the Moffatt-Ladd House at Portsmouth, New Hampshire: an elegant classical residence built in 1763 for young Samuel by his father, John Moffatt, overlooking the Piscataqua River where the Moffatt wharves and warehouses were located. In the nineteenth century, lovely French scenic wallpapers, grisaille views of Italian harbors, were installed. See the description of the house by Jane C. Giffen in *Connoisseur* (October and November 1970).

18. I am grateful to Louisa Dresser for calling the Savage miniature to my attention. For other partial exceptions to the pattern, see Charles Willson Peale's *Unknown Lady of Maryland*, 1775 (Fogg Art Museum), the background of which looks like Chesapeake Bay. For women and the sea in the early literature, see Stein, "Pulled Out of the Bay," pp. 17–21, 30–32. In the nineteenth century, the pair of portraits of Captain and Mrs. William Sampson, c. 1850 (*Kennedy Quarterly*, 12 [October 1974], pls. 104 and 105) both have seascape backgrounds but his is fully open, corresponding to the telescope in his hand, hers just glimpsed to the left of the drapery that encloses her, corresponding to the clasped book in her hand.

19. For the *Waldo* portrait and the Smibert letter, see Marvin Sadik, *Colonial and Federal Portraits at Bowdoin College* (Brunswick, Maine, 1966), pp. 57–62.

20. The full research on the Newark painting, to which the discussion above is indebted, has been undertaken by Melanie Schwarzer and will be made available subsequently. The Canot engraving of Havana is reproduced in part in Jules David Prown, *John Singleton Copley* (Cambridge: Harvard University Press, 1966), II, pl. 370. For biographical background on Williams, see David H. Dickason, *William Williams: Novelist and Painter of Colonial America, 1727–1794* (Bloomington: Indiana University Press, 1970).

2.
From Classic to Romantic

21. For a sampling of the Revolutionary War prints, see *American Printmaking: The First 150 Years*, pls. 30, 31, 39, 41, 43, 54, 55, 63, 64, 65, 69. On Charles Willson Peale's now unlocated seascapes, see the supplement to Charles C. Sellers's catalogue of Peale, *Transactions of the American Philosophical Society*, LIX, pt. 3 (1969), 12–13. Early in his career Peale had painted a number of rather stiff window-view seascape portraits. In 1787 he did an important variant on the type, placing *Captain James Josiah* inside the cabin of his China trade vessel, the *Asia*, with compass, chart, and a view out the cabin windows (*ibid.*, p. 68 and pl.). Because this work locates the figure realistically, rather than only conceptually, in sea space (though the actual cramped quarters are given imaginative outreach through the oriental names visible on the chart), the work is a movement away from the emblem portrait.

22. The print source for *The Return of Neptune* and the *Galatea* and its print source are reproduced in Prown, *Copley*, I, pls. 7, 8, 10. It is worth noting, in the light of preceding and subsequent discussion of American interest in the horizontal format, that among Copley's alterations of his source in the *Neptune* is the introduction of a horizon line. Only four of Copley's American portraits include the boat-harbor background (sketchily painted): two of Nicholas Boylston (1767), one of Thomas Greene

(1758), and the most open of them all, the John Amory of 1768 (Prown, I, pls. 56, 182, 184, 220).

23. My extended full discussion and documentation of the *Watson*, its sources in theory and in Renaissance painting, its relation to the American seascape tradition both visual and verbal, and its "Americanness," is forthcoming as "Copley's *Watson and the Shark* and Aesthetics in the 1770's," in a festschrift on colonial American literature and aesthetics. For the time being, the best source is Prown, II, 267–74; for the eighteenth-century background, see Edgar Wind, "The Revolution of History Painting," *Journal of the Warburg Institute*, 2 (1938–39), 116–27.

24. See the classic study of Samuel H. Monk, *The Sublime* (New York: Modern Language Association, 1935); J. T. Boulton's introduction to the best modern edition of Edmund Burke, *Philosophical Enquiry into the Origin of Our Ideas of the Sublime and Beautiful* [1st ed., 1757] (London: Routledge & Kegan Paul, 1958), is also very useful.

25. This passage comes in Melville's great metaphysical and epistemological excursus on the sublime in *Moby-Dick*: chap. xlii, "The Whiteness of the Whale."

26. James Howgego, "Copley and the Corporation of London," *Guildhall Miscellany*, 9 (July 1958), 34–43. Wind also explores the importance of the Americans in his "Revolution of History Painting," pp. 124–26.

27. Background on the two youthful works is supplied in *Benjamin West, 1738–1820* (Philadelphia: Pennsylvania Museum of Art, 1938), pp. 15–16. The *Storm at Sea* seems especially close in format to the work of Claes Claeszoon Wou (see Bol, *Holländische Marinemalerei*, pls. 79, 80, 81). For West and the sublime, see Grose Evans, *Benjamin West and the Taste of His Times* (Carbondale: Southern Illinois University Press, 1959), pp. 55–81.

28. Although no single source for this watercolor has been located, in manner it seems close to the mezzotints published by John Boydell in the middle 1770s after Claude's *Liber Veritatis*, then in the collection of the Duke of Devonshire. By 1787 Boydell's foreign trade in prints was immensely successful. See William T. Whitley, *Artists and Their Friends in England 1700–1799* [1928] (New York: Benjamin Blom, 1968), II, 71–72.

29. The *Rocky Coast with Banditti* (Museum of Early Southern Decorative Arts) is reproduced in Wilmerding, *History*, pl. 35. It is by no means a coincidence that the *Oxford English Dictionary* finds the first usage of the word *seascape* in 1799 (some two hundred years after the first usage of *landscape*). By contrast to other terms like *marine*, the word *seascape* itself implies both a subject matter *and* a point of view. Romantic perception had created the need for a new term.

30. Both the *Coast Scene* (Columbia Museum of Art) and the *Ship at Sea in a Squall* (Fogg Art Museum) are reproduced in Wilmerding, *History*, pls. 36 and 38.

Allston also did a few other unlocated seascapes, including one in watercolor for Thomas Handasyd Perkins, with whom he traveled back from Europe in 1818. See E. P. Richardson, *Washington Allston*, rev. ed. (New York: Thomas Y. Crowell-Apollo, 1967), cat. #79, 86, 114, 176. His later attitude toward the sea—a tendency to avoid its radical implications—and his own artistic situation is captured nicely in a poem which he composed to Rubens:

> Thus o'er his art indignant Rubens reared
> His mighty head, nor critic armies feared.
> His lawless style, from vain pretension free,
> Impetuous rolling like a troubled sea,
> High o'er the rocks of Reason's ridgy verge
> Impending hands; but, ere the foaming surge
> Breaks o'er the bound, the under-ebb of taste
> Back from the shore impels the watery waste.

Quoted from Jared B. Flagg, *The Life and Letters of Washington Allston* (New York: Charles Scribner's Sons, 1892), pp. 409–10.

3.
The Crystallization of a National Identity

31. The Stuart *Washington* was painted in Philadelphia in 1797. For the circumstances surrounding it in Stuart's career, see John K. Howat's essay on the Stuart Vîcomte de Noailles portrait, *Metropolitan Museum of Art Bulletin*, 29 (March 1971), 327–40. That this rare seascape *Washington* came into the possession of Alexander Hamilton is suggestive, considering Hamilton's interest in the sea and American commercial policy (Lawrence Park, *Gilbert Stuart* [New York: William Edwin Rudge, 1926] III, 861–62). The Stuart full-length posthumous *Washington at Dorchester Heights*, 1806 (Museum of Fine Arts, Boston), contains a sea view in the background, though Washington is equally isolated from it. An earlier John Trumbull *Washington*, 1780 (Metropolitan Museum of Art), painted from memory in London, which showed Washington at West Point with two warships maneuvering in the river below, was influential in Europe through engravings (Albert Ten Eyck Gardner and Stuart Feld, *American Paintings: A Catalogue of the Collection of the Metropolitan Museum of Art, I* [New York, 1965], pp. 101–2). James Peale's *Washington and His Generals at Yorktown*, c. 1786 (Maryland Historical Society), also incorporated a sea view. But in none is there any dynamic interaction between figure and sea; all are treated emblematically.

32. The American audience's ability to judge the accuracy of a battle painting is amply clear if one compares the Cornè *"Hornet" and "Peacock"* with Capt.

James Lawrence's letter to the secretary of the navy of 19 March 1813, printed in full with the wood engraving after Cornè in Abel Bowen's *Naval Monument* (Boston, 1816), pp. 36–39. For Birch's many War of 1812 paintings, see the checklist in Doris Jean Creer's "Thomas Birch: A Study of the Condition of Painting and the Artist's Position in Federal America" (unpublished master's thesis, University of Delaware, 1958).

4.
In Pursuit of the Romantic Sublime

33. For the identification of the sublime with American nature, see Perry Miller, "The Romantic Dilemma in American Nationalism and the Concept of Nature," *Nature's Nation* (Cambridge: Harvard University Press, 1967), pp. 196–207. The classic early American statement is Washington Irving's "Author's Account of Himself" and "The Voyage" in *The Sketch Book* (1819–20), even though Irving's persona Geoffrey Crayon opts out of the sublime voyage—fully aware of its terrifying implications. On the international context, see W. H. Auden, *The Enchafèd Flood* [1950], (New York: Vintage-Knopf, 1967).

34. For the immediate context, see Lorenz Eitner, "The Open Window and the Storm-tossed Boat: An Essay in the Iconography of Romanticism," *Art Bulletin*, 37 (December 1957), 279–90; and George P. Landow, "Shipwrecked and Castaway on the Journey of Life: An Essay Towards a Modern Iconography," *Revue de littérature comparée*, 46 (octobre-décembre 1972), 569–96. For the earlier tradition see the suggestive backgrounds in Ewald M. Vetter, "Sant peters schifflin," *Kunst in Hessen und am Mittelrhein: Shriften der Hessischen Museen*, 9 (1969), 7–34; Bernard Blume, "Lebendige Quell und Flut des Todes: Ein Beitrag zu einer Literaturgeschichte des Wassers," *Arcadia*, I (1966), 18–30; and J. Richard Judson, "Marine Symbols of Salvation in the Sixteenth Century," *Marysas*, Supplement I (1964), 136–52. On the well-known Shaw *Deluge* (long attributed to Allston), see Gardner and Feld, *American Paintings*, pp. 130–33. John Martin's *Deluge* was shown in New York in 1829. It is worth noting that the Shaw *Deluge* was presented to the Metropolitan in 1909 by William Merritt Chase, whose Shinnecock seascapes of the 1890s are a rejection of all the literary and Biblical implications of the Shaw work.

35. For the American followers of the Dutch, see Wilmerding, *History*, chap. vi, and Barbara Novak, *American Painting of the Nineteenth Century* (New York: Praeger Publishers, 1969), pp. 113–15. Among the Americans for whom Turner was an important force are Cole, who responded negatively in his visit to Turner's studio in 1829, Frederic Church, James Hamilton, Thomas Moran, and those whose exposure to Turner came, at least initially, through the writings of John Ruskin, like John William Hill and John Henry Hill, Aaron Draper Shattuck, William Trost Richards. See Roger B. Stein, *John Ruskin and Aesthetic Thought in America, 1840–1900* (Cambridge: Harvard University Press, 1967).

36. This fact has been noted by many; the implications have been discussed most perceptively by John W. McCoubrey, *American Tradition in Painting* (New York: George Braziller, 1963) and Novak, *American Painting of the Nineteenth Century*.

37. Compare Cropsey's earlier *View of the Isle of Capri* (1848), illustrated in William F. Talbot, *Jasper F. Cropsey, 1823–1900* (Washington: National Collection of Fine Arts, 1970), p. 69, painted on his first European trip, with its traditional Claudian tower to the left, locating us in an enclosed space. In the 1855 *Coast Scene* the rocks are barely a protective barrier to the power of the sea beyond.

38. Again, the male-female, sea-land alternatives are apparent.

39. The literature on Fortuna is large and impressive; for background see Howard K. Patch, *The Goddess Fortuna in Mediaeval Literature* (Cambridge: Harvard University Press, 1927); for an example of the serial image, see Little Collection, *Land and Seascape*, pls. 63, 64; for a shipwreck portrait, see *ibid.*, pl. 96. The Heade is reproduced in color in Wilmerding, *History*, pl. XIV.

40. One of the earliest of the type is the gouache *Snow "America" of Marblehead*, 1803 (Peabody Museum of Salem), illustrated in *Michele Felice Cornè, 1752–1845* (Salem: Peabody Museum, 1972), pl. 5. For variations on the type, compare J. H. Wright, *U.S. Ship Constellation* (1833) in the *M. and M. Karolik Collection of American Paintings, 1815–1865* (Boston and Cambridge: Museum of Fine Arts and Harvard University Press, 1949), pp. 524–26; and [William] Plumer's *Ocean Squall* (1868), Little Collection, *Land and Seascape*, pl. 6.

41. Compare Cordingly, *Marine Painting in England*, pls. 59, 81, 82.

42. *The Education of Henry Adams* (Boston: Houghton Mifflin Company, 1918), p. 92; cf. Miller, "The Romantic Dilemma in American Nationalism," pp. 204–7; and Alan P. Wallach, "Cole, Byron, and the *Course of Empire*," *Art Bulletin*, 50 (December 1968), 375–79 and pls.

43. The full discussion of the pictorial and conceptual background of *The Voyage of Life* must await the publication of Howard Merritt's catalogue raisonné of Cole, for the dating of the various sketches is still unclear. The standard source on the work still remains Louis L. Noble's *Life and Works of Thomas Cole* [1st ed., 1853], ed. Elliot S. Vesell (Cambridge: Harvard University Press, 1964), pp. 208–18 and pas-

sim. It is worth noting that in terms of its popular appeal, the panel of the series most copied in vernacular versions was the Claudian *Youth*.

44. Turner was not, of course, averse to painting angels, as his *Angel Standing in the Sun*, 1846 (Tate Gallery) testifies. Yet in the same year Turner completed *"Hurrah! For the Whaler Erebus! Another Fish!"* (Tate Gallery), one of several works inspired by his reading of Thomas Beale's 1839 whaling narrative. Turner's astonishing technique frequently blinds critics to the fact that he was a romantic artist who could, like Cole, turn both outward into the world and inward to the mind, the spiritual, the mythological.

45. For Church, see his *Vision of the Cross* studies (Olana); the impact on Poe, in *Eureka* (1848), and on Melville still needs to be accurately assessed; for Cooper see the suggestive discussion in Philbrick, *Cooper and Sea Fiction*, pp. 233–37; for Hamilton, see his engraving of "The Wreck of the Ariel" from Cooper's *Pilot* in Susan Fenimore Cooper, *The Cooper Gallery* (New York: Miller, 1865).

5.

Maritime Nationalism

In Search of a History

46. *Views and Reviews in American Literature, History and Fiction, First Series* [1845], ed. C. Hugh Holman (Cambridge: Harvard University Press, 1962), p. 87. The same heights of Darien (Panama) had excited Keats "On First Looking into Chapman's Homer" and were to generate Nick Carraway's final meditation in *The Great Gatsby*.

47. Not all Hicks's *Peaceable Kingdom*s incorporate the West *Penn's Treaty*: others of the Kingdom of Conflict variety, which use the grouping of figures entwined in banners saying "Peace on Earth Good Will To Men," sometimes open up the sea space more fully. But they all serve the same emblematic purpose and the sea is fully framed. Hicks's Quaker predecessor John Woolman treated his trip to England typologically in the last section of his *Journal* (first published 1774).

48. Francis Parkman, *The Discovery of the Great West: La Salle* [1869], ed. William R. Taylor (New York: Rinehart Editions, 1956), pp. 226–27. Mark Twain, taken with Parkman's ironic twisting of sublime rhetoric, quoted it entire at the end of the second chapter of *Life on the Mississippi* (1883).

49. The Chapman work, engraved by M. I. Danforth, and the Hicks painting after it are illustrated in Alice Ford, *Edward Hicks: Painter of the Peaceable Kingdom* (Philadelphia: University of Pennsylvania Press, 1952), p. 145. The Cornè is reproduced in Peabody

Museum, *Cornè*, pl. 67. Kenneth C. Lindsay discusses briefly the greed motif in his *Works of John Vanderlyn* (Binghamton: Art Gallery, State University of New York at Binghamton, 1970), pp. 74–75. The Hamilton work, inspired by Rogers's *Voyage of Columbus*, is reproduced in Arlene Jacobowitz, *James Hamilton, 1819–1878: American Marine Painter* (Brooklyn: The Brooklyn Museum, 1966), p. 33. Hamilton went on to do a wide range of seascapes including nationalist works like *Old Ironsides*, 1863 (Pennsylvania Academy of the Fine Arts), works based on literary sources like the *Ancient Mariner*, 1863 (Pennsylvania Academy of the Fine Arts), or on Cooper sea novels; he also did stunning engravings after the Arctic sketches of Elisha Kent Kane.

50. For a brilliant discussion of this symbolic juxtaposition, see David C. Huntington, *Art and the Excited Spirit* (Ann Arbor: University of Michigan Museum of Art, 1972), pp. 10–12.

The Celebration of Commerce

51. Quoted in John Wilmerding, *Robert Salmon: Painter of Ship & Shore* (Salem and Boston: Peabody Museum and Boston Public Library, 1971), p. 111. For Turner's impact on Salmon, see *ibid.*, pp. 55, 64–68.

52. *The Works of Ralph Waldo Emerson*, ed. J. E. Cabot (Boston: Houghton Mifflin Company, 1883), I, 110–11. For a related but somewhat different interpretation of Emerson's importance, see Novak, *American Painting of the Nineteenth Century*, passim.

53. For Perkins and Salmon, see Wilmerding, *Salmon*, pp. 40–41, 45.

54. Wilmerding, *Salmon*, p. 91 and appendix of Salmon's list of paintings, #648. See his "fansy fires," #705, 706, 708; and cf. his note on #839: "Shore and figure No ship or boat. Ship reck put in after"—presumably because it would help the work to sell.

55. Henry T. Tuckerman, *A Memorial of Horatio Greenough* [1853] (New York: Benjamin Blom, 1968), pp. 78, 124–25. On the "Young America" nationalists, see Perry Miller, *The Raven and the Whale* (New York: Harcourt, Brace and Company, 1956). In these and subsequent years, "Young America" was a favorite name for ships—and yachts that raced in international competition.

The Domestication of Seascape

56. On Church's Arctic experience, see David C. Huntington, *The Landscapes of Frederic Edwin Church* (New York: George Braziller, 1966), pp. 83–87, which emphasizes the spiritual character of these works. On Bradford, see John Wilmerding, *William Brad-*

135

ford, 1823–1892 (DeCordova Museum and Whaling Museum of New Bedford, 1969).

57. For typical illustrated temperance tracts, see "Pay Night" or "Tom Starboard and Jack Halyard," American Tract Society pamphlets bound together as *Pictorial Narratives* (New York: J. A. Ackley, n.d.). Lane's "Alcohol Rocks" is illustrated in John Wilmerding, *Fitz Hugh Lane* (New York: Praeger Publishers, 1971), pl. 13. For a rather different post–Civil War version of the genre seascape, closer to the enigmatic Norslup (?) work, see John George Brown's *The Longshoremen's Noon*, 1879 (Corcoran Gallery), illustrated in Patricia Hills, *The Painters' America: Rural and Urban Life, 1810–1910* (New York: Praeger Publishers for the Whitney Museum of American Art, 1974), pl. 139.

58. The documentation of the following pages poses special methodological problems, because the text and illustrations offer a special perspective on American folk art. The collections, the published catalogues, and the unpublished records not only of specialized maritime museums like the Peabody Museum of Salem, the Whaling Museum of New Bedford, the Kendall Whaling Museum, Mystic Seaport, the new South Street Seaport Museum in New York City, the Philadelphia Maritime Museum, the Mariners Museum, Newport News, Virginia, and numerous others, but also of the major American art museums with decorative arts collections, specialized museums like the Museum of American Folk Art, and small local historical societies like that at Stonington, Connecticut (which has in the carved tailpiece of the *Mary and Susan* a minor materpiece) —all of these contain rich and varied materials related to American seascape. In addition, books and exhibition catalogues on American folk art from the 1930s on to the Whitney Museum of American Art's *Flowering of American Folk Art 1776–1876* (New York: Viking Press, 1974) have important examples of sea-related folk art.

The problem is that, for all the interest shown in the formal decorative strength of this work, the material is grouped—almost without exception—in relation to craft and classified as to type of object or use rather than grouped in relation to its theme and meaning. (Peter C. Welsh's *American Folk Art: The Art and Spirit of a People. From the Eleanor and Mabel Van Alstyne Collection* [Washington: Smithsonian Institution, 1965] is one brief but immensely suggestive exception to this pattern.) In this study my attempt has been to stress thematic continuities between the "trained" and the "folk" artist. Without denying the difference both in skill and in final visual impression between the two, a difference that has been fruitfully explored by others, my concern is with describing the shared attitudes and basic expressive gestures of American artists and their audience in relation to the sea.

Until an adequate thematic and iconographic index of American art (whether of seascape in particular or of folk art in general) is developed, documentation of examples from the existing sources will be impossibly cumbersome and arbitrary. In lieu of that, the reader is referred to the items in the general bibliographical listing and to Lipman and Winchester, *Flowering of American Folk Art*, for discussion of types.

I wish to express my special debt of gratitude to the staffs of Mystic Seaport and Old Sturbridge Village, who have helped in countless ways to clarify my perspectives on these questions.

6.
Scenic America: Intimate Seascape and Opening Vistas

59. Henry James, *Hawthorne* (1879) in *The Shock of Recognition*, ed. Edmund Wilson, rev. ed. (New York: Farrar, Straus and Cudahy, 1955), p. 536. For the naval art of the war, see Herman Warner Williams, Jr., *The Civil War: The Artist's Record* (Boston: Beacon Press, 1961), pp. 32, 118–21, 144–45, 180–92; and *The Civil War: A Centennial Exhibition of Eyewitness Drawings* (Washington: National Gallery of Art, 1961), pp. 24–25, 30, 52–53, 66, 80, 96–97. In 1874–75 James Hamilton, working from sketches done on the spot in 1862 by Col. Samuel Wetherill, completed a series of paintings on the *Action Between the "Monitor" and "Merrimac"—Morning, Noon, and Night* (see Jacobowitz, *Hamilton*, pp. 70–71).

60. Wilson, ed., *Shock of Recognition*, p. 536.

61. Stein, *Ruskin and American Aesthetic Thought*, pp. 1–56, 78–123, 146–56 passim. It should be emphasized that Americans tended to simplify the complex aesthetic theories of Ruskin and picked up especially his emphasis on the mimetic, rather than his emphasis on the imagination as a combining power. For a corrective view, see George P. Landow, *The Aesthetic and Critical Theories of John Ruskin* (Princeton: Princeton University Press, 1971). I have underestimated, in my early study, the work of both the Hills and Richards. For a scholarly reappraisal of Richards's early career, see Linda Ferber's catalogue, *William Trost Richards: American Landscape Painter, 1833–1905*, (Brooklyn: The Brooklyn Museum, 1973), esp. pp. 24–32.

62. For the Shattuck chronology, see *Aaron Draper Shattuck, N.A., 1832–1928* (New Britain [Connecticut] Museum of American Art, 1970).

63. The letter from Ruskin is quoted in *American Etchings*, ed. Ernest Knaufft, Part XII (New York, n.d.). In John Henry Hill's pamphlet on his father, *John William Hill: An Artist's Memorial* (New York, 1888), he describes their trip to the Maine coast in 1857,

just after they had both read Ruskin. He singles out a large drawing, more dramatic in mode than either watercolor but equally concerned with Ruskinian truth to nature:

> It represents a reach of sea shore, with massive rocks draped with sea weeds, receiving the wild onset of turbulent waves, and dashing them to whitened foam. So true is the feeling expressed in this drawing that the spectator may imagine himself placed before the actual scene, and inhaling the freshness of the salt sea air.

64. Gifford used the older sublime format in *Two Figures and Boat on Beach* (1863), which should be compared with the *Boat on a Beach*. They are reproduced side by side in Elton Hall's catalogue, *R. Swain Gifford, 1840–1905* (New Bedford: Whaling Museum, 1974), pls. 4 and 5; *"Fish Rock"* is pl. 40.

65. I am indebted to Theodore E. Stebbins, Jr., some of whose work on American watercolor was presented at the University of Delaware conference on nineteenth-century American art in April 1974. On the "etching craze," see Albert Ten Eyck Gardner, *Winslow Homer, American Artist: His World and His Work* (New York: Clarkson N. Potter, 1961), pp. 167–85.

66. The *Atlantic Storm* was reproduced by Evan Charteris in his biography, *John Sargent* (New York: Charles Scribner's Sons, 1927), opp. p. 42. The *Oyster Gatherers* (Corcoran Gallery) and *Boys on a Beach* (Clark Art Institute, Williamstown, Massachusetts) in Richard Ormond, *Sargent* (New York: Harper and Row, 1970), fig. 7 and pls. 4 and 5.

67. For a stimulating but somewhat different interpretation of the comparison between the *Meditation* and the *Coast Scene*, in relation to American luminism, see Novak, *American Painting of the Nineteenth Century*, pp. 98–101.

68. *The Bathe at Newport* and another early beach scene, *August in the Country—The Sea Shore* (1859) are reproduced in Barbara Gelman, ed., *The Wood Engravings of Winslow Homer* (New York: Crown Publishers–Bounty Books, 1969), pp. 13, 34. The costs of the Civil War are measured in his 26 August 1865 *Harper's Weekly* engraving of a young couple in a carriage with the sea behind them. He still wears his Union cap while she drives. The title: *Our Watering Places—The Empty Sleeve at Newport* (ibid., p. 93). *Sailing the Catboat* is a study for *Breezing Up*, 1876 (National Gallery of Art), in which the little lighthouse is replaced by an interestingly two-dimensional sailboat on the horizon that contrasts with the sculptural feeling of the catboat near us. Together the boats and the treatment of the sea remind us that *Breezing Up* is fundamentally an experiment in paint.

69. *Alfred Thompson Bricher, 1837–1900* (Indianapolis Museum of Art, 1973), p. 22.

7.
Tragedy and Apocalypse

70. For the continuity of this vision, which we have noted earlier in relation to Whitman's poem of that name, see Book I of Henry Nash Smith, *The Virgin Land: The American West as Symbol and Myth* (Cambridge: Harvard University Press, 1950).

71. Vedder's seascapes range from Cohasset, Massachusetts, beach scenes to little Italian coastal scenes to consciously symbolist works like *Memory* or the most famous of all, *The Lair of the Sea Serpent*, 1864 (Museum of Fine Arts, Boston), which combines the horizontal format, the beach and dunes, and the intruding, threatening, outsized snake. Vedder even did some modern emblems of Fortuna. See Regina Soria, *Elihu Vedder: American Visionary Artist in Rome (1836–1923)* (Rutherford, New Jersey: Fairleigh Dickinson University Press, 1970), for illustrations.

72. For illustrations of these and the following Ryders, see Lloyd Goodrich's immensely helpful *Albert Pinkham Ryder* (New York: George Braziller, 1959), which includes when possible early photographs that preserve details now sunken or difficult to catch photographically, like the light on the gunwale in *Moonlit Cove*.

73. For Newman, see Marchal E. Landgren's *Robert Loftin Newman, 1827–1912* (Washington: Smithsonian Institution Press for the National Collection of Fine Arts, 1974). The little recently recovered collaborative triptych by Ryder and Newman (1898), reproduced as pl. 43 in Landgren, emphasizes again Ryder's filling the space with his forms. On their relations, and artistic context, see the important essay by Albert Boime, "Newman, Ryder, Couture, and Hero-Worship in Art History," *American Art Journal*, 3 (Fall 1971), 5–22.

8.
The End of an Era

74. The paintings which Peto rearranges may be by F. D. Briscoe, a Philadelphia marine painter whose work Peto owned. See *American Paintings, Watercolors, and Drawings from the Collection of Jo Ann and Julian Ganz* (Santa Barbara Museum of Art, 1973).

75. See Harvey L. Jones, *Mathews: Masterpieces of the California Decorative Style* (Oakland, California: The Oakland Museum, 1972), cat. nos. 23, 27, 28, 52.

Selected Bibliography

Abby Aldrich Rockefeller Folk Art Collection. *Land and Seascape as Observed by the Folk Artist: An Exhibition from the Collection of Bertram K. and Nina Fletcher Little.* Introduction and catalogue by Nina Fletcher Little. Williamsburg, Virginia, 1969.

ALBION, ROBERT G. *Naval and Maritime History: An Annotated Bibliography.* 4th edition. Mystic, Connecticut: Marine Historical Association, 1972.

American Federation of Arts. *John Frederick Kensett, 1816–1872.* Selected by John K. Howat. New York, 1968.

American Printmaking: The First 150 Years. Text by Wendy J. Shadwell. New York: The Museum of Graphic Art, 1969.

Arts Council of Great Britain. *"Shock of Recognition." The Landscape of English Romanticism and the Dutch Seventeenth-century School.* London and The Hague: The Tate Gallery and The Mauritshuis, 1971.

AUDEN, W. H. *The Enchafèd Flood; or The Romantic Iconography of the Sea.* 1950; reprinted. New York: Knopf-Vintage, 1967.

BARBEAU, MARIUS. "All Hands Aboard Scrimshawing." *American Neptune,* 12 (April 1952), 3–26.

BEAM, PHILIP C. *Winslow Homer at Prout's Neck.* Boston: Little, Brown and Company, 1966.

BERMAN, BRUCE D. *Encyclopedia of American Shipwrecks.* Boston: Mariners Press, 1972.

BOL, LAURENS J. *Die Holländische Marinemalerie des 17. Jahrhunderts.* Braunschweig: Klinkhardt & Biermann, 1973.

Boston, Museum of Fine Arts. *American Paintings in the Museum of Fine Arts, Boston.* 2 vols. Boston, 1969.

BREWINGTON, M. V. *Shipcarvers of North America.* 1962; reprinted. New York: Dover Publications, 1972.

The Brooklyn Museum. *The Coast and the Sea: A Survey of American Marine Painting.* Organized by John I. H. Baur. Brooklyn, 1948.

BROWN, JEFFREY R. *Alfred Thompson Bricher, 1837–1900.* Indianapolis, Indiana: Indianapolis Museum of Art, 1973.

CAWLEY, ROBERT RALSTON. *Unpathed Waters: Studies in the Influence of the Voyagers on Elizabethan Literature.* Princeton: Princeton University Press, 1940.

CORDINGLY, DAVID. *Marine Painting in England 1700–1900.* London: Studio Vista, 1974.

CREER, DORIS JEAN. "Thomas Birch: A Study of the Condition of Painting and the Artist's Position in Federal America." Unpublished master's thesis, University of Delaware, 1958.

CUMMER GALLERY OF ART. *American Paintings of Ports and Harbors, 1774–1968.* Jacksonville, Florida, 1969.

DICKASON, DAVID HOWARD. *William Williams: Novelist and Painter of Colonial America, 1727–1791.* Bloomington: Indiana University Press, 1970.

EITNER, LORENZ. "The Open Window and the Storm-tossed Boat: An Essay in the Iconography of Romanticism." *Art Bulletin,* 37 (December 1957), 279–90.

EVERSON MUSEUM OF ART. *American Ship Portraits and Marine Painting.* Syracuse, New York, 1970.

FAIRBANKS, JONATHAN. "Yarns of a Sailor in Yarn." *Antiques* 16 (September 1929), 210–11.

FERBER, LINDA S. *William Trost Richards: American Landscape and Marine Painter, 1833–1905.* Brooklyn: The Brooklyn Museum, 1973.

FORBES, ALLAN. "The Story of Clipper Ship Sailing Cards." *Proceedings of the American Antiquarian Society,* 59 (Worcester, 1950), 225–74.

GARDNER, ALBERT TEN EYCK. *Winslow Homer, American Artist: His World and His Work.* New York: Clarkson N. Potter, Inc., 1961.

——— and STUART FELD. *American Paintings: A Catalogue of the Collection of the Metropolitan Museum of Art, I.* New York, 1965.

GOODRICH, LLOYD. *Albert Pinkham Ryder.* New York: George Braziller, 1959.

———. *Winslow Homer.* New York: The Macmillan Company, published for the Whitney Museum of American Art, 1944.

GROCE, GEORGE C. and DAVID H. WALLACE. *The New-York Historical Society's Dictionary of Artists in America, 1564–1860.* New Haven: Yale University Press, 1957.

HARRIS, NEIL. *The Artist in American Society: The Formative Years, 1790–1860.* New York: George Braziller, 1966.

HUNTINGTON, DAVID C. *The Landscapes of Frederic Edwin Church: Vision of an American Era.* New York: George Braziller, 1966.

Indiana University Art Museum. *The American Scene, 1820–1900.* Organized by Louis Hawes. Bloomington, 1970.

JACOBOWITZ, ARLENE. *James Hamilton, 1819–1878: American Marine Painter.* Brooklyn: The Brooklyn Museum, 1966.

JONES, HOWARD MUMFORD. *O Strange New World: American Culture, The Formative Years.* New York: Viking Press, 1964.

Kennedy Galleries. "American, English, and European Marine Paintings." *Kennedy Quarterly,* 13 (October 1974), 129–76.

LANDGREN, MARCHAL E. *Robert Loftin Newman, 1827–1912.* Washington, D.C.: Smithsonian Institution Press for the National Collection of Fine Arts, 1974.

LANDOW, GEORGE P. "Shipwrecked and Castaway on the

Journey of Life: An Essay Towards a Modern Iconography." *Revue de littérature comparée*, 46 (octobre-décembre 1972), 569–96.

LARKIN, OLIVER. *Art and Life in America*. 2nd edition. New York: Holt, Rinehart and Winston, 1960.

LINDSAY, KENNETH C. *The Works of John Vanderlyn: From Tammany to the Capitol*. Binghamton: University Art Gallery, State University of New York at Binghamton, 1970.

LIPMAN, JEAN, and ALICE WINCHESTER. *The Flowering of American Folk Art 1776–1876*. New York: Whitney Museum of American Art and Viking Press, 1974.

MCCOUBREY, JOHN W. *American Tradition in Painting*. New York: George Braziller, 1963.

MELVILLE, HERMAN. *Moby-Dick* [1851]. Edited by Harrison Hayford and Hershel Parker. New York: Norton Critical Edition, 1967.

MORISON, SAMUEL ELIOT. *The European Discovery of America: The Northern Voyages, A.D. 500–1600*. New York: Oxford University Press, 1971.

———. *The Maritime History of Massachusetts, 1783–1860*. 1921; reprinted. Boston: Houghton Mifflin–Sentry, 1961.

Munson-Williams-Proctor Institute. *John Quidor*. Essay by John I. H. Baur. Utica, New York, 1965.

Museum of American Folk Art. *Hooked Rugs in the Folk Art Tradition*. New York, 1974.

National Maritime Museum, Greenwich. *Concise Catalogue of Paintings*. London: Her Majesty's Stationery Office, 1958.

NOBLE, LOUIS LEGRAND. *The Life and Works of Thomas Cole* [1853]. Edited by Elliot S. Vesell. Cambridge: Harvard University Press, 1964.

NOVAK, BARBARA. *American Painting of the Nineteenth Century: Realism, Idealism, and the American Experience*. New York: Praeger Publishers, 1969.

Peabody Museum of Salem. *Michele Felice Cornè, 1752–1845: Versatile Neapolitan Painter of Salem, Boston, and Newport*. Foreword and Notes by Philip C. F. Smith. Introduction by Nina Fletcher Little. Salem, Massachusetts, 1972.

PHILBRICK, THOMAS. *James Fenimore Cooper and the Development of American Sea Fiction*. Cambridge: Harvard University Press, 1961.

Portrait of a Place: Some American Landscape Painters in Gloucester. Essay by John Wilmerding. Catalogue by James F. O'Gorman. Gloucester, Massachusetts: 350th Anniversary Celebration, Inc., 1973.

PROWN, JULES DAVID. *John Singleton Copley*. 2 vols. Cambridge: Harvard University Press, published for the National Gallery of Art, 1966.

REYNOLDS, SIR JOSHUA. *Discourses on Art*. Edited by Robert R. Wark. San Marino, California: Huntington Library, 1959.

RICHARDSON, E. P. *Washington Allston: A Study of the Romantic Artist in America*. Revised edition. New York: Thomas Y. Crowell–Apollo, 1967.

Rivers and Seas: Changing Attitudes Toward Landscape, 1700–1962. Cambridge, Massachusetts: Busch-Reisinger Museum, 1962.

Scrimshaw: Folk Art of the Whalers. Text by Walter K. Earle. Illustrations by Jane Davenport. Cold Spring Harbor, New York: Whaling Museum Society, Inc., 1957.

Seventeenth Century Painting in New England. Compiled and edited by Louisa Dresser. Worcester, Massachusetts: Worcester Art Museum, 1935.

SHEPARD, LEWIS A. *American Painters of the Arctic*. Amherst, Massachusetts: Mead Art Gallery, Amherst College, 1974.

STEBBINS, THEODORE, JR. *Martin Johnson Heade*. Baltimore: University of Maryland, 1969.

STEIN, ROGER B. "Pulled Out of the Bay: American Fiction in the Eighteenth Century." *Studies in American Fiction*, 2 (Spring 1974), 13–36.

———. "Seascape and the American Imagination: The Puritan Seventeenth Century." *Early American Literature*, 7 (Spring 1972), 17–37.

TATHAM, DAVID. *The Lure of the Striped Pig: The Illustration of Popular Music in America, 1820–70*. Barre, Massachusetts: Barre Imprint Society, 1973.

TUCKERMAN, HENRY T. *Book of the Artists. American Artist Life, Comprising Biographical and Critical Sketches of American Artists: Preceded by an Historical Account of the Rise and Progress of Art in America* [1867]. Reprinted. New York: James F. Carr, 1967.

University of Michigan Museum of Art. *Art and the Excited Spirit: America in the Romantic Period*. Exhibition organized by David C. Huntington. Ann Arbor, 1972.

VON GROSCHWITZ, GUSTAVE. *The Seashore: Paintings of the 19th and 20th Centuries*. Pittsburgh: Museum of Art, Carnegie Institute, 1965.

WELSH, PETER C. *American Folk Art: The Art and Spirit of a People, from the Eleanor and Mabel Van Alstyne Collection*. Washington, D.C.: Smithsonian Institution, 1965.

WILMERDING, JOHN. *A History of American Marine Painting*. Salem and Boston: Peabody Museum of Salem and Little, Brown and Company, 1968.

———. *Fitz Hugh Lane*. New York: Praeger Publishers, 1971.

———. *Robert Salmon, Painter of Ship and Shore*. Salem and Boston: Peabody Museum of Salem and Boston Public Library, 1971.

Winterthur Conference Report 1970. *Prints in and of America to 1850*. Editor John D. Morse. Charlottesville: University Press of Virginia, 1970.

Winterthur Conference Report 1971. *American Painting to 1776: A Reappraisal*. Editor Ian M. G. Quimby. Charlottesville: University Press of Virginia, 1971.

Index

Page numbers in *italics* denote illustrations